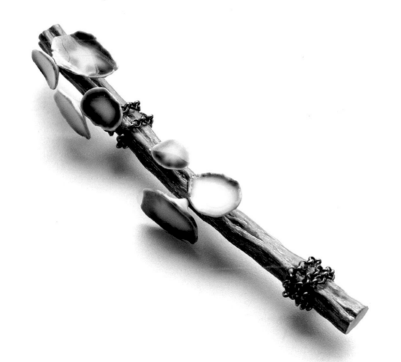

design & make
mixed media
jewellery

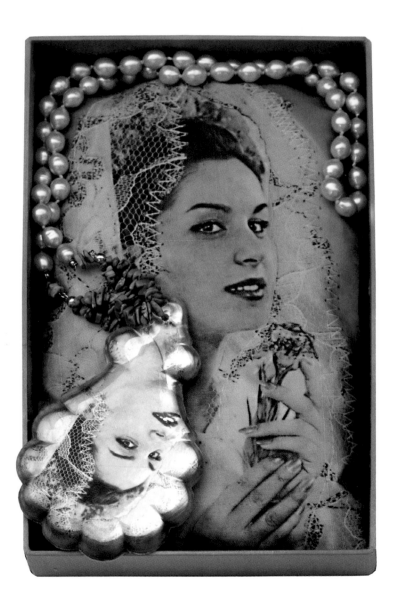

Spanish Bride, Mecky van den Brink. Whetted glass, silver leaf, flock (backside), turquoise, pearl.
Box 14 cm x 22 cm x 5 cm, glass pendant 12 cm x 7 cm.

design & make
mixed media
jewellery

JOANNE HAYWOOD

DISCLAIMER

Everything written in this book is to the best of my knowledge and every effort has been made to ensure accuracy and safety but neither author nor publisher can be held responsible for any resulting injury, damage or loss to either persons or property. Any further information which will assist in updating of any future editions would be gratefully received. Read through all the information in each chapter before commencing work. Follow all health and safety guidelines and where necessary obtain health and safety information from the suppliers. Health and safety information can also be found on the internet about certain products.

First published in Great Britain 2009
A&C Black Publishers
36 Soho Square
London W1D 3QY
www.acblack.com

ISBN 978-0-7136-8867-2

Copyright © 2009 Joanne Haywood

CIP catalogue records for this book are available from the British Library and the U.S. Library of Congress.

Frontispiece: *Green Mushrooms Brooch*, Terhi Tolvanen. Rosemary wood, paint, porcelain, silver, porcelain made in EKWC. 18 cm length. 2007.

Commissioning editor: Susan James
Managing editor: Sophie Page
Book design: Sally Fullam and Sutchinda Thompson
Cover design: Sutchinda Thompson
Copy editor: Jo Waters

Printed and bound in China

contents

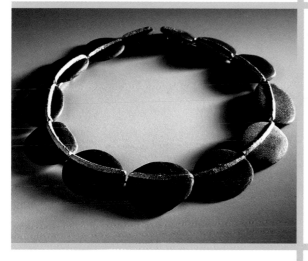

acknowledgements

I would like to thank the following makers for being so generous in sharing their work and photographs
Shana Astrachan, Ami Avellán, Kirsten Baks, Maike Barteldres, Ela Bauer, Rosie Bill, Alexander Blank, Iris Bodemer, Kate Brightman, Sebastian Buescher, Carla Castiajo, Min-Ji Cho, Lee Dalby, Miranda Davis, Cilmara de Oliveira, Christine Dhein, Ute Eitzenhöfer, Nicolas Estrada, Shelby Fitzpatrick, Jantje Fleischhut, Gill Forsbrook, Angela Gleeson, Stefan Heuser, Leonor Hipólito, Ornella Iannuzzi, Antje Illner, Mari Ishikawa, Hu Jung, Steffi Kalina, Mila Kalnitskaya and Micha Maslennikov (mi mi Moscow), Sarah Keay, Kyeok Kim, Adele Kime, Steffi Klemp, Kerstin Klux, Heeseung Koh, Yael Krakowski, Robin Kranitzky and Kim Overstreet, Gilly Langton, Anna Lewis, Tina Lilienthal, Paula Lindblom, Keith Lo Bue, Åsa Lockner, Kristin Lora, Claire Lowe, Marcia MacDonald, Alison Macleod, Ermelinda Magro, Lindsey Mann, Sharon Massey, Rachel McKnight, Juliette Megginson, Amandine Meunier, Marco Minelli, Sonia Morel, Ai Morita, Linda Kaye Moses, Kathie Murphy, Evert Nijland, Carla Nuis, Ineke Otte, Ruudt Peters, Lina Peterson, Natalya Pinchuk, Jo Pond, Suzanne Potter, Katja Prins, Ingrid Psuty, Jo Pudelko, Ramon Puig Cuyas, Uli Rapp, Ulrich Reithofer, Tabea Reulecke, Loukia Richards, Anna Rilkinen, Marc Rooker, Philip Sajet, Lucy Sarneel, Karin Seufert, Susan Skoczen, Suzanne Smith, Kathleen Taplick & Peter Krause (Body Politics), Deepa Taylor, Terhi Tolvanen, Cynthia Toops, Fabrizio Tridenti, Jessica Turrell, Mecky Van Den Brink, Felieke Van der Leest, Machteld Van Joolingen, Rachelle Varney, Manuel Vilhena, Andrea Wagner, Polly Wales, Lisa Walker, Silvia Walz, Lynda Watson, Dionea Rocha Watt, Francis Willemstijn, Anastasia Young, Stefano Zanini.

I would like to thank the following galleries for their assistance
Alternatives Gallery, Flow Gallery, Galerie Rob Koudijs, Galerie Marzee, New Ashgate Gallery, Velvet da Vinci.

I would like to thank the following people for their continuous faith and support
Marc, Nick, Ian, Sonia, Kate, Mike, Alice and Luigi. Thanks also go to special friends June, Saskia, Magic Mo and the gang at NWK.

I would like to thank Liz Olver for all her advice and her generous encouragement.
Thanks to Alan Parkinson for the great photography and making the shoots good fun to work on.
And finally, thanks to Susan James and A&C Black Publishing, for making the book a possibility.

Author: Joanne Haywood
joannehaywood51@hotmail.com
www.joannehaywood.co.uk

Photographer: Alan Parkinson
alan@aperture56.com
www.aperture56.com

introduction

An example of mixed media jewellery that made a distinct impression on me at a young age was a collection of Mesopotamian court jewellery at the British Museum. Made in *c.*2500BC, the jewellery was created from a number of materials but what really impressed me was the vivid blue lapis against the buttery shine of the gold that had been fashioned into leaves. The jewellery looks like a collage of techniques and materials utilising embossing, stringing, carving and cutting. It seemed marvellous that something so old looked so brilliant. To this day I still feel excited when I see this work. I like to imagine the jeweller making it and what it may have looked like on a living Sumerian all those thousands of years ago. The court jewellery really does illustrate the best attributes of mixed media jewellery; skill in making, individuality and a passion for materials and their meanings.

Studio jewellers today often choose to work with a selection of materials rather than opting for solitary metals. Sometimes a specific group of materials will become the modus operandi of a jeweller, lasting for many years. At other times a maker may choose specific materials in response to a particular brief. They may find that it only suits that one piece of jewellery and move on to a completely different combination for the next challenge.

Techniques in mixed media work can be diverse and might explore traditional jewellery skills alongside your own experiments and those poached from textiles, fine art and fashion. Virtually any material, both natural and manmade, might be used. 'Mixed media jewellery' defined very simply, is mixing more than one material together to form a piece of jewellery, but more often than not jewellers working with mixed media seem to push the boundaries of traditional jewellery. To pilfer the words of Cole Porter, when it comes to mixed media jewellery, *anything goes!*

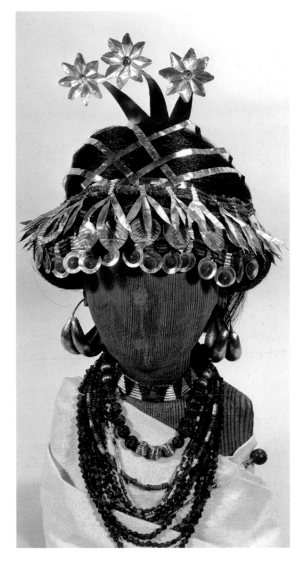

Sumerian court jewellery. Gold, lapis lazuli beads, carnelian, agate. Various sizes. c.2500BC. Sumerian, Ur.

This book examines a wide range of materials in a series of jewellery projects. It will introduce you to basic jewellery techniques and tools, as well as less traditional ways of working. *Exploring design*, page 34, covers the basics of how to get the most from preparing to make.

The gallery pages focus on makers whose work links to the projects either by choice of materials or intentions. The gallery pages aim to put the projects into context, showcasing a

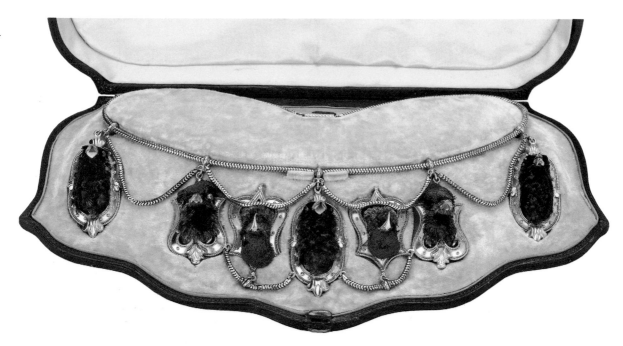

Gold necklace set with the heads of hummingbirds. Gold and feathers, shown in the original manufacturer's case of Harry Emanuel of Bond Street. Width: 20 cm. 1865–1870. UK.

selection of intriguing mixed media work in a wide range of materials and techniques.

Meet the makers, p120 will introduce you to mixed media jewellers working around the world, to illustrate the diverse nature of mixed media and to see how they approach designing and making.

CONTEXTUALISING

A wide variety of materials have always been used in making jewellery. 'Mixed media jewellery', is by no means a modern phenomenon. Bones, seeds, shells and other found and collected objects are often seen in very early jewellery, mixed together, creating very individual works.

Metals were used early on in jewellery, including gold, copper and silver. Gold has always held symbolic qualities of wealth and magic which have not really left our modern psyche. Important in many cultures and used in folklore and histories, gold is still a popular choice for jewellers today. Metal has always been used in conjunction with other materials, sometimes precious, sometimes non-precious.

Jewellery can embody a special meaning for the wearer. Sometimes these meanings are projected by the materials themselves. Victorian jewellery often uses combinations of materials as a storytelling device or a secret message. A mix of different stones might have been used to spell a message of love, alongside a precious metal such as gold. Hair was often incorporated in jewellery for remembrance. Examples often show intricate weaving and plaiting techniques.

Enamel coupled with metal was used early in history, spanning different continents. Egyptian jewellery often favours these materials, combined with a variety of colourful stones. Romano-British pendants from the 1st to the 3rd centuries AD are remarkable in their design and skill. Roman jewellery finds from Kent and the surrounding areas from the 6th century AD look surprisingly modern. Enamelling has remained a revered jewellery technique, and an opportunity for craftsmen to showcase their skill.

Cut paper work makes appearances in jewellery in the seventeenth century, often attributed to nuns, and showing the images of saints. These intricate studies are extraordinary and they have endured the perishing effects of

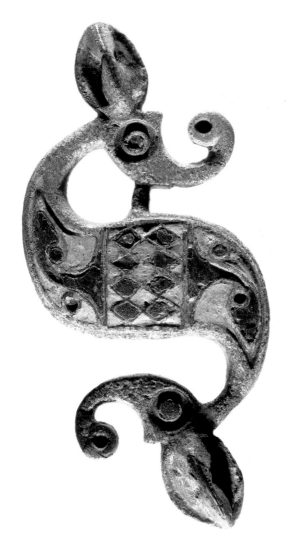

Dragonesque brooch. Champlevé enamel
and bronze. Length: 7cm. 1st or 2nd century
AD. Roman Britain.

technical advances in mind, as well as a
consideration for the value of materials and what
it says about the wearer.

During the eighteenth and nineteenth
centuries, miniature seed pearl work was popular.
Very fine compositions were created on blue
enamel backgrounds and mounted in metal and
glass frames. These pieces have a collage feel that
is often intrinsic to mixed media work.

In the late nineteenth century, a London
jeweller, Harry Emanuel, created a remarkable
humming bird necklace, using real feathers and
gold mounts. Equally, makers from overseas were
feeding the trend for mixed media jewellery.
The British Museum displays two humming bird
brooches made in Venezuela specifically for
export to the UK. These micro-studies of birds
were produced on a mother-of-pearl base and set
on a metal and glass mount.

It is interesting to compare European jewellery
from the seventeenth to the nineteenth centuries
with contemporary works in America. There was
and still is a strong appreciation in America for
textiles as adornment that had not been paralleled in
Europe. The readiness of materials obviously played
a big part, but it is interesting to see how different
value systems are created in different cultures.

You can track the development of studio
jewellery back to jewellers working in the mid
part of the last century, but they in turn would
have been influenced by jewellers before them
working in a similar art-based way. René Lalique
produced work that has the spirit of a studio
jeweller and the same excitement and
development of techniques.

Since the 1960s, studio jewellery has
advanced rapidly and has found new audiences
and students. Makers and writers cite different
jewellers as being responsible for paving the way
or influencing future makers. For me it has always
been makers who have had their own unique
vision and who have veered along a new path that
are the real heroes of jewellery; Hermann Jünger,
Caroline Broadhead, Tone Vigeland and David
Poston are among them.

time by being placed inside glass and gold settings.

In the nineteenth century, steel and iron
became popular materials for jewellery. In Berlin,
factories replaced precious metal jewellery with
iron jewellery because the state at the time had
asked for donations of gold to help with the war
efforts. Not only were makers and wearers
excited by new techniques and materials, it was
also seen as very patriotic to wear 'Berlin iron'.
Cast iron cameos of the 1820s and 30s were set
on shiny steel surfaces, being designed with

1. materials

There are no constraints or exclusions when it comes to choosing materials for mixed media jewellery. There is an endless number to choose from and an equally endless number of outcomes for each material.

Mixed media jewellery is an interesting area for makers and wearers alike. Often the work has a heightened sense of excitement as the materials are chosen with a passion and respect for their inherent properties.

The following materials feature in one or more of the project chapters.

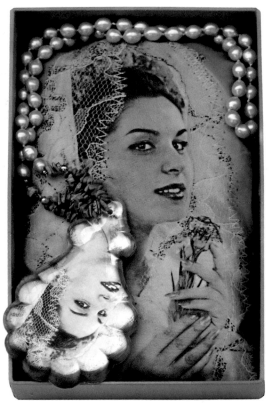

1

1 **Spanish Bride**, Mecky van den Brink.
 Whetted glass, silver leaf, flock
 (backside), turquoise, pearl.
 Box 14 cm x 22 cm x 5 cm,
 glass pendant 12cm x 7cm x 1cm,
 total lengths 58 cm. 2006.

2 **Winter Series Brooch**, Jessica Turrell.
 Silver, copper, vitreous enamel.
 5 cm x 4 cm x 0.7 cm. 2008.

3 **Book Cover Brooch**, Jo Pond. Silver,
 book cover, pearls. Height 9 cm. 2007.

4 **Green Mushrooms Brooch**,
 Terhi Tolvanen. Rosemary wood, paint,
 porcelain, silver, porcelain made in
 EKWC. 18 cm length. 2007.

5 **Resin and Thread Necklace**, Kathie
 Murphy. Polyester resin, polyester
 thread. 1.8 cm x 1.8 cm x 65 cm. 2006.

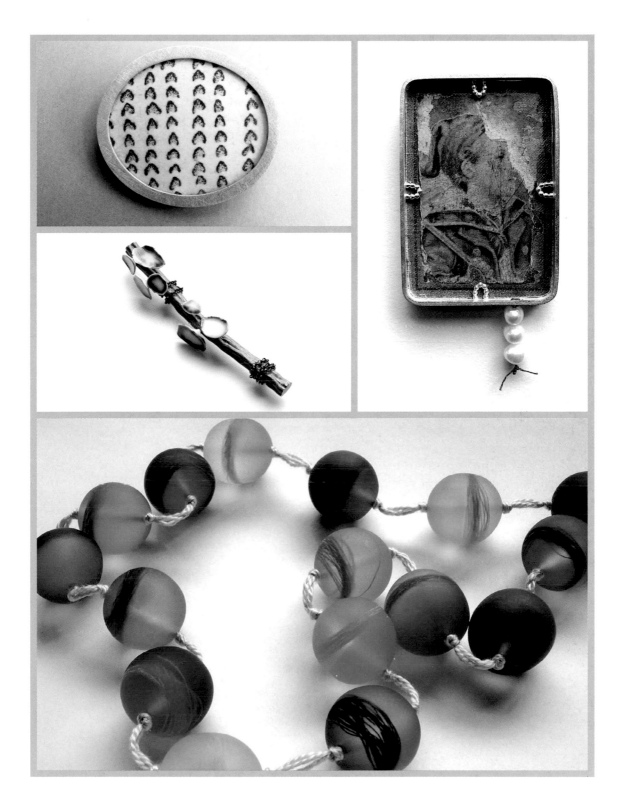

metals

Metals are used across the breadth of jewellery, whether it is fine, costume, fashion, or art and studio jewellery. Silver and gold are popular choices and are chosen for many reasons, including changeable surfaces, malleability, longevity and often because of their inherent value. Metals can be broken down into three groups as follows:

PRECIOUS METALS

Platinum, silver and gold are precious because of their properties of strength, colour, malleability and rarity. Gold can be purchased in different levels of purity and can range in colour from yellow, green and red.

BASE METALS

Bronze, copper, nickel, tin, zinc and aluminium are less expensive than precious metals and are not as commonly used in jewellery, although they are popular in fashion jewellery for casting and mass productions. Some jewellers are very successful in developing the properties of base metals. For example, Lindsey Mann uses aluminium in her work and produces coloured surfaces that are playful and intricate.

REFRACTORY METALS

Titanium and niobium are lightweight metals which are sometimes used in studio jewellery. However, they are difficult to work with as they are hard to saw and cannot be soldered by conventional means. Therefore, cold forming methods of bending, riveting and binding have to be adopted. Paradoxically, the problems that a material poses can be attractive to a maker, like a puzzle to solve. An attractive property for refractory metals is that they can be coloured with electricity or heat.

Metals are available in many formats such as sheet, tube, prefabricated findings, wire, leaf and clay (PMC).

Many studio jewellers use silver and/or gold in combination with another material. This combination can be used for a variety of reasons. Firstly it can contrast with the qualities of a textile, plastic or wood. Equally it might add strength, a framework for a thin paper structure, or a metal box form could hold resin or small delicate items. Some jewellers might choose to use a precious metal to add value when used alongside a less expensive material.

Metal leaf.

18 ct Green Gold

22 ct Moon Gold

22 ct Yellow Gold

12 ct White Gold

23³/₄ ct Warm Gold

Palladium

23 ct Red Gold

Genuine Silver

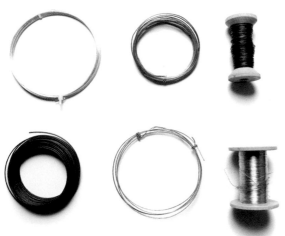

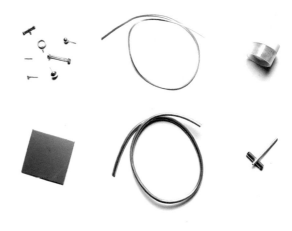

WIRE Left to right, top row: silver, copper, binding wire. **Bottom row**: steel, brass, fuse wire.

SILVER Left to right, top row: findings, square wire, PMC. **bottom row**: sheet, round wire, tube.

plastics

Plastics are seen as a non-precious material and can be often overlooked for this reason. However, many jewellers recognise that when worked with skill, their jewellery can rival the beauty of any precious metal or stone.

Plastic is a versatile material that can be purchased in different formats such as sheet, tube and textured surfaces.

Polypropylene is a plastic that can be purchased in different sheet thickness and colours. It has very good sculpting properties which have been explored by jewellers such as Rachel McKnight, Gill Forsbrook and Tom Mehew, who use the techniques of scoring, folding, cold forming and juxtaposing the material with silver components.

Liquid plastics such as resins are becoming more popular. Kathie Murphy is one of its advocates and her book, *Resin Jewellery*, in A&C Black's Jewellery Handbook series, is a must for any student wanting to develop their skills in this area.

Recycled plastics can be interesting to work with, including toothbrushes, drink bottles, computer parts and buttons.

Above: Found plastics. **Below**: Polypropylene.

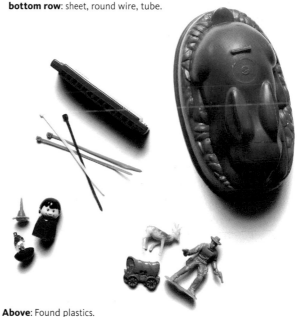

wood

Wood is often used in jewellery to explore its noble and pure associations. Very often it is used alongside other materials and the surface is sometimes coloured or treated. Like metal and plastic, it can be purchased in premade forms and sizes.

Most contemporary makers are aware of environmental issues and purchase wood from a renewable source, especially when buying exotic woods such as zebrano, burbinga and purpleheart.

Wood surfaces are very versatile. Some makers leave the surface untouched to reveal the material's natural beauty, whereas others might carve, varnish or paint the surface to bring out other qualities. Francis Willemstijn uses wood to create collage jewellery. The dark wood is mixed with precious metals to add contrast.

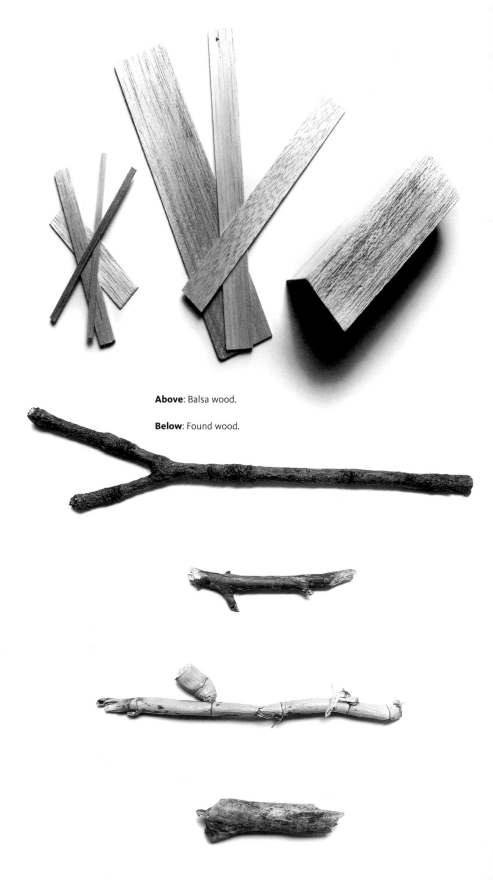

Above: Balsa wood.

Below: Found wood.

paper

Paper is a material often taken for granted, seen as a disposable material used for newspapers, money and junk mail. Most makers use paper to design or draw on but only a small number think about it as a material to use in jewellery. I think this is largely due to the delicacy of the material, or at least its perceived delicacy. However, paper can in fact be a durable material if varnished, layered, laminated or used in conjunction with other materials. Sometimes the fragile nature of paper is the focus of a piece of jewellery and many wearers will appreciate the fact that it has to be worn carefully, maybe for special occasions or displayed for the most part as sculpture.

Many papers, bought and found can have special qualities that appeal to makers. The bloom on an old letter or book can be quite beautiful. Papier-mâché is a technique that, once separated from our memories of primary school or wallpaper paste disasters, can be used to produce sensuous forms and large volumes of a light and wearable nature.

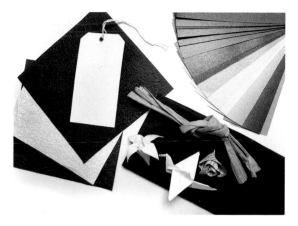

Clockwise from left: Japanese handmade paper, luggage tag, metallic paper, black tissue paper, green crêpe paper, recycled book in a flower form and an origami bird and flower.

Laminating is a good way of protecting paper and gives a different surface finish. Laminators are now fairly inexpensive pieces of equipment and can be found in high street stationers.

Handmade paper can produce interesting surfaces and can be used to produce cast forms and relief surfaces. As with any material, experimentation can result in unexpected and attractive results.

photographs & printed images

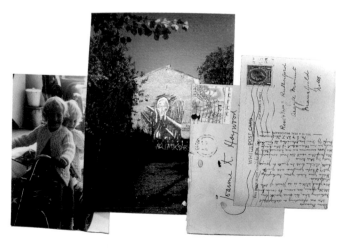

Left to right: family photo, photograph taken in Oslo, envelope with stamp and postmark, vintage postcard with stamp and script.

Photographs, whether they are family portraits, holidays snaps, architectural details or Victorian flea market finds, can be used as a starting point for a piece of jewellery. Many have a mysterious or sentimental quality that can produce jewellery objects that are like three-dimensional riddles to be solved from the clues presented.

I have always found maps fascinating to look at, especially old maps of London where road names change and bridges are added or removed. Maps are beautiful objects and are fairly inexpensive to work with. Equally, stamps are interesting to use in jewellery and have a precious quality in their own right.

textiles

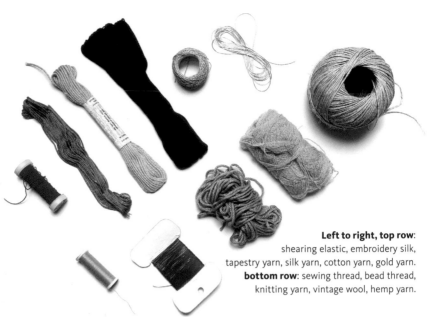

Textiles are becoming a popular choice for jewellers and are seemingly more accepted by the buying public. Textile techniques are also adopted by jewellers for use with non-traditional materials, for example, knitted electrical plastics or pleated rubber.

Just like metals, textiles present a huge array of techniques which can be adopted, such as printing, knitting, felt making, embroidery, smocking and collage.

Below I have included some of the textiles you will encounter in the project chapters:

YARNS

Embroidery silks, knitting yarns in a variety of materials, cotton, wool, blends of materials, sewing threads, shearing elastic, silk threads and hemp yarn. There are hundreds of colours and variations to choose from.

SURFACES

Felt, both handmade and acrylic, calico and cotton.

FINDINGS

Poppers, buttons and sewing needles.

Left to right, top row: shearing elastic, embroidery silk, tapestry yarn, silk yarn, cotton yarn, gold yarn. **bottom row**: sewing thread, bead thread, knitting yarn, vintage wool, hemp yarn.

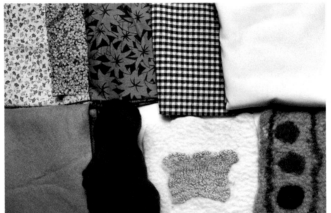

Left to right, top row: three printed cottons, gingham, calico. **Left to right, bottom row**: manmade acrylic felt, natural felt, handmade felt with imbedded knitting, hand made felt experiment.

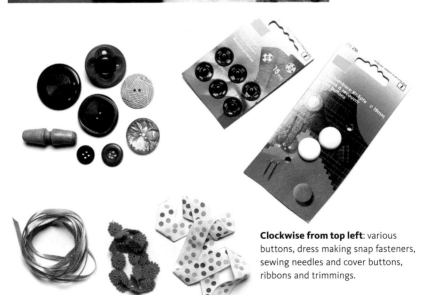

Clockwise from top left: various buttons, dress making snap fasteners, sewing needles and cover buttons, ribbons and trimmings.

glass

Glass is becoming more popular as a jewellery material; slumped, blown and found glass can be used. It has precious qualities despite its relative inexpensiveness when compared to precious metals.

Enamelling has a long standing tradition in jewellery making. Many makers working today are experimenting with new processes and techniques with exciting results. One of these innovative makers is Jessica Turrell whose work centres on her research into new applications of the material.

Again, combining glass with metal is a common jewellery coupling. Sometimes makers are deterred from working with glass because it can break easily when making or wearing. However this fragile nature is, I think, part of its appeal.

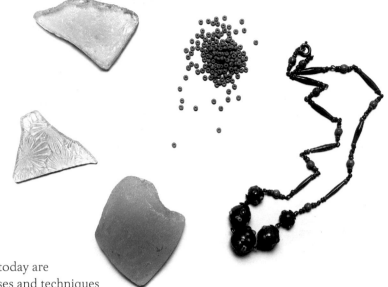

Above, left to right: Found glass, glass beads and Venetian glass beads.

found objects

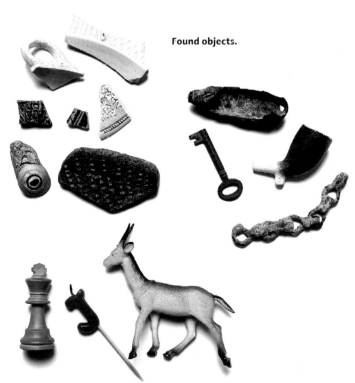

Found objects.

Found objects can be among the most exciting to work with. Discarded objects can have a character which inspires a design idea or a series of objects. When combined with other materials they create interesting contrasts. Found objects can encompass anything from street litter, shells, discarded toy parts, odd earrings, clay pipes and ceramic shards.

Objects found on the beach or foreshore have a magic quality that can conjure up memories or stories. Charity shops and flea markets can be an interesting source for unexpected objects. In truth, anything can be used to make jewellery; all you need is the desire to make and experiment.

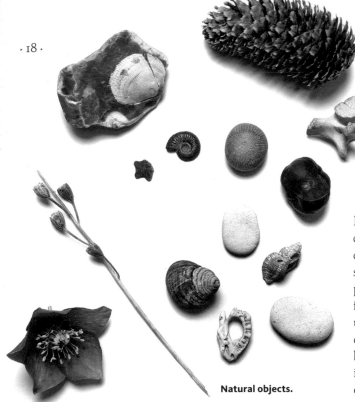

natural objects

Like found objects, natural objects have a character that can inspire makers. Some natural objects might be found objects too, for example, seed pods, sponges, twigs, botanical items and pebbles. Natural objects may also be purchased, for example, special shells, silkworm cocoons or unusual feathers. When purchasing natural objects, it is important to check they are supplied by a responsible company that sources materials in an eco-friendly way, without disrupting our environment.

Natural objects.

paint & pigment

Paint is a material not commonly associated with jewellery. For studio jewellers who use paint, it is often to add colour and sometimes to question the concept of, and what we expect from, jewellery. There are many paints to choose from; standard artist paints, watercolour, acrylic and gouache, commercial car paints, household emulsion paints, enamel toy paints and natural handmade dyes.

The project chapters use a number of paints and a variety of techniques. Sometimes the paint is prominent in the designs and at other times is melded with other materials.

Any material that can add colour to a surface could be included in jewellery work.

Spray paint, both industrial car paints and more craft intended brands, can produce exciting effects. It is also possible to purchase primer spray to prepare the surface for a colour.

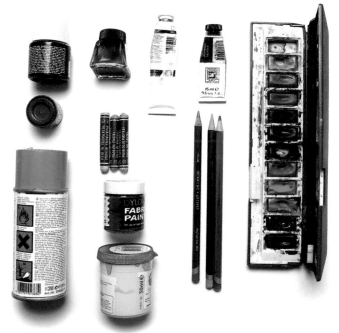

In vertical rows from left: silk paint, enamel paint, spray paint, ink, oil pastel, fabric paint, emulsion paint, acrylic paint, gouache paint, coloured pencils and watercolour paint.

beads

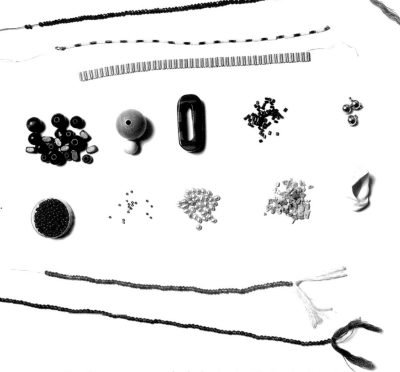

Since ancient times, humans have always made beads, from early pieces made from shells, bones and enamelled Egyptian beads, to Venetian glass beads and granulated metal beads. Any material can be used as a bead as long as it has a piercing. It is also worth looking out for items that are natural beads such as haggle stones.

malleable materials

Top three rows: garnets, bugle glass beads with silver, bugle beads.
Middle two rows, clockwise from left: green wooden beads, natural wooden beads, bakelite scarf bead, glass beads, gold beads, natural shell bead, turquoise chip beads, freshwater pearls, tiny glass beads, red glass beads.
Bottom two rows: carnelian beads, iolite beads.

Materials that can be moulded by hand and basic tools are used by jewellers either for final pieces or as models and objects to cast from, like wax.

Milliput®, is an air-hardening material used by plumbers and restorers, and polymer clay, which has plasticine-like qualities and hardens in the oven. Polymer clay is often overlooked as a material for jewellery making. I think this is due to the associations it might have with plasticine and childlike constructions. However, like any material it can look beautiful when worked by a maker with skill. Cynthia Toops is a jeweller who uses polymer clay to produce intricate three-dimensional patterns and forms, which could not be further from the childlike sculptures one might imagine.

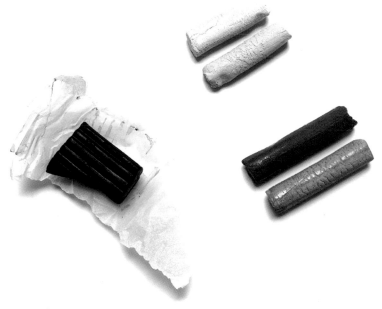

Left to right: Fimo®, Milliput®.

the gallery

		1		5	6
2	3	4		7	

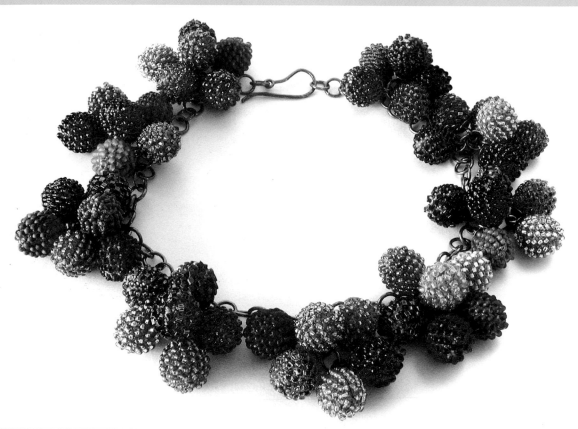

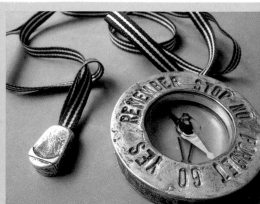

1. **Grapes Necklace**, Yael Krakowski. Oxidized silver, glass beads, thread. 18 cm diameter. 2006. Israeli, lives and works in Canada.
2. **Propeller Brooch**, Lindsey Mann. Printed anodised aluminium, precious white metal. 7.5 cm x 1 cm. 2007. England.
3. **Necklace – Growth Series**, Natalya Pinchuk. Wool, copper, enamel, plastic, waxed thread, stainless steel. 76 cm long. 2007. Russian, lives and works in USA. Courtesy of Rob Koudijs Galerie.
4. **Compass**, Ami Avellán. Cast silver 925, cotton ribbon, compass. 6 cm x 56 cm x 1.4 cm. 2005. Finland.
5. **Staphorst Brooch**, Francis Willemstijn. Wood, iron, gold, silver. 14 cm x 11 cm x 7 cm. 2006. The Netherlands.
6. **Maze Brooch**, Cynthia Toops and Chuck Domitrovich. Polymer clay and silver. 5.2 cm x 5.2 cm x 1 cm. 2006. USA.
7. **Slate Pebble Brooch**, Maike Barteldres. Slate pebbles from Cornwall, sterling silver. 8 cm x 6 cm x 1 cm. 2007. German, lives and works in England.

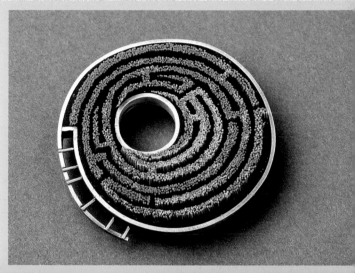

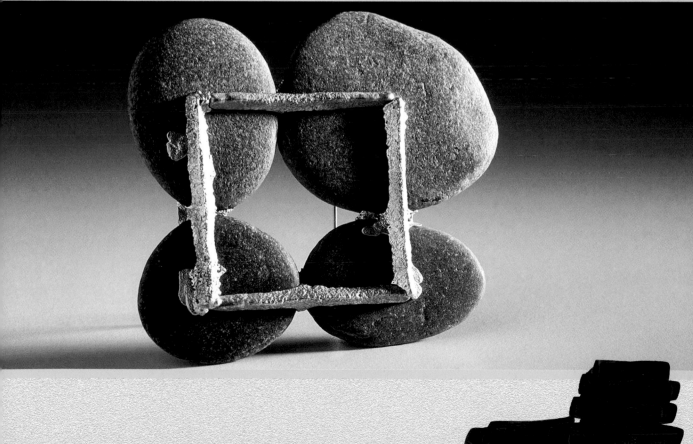

2. basic jewellery techniques

This chapter gives you a basic introduction to metal-working techniques used by jewellers. Some of the techniques are transferable for use with wood, plastics and other materials.

The following techniques are used in many of the project chapters and I have gone into greater detail here to help you get more out of the making process. While I am covering the techniques that are fundamental to the projects, this is not intended as a complete course for beginners. However, mixed media jewellery employs techniques from many material families and so the simple methods covered should give you a basic understanding of jewellery making.

I have listed some excellent books in the further reading section that will provide you with sources to form a wider knowledge base about specialist metal techniques, but the following will get you started.

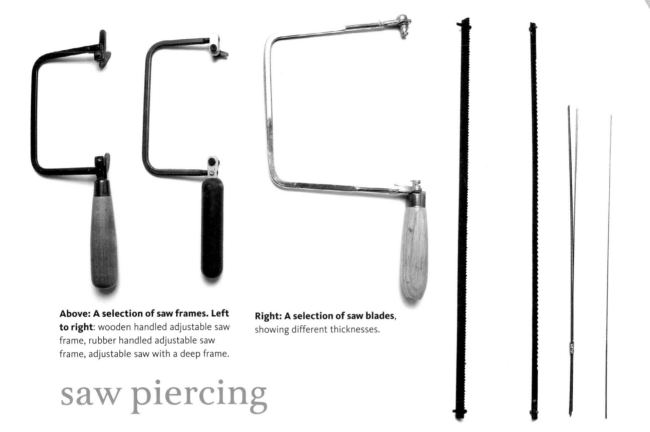

Above: A selection of saw frames. Left to right: wooden handled adjustable saw frame, rubber handled adjustable saw frame, adjustable saw with a deep frame.

Right: A selection of saw blades, showing different thicknesses.

saw piercing

Saw piercing is used in the following projects: Candle ring; Mudlarking pendant; Wood and willow pendant.

Saw piercing is one of the first techniques I learnt as a jeweller and it is fundamental to many jewellers' work. The first thing to mention is the blades, which come in different sizes from a coarse number 6, then 5, 4, 3, 2, 0 and then 1/0, 2/0, 3/0, 4/0, 5/0 down to the finest at 6/0. I generally use a medium size 2/0, which I found about right for all the project chapters that use saw piercing. For a thicker metal sheet, you would need a 4 or 5, and equally for a thicker acrylic sheet or hard wood, you would need a coarser blade.

Blades are sold in bundles of twelve or a gross (twelve bundles of twelve). If you are starting out, consider getting a gross. When you are new to saw piercing, it is not unusual to break quite a few blades as they are very small. A beginner's class can sound like a symphony of pings as you listen to all the blades snap. This is nothing to worry about, you will get better with time and experienced jewellers still break them.

Next you need a saw frame. A fixed frame in metal with a wooden handle is standard and you can also purchase adjustable and deeper frames with a bigger cutting depth.

To fix the blade into the frame, hold the frame against your jewellers' bench or a sturdy surface. Hold the blade with the teeth facing towards you and down. I always think of a Christmas tree to remember the shape. Place the top end of the blade into the top end of the saw frame and tighten the screw. Push the saw frame against the bench while holding the handle and then tighten the bottom screw with the blade in place. Make sure that the blade is taut and makes a high pitched ping when plucked.

When you use the saw, make sure you do not force the blade. The teeth will cut with every downward stroke. Keep the saw frame upright when sawing, and do not be tempted to angle it forwards or backwards as it ideally needs to be 90 degrees to your work. For

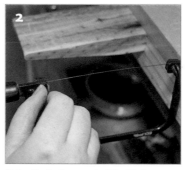

Fixing the top end of the blade into the frame.

Fixing the bottom end of the blade into the frame.

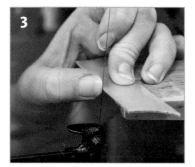

The first cut, showing how to use your thumb as a guide.

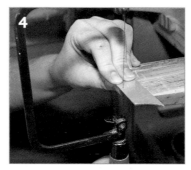

Sawing a straight line, showing how to hold the saw.

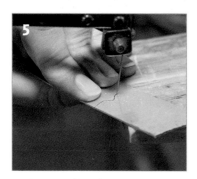

Sawing a wavy line, showing how to turn the silver.

the first cut into your metal, it can help to use your thumb as a guide for the blade, obviously keeping it free from the teeth. Move the saw up and down, you will soon find a rhythm that works. If you are new to saw piercing, try sawing straight lines to practise. When you are happy with your technique, you can try

a wavy line or turning a corner. To do this, you have to turn the work with your free hand whilst you saw. Do this quite slowly when you are first learning to keep the lines accurate.

To take out an area in the middle of a sheet of metal, drill a small hole in the surface, just inside the line you have drawn, and then undo the screw on the bottom of the saw frame and feed the blade through the hole and re-tighten. You can then saw pierce out the section you have drawn.

When practising, you might like to draw patterns with different lines and pierced silhouettes. If a blade gets stuck in your work and breaks, you can carefully remove it with pliers.

cutting tube

Cutting tube is used in the following project: Candle ring.

A joint or tube cutter is useful when you need to saw tube to size. It is a hand-held tool that holds the tube in place as you saw. It gives you a guide to saw a straight line. They often have a moveable part which allows you to saw to a particular length. This is useful when you need more than one piece of the same length.

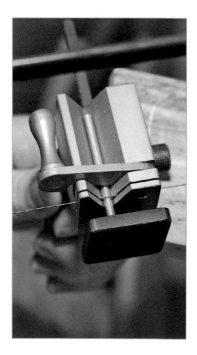

Sawing a section of tube in a joint cutter/tube cutter.

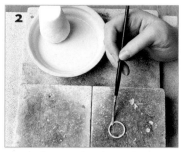

Mixing the borax flux with water.

Painting flux onto the silver surface.

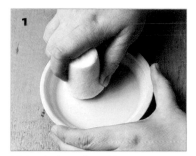

Cutting a piece of hard solder.

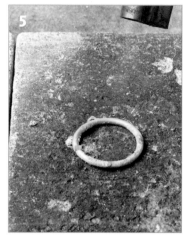

Placing the solder on the silver join with tweezers.

Heating the silver and solder with a hand torch.

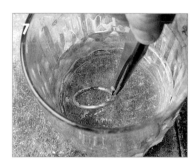

Flowing solder at the join.

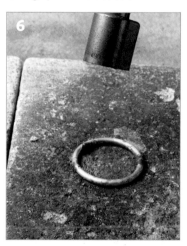

Quenching the silver in water.

soldering

Soldering is used in the following project: Candle ring.

Soldering is another basic technique and usually one of the first techniques a jeweller will learn. It is the best way to join metal together. I use my hand torch for soldering, rather than a larger compressed-air torch.

Practise builds accuracy and confidence. If you melt a piece by accident when you are learning, it is annoying but most jewellers will have experienced such a disaster. In fact it is quite a good thing to experience as you then know exactly how hot you can make the metal before it melts.

There are different types of solder you can use to join metals. For the project chapters you need to learn how to use silver solder. Silver solder contains silver, copper and zinc in different quantities that form hard, medium and easy/extra easy solder, which all have different melting points. Hard is the highest and extra easy is the lowest. If you are using solder strip then you need to use flux to help the solder flow. This comes in liquid, powder or paste forms. Most jewellers learn by using a borax cone and grinding it in a

ceramic dish like a pestle and mortar with a little water.

Once you have ground down a little of the borax in the water, you paint a small amount onto the join, but before you do this make sure the silver is cleaned in pickle (see below). Then it can be placed on a heat mat and soldering block.

Next, add a small amount of solder and heat until the solder melts. You are waiting for the silver to become cherry red. Make sure you are not working with a bright light on the work, so you can really see the changes of colour when the silver heats up.

Start heating the metal gently at first. Have some metal tweezers or a solder poke at the ready in case the solder shifts place – the flux will bubble a little, which can dislodge the solder. Make sure you are

heating the whole object and not just the join. You are aiming to evenly heat the metal. You will know when the solder has filled the seam as it will become shiny and run. At this point, remove the heat or you will risk melting the metal. Leave to cool a little and then quench in water. If quenching small items like earrings and rings, you can use an old glass beaker for the water. You can then clean the item again in pickle and, if needed, you can scrub with a toothbrush and washing up liquid.

The above describes the traditional way to solder and it is a good skill to learn. Alternatively, you can use a solder paste which can be purchased in a syringe and includes combined solder and flux. This is a faster process as you just apply the paste to the

join and heat with a torch, as you would flux and solder strip. It is a handy item to have if you are soldering multiple items such as lots of earring posts. Some jewellers might see this as lazy or a short cut. I think it is advantageous to try every traditional method you can when you begin, and eventually try both methods and decide for yourself what you prefer.

pickling

Pickling is used in the following project: Candle ring.

Pickling is the technical term for cleaning metals in a solution of sulphuric acid and water. It cleans the surface and removes

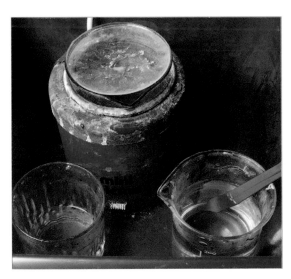

Pickling equipment.

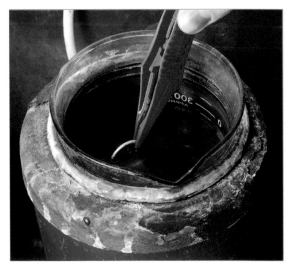

Adding silver to the pickle with plastic tweezers.

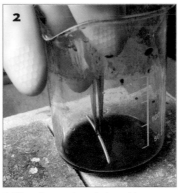

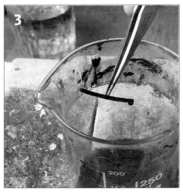

Adding oxidising solution to a glass (wearing gloves and safety glasses).

Adding silver to the solution with tweezers.

Removing the silver after a few seconds.

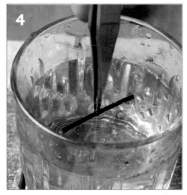

Adding the silver to water to clean, before cleaning again with more water and washing up liquid.

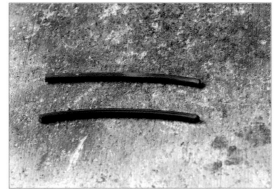

A comparison of oxidising methods. The top sample shows natural oxidising with heat from a torch. The one dipped in solution is shown below with a much more even coverage.

oxidising

any surface fire scale. When silver is cleaned in pickle, it turns a lovely shade of white, which some jewellers use as a feature in their work, although it soon dulls down to a matt finish.

Avoid adding binding wire to the acid solution as it will coat your metal with a copper layer. Always use plastic or brass tongs when removing and adding items.

The pickle is always added to the water and never the other way round – usually about 50g per litre of water, but you can read the instructions the supplier will give you.

Pickle also needs to be used warm, between 30°– 80°C. Safety pickle is a safer alternative to using sulphuric acid and can be added to water in the same way. I use safety pickle in my studio and it works very well.

For heating pickle I use a mini pickle bath which has a thermostat and can be plugged into an electrical socket. You could use a mini electric hob with a Pyrex dish as an alternative or a slow cooker. Obviously this would have to be used solely for pickle and could not be used in a kitchen afterwards.

Oxidising is used in the following project: Popper and thread earrings.

Silver and other metals including copper and brass will oxidise naturally as there is sulphur present in the air, so over time silver jewellery naturally oxidises. When you heat metal, a layer of oxide will form on the surface when the heat from the torch mixes with oxygen in the air. Some

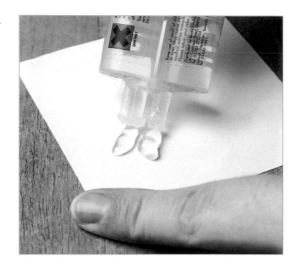

Squeezing the two parts from the tube.

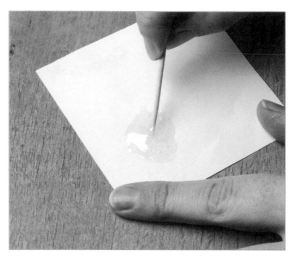

Mixing the two parts together with a cocktail stick.

jewellers spend much of their time cleaning oxidised surfaces but others, including myself, find oxidised surfaces to be beautiful.

When producing an oxidised, blackened finish, you have a number of options, including heating the metal with a torch or applying potassium sulphide. There are other methods using household ammonia and vinegar and many jewellers spend many hours developing new oxidising finishes and patinas with different shades and colours.

For some of my work I oxidise silver on a wood or charcoal fire. This is not generally adopted as a jewellery technique but I have produced some very interesting shades and unexpected results. Perhaps part of the appeal is that it is not a traditional technique, and there are not many jewellers throwing their work on a fire.

For the Popper and thread earrings, I used an oxidising solution to get an overall blackened shade. This can be painted onto the surface or dipped and then rinsed in water. Make sure when you are oxidising to wear gloves, goggles and do it in a well-ventilated area. All oxidising solutions come with instructions and health and safety advice. If you are unsure about using a chemical solution then you could explore heating the metal with a torch which will blacken the silver, although it will be less even. Whatever techniques you use, always plan for safety and store solutions correctly.

Some jewellers coat oxidised silver in a wax or lacquer to protect the finish. I find it interesting to see the surface change naturally over time.

epoxy resin glue

Epoxy resin glue is used in the following project: Candle ring.

Epoxy resin glue is available in most craft and hardware shops. They are supplied in two separate tubes which can be mixed together. One tube contains resin, the other a hardener. The two parts are mixed together and they set. It is thermosetting plastic and so once it is set, it remains hard and is not easily removed. You can buy them in a number of setting rates. Some longer setting versions make it easier to reposition items.

I usually mix the resin and hardener together using a cocktail stick. The glue usually comes with a spatula, but I find when you work with cocktail sticks you can mix the glue and apply it to small areas with more accuracy.

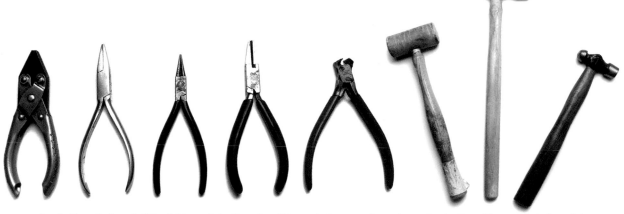

A selection of pliers. Left to right: parallel action pliers, flat nosed pliers, round nosed pliers, half round pliers and end cutters.

A selection of hammers. Left to right: wooden hammer, riveting hammer, jobbing hammer.

bending & forming

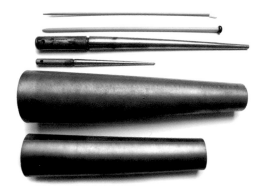

A selection of formers. Top to bottom: two knitting needles, ring mandrel, small ring mandrel, oval mandrel and round mandrel.

Bending and forming is used in the following projects: Bead brooch, Candle ring.

Most of the bending in the project chapters is done with wire. Your fingers are good tools for bending wire around objects such as mandrels or knitting needles. Often you will need to anneal (see page 31) the metal before you bend it. The project chapters let you know if you need to do this for each piece.

Pliers are good for bending metal but you need to be careful not to leave marks on the metal surface whilst gripping. Round-nosed pliers can be used to curve wire and half-round pliers are good for shaping a ring because the wire can be guided into a smooth curve. Flat-nosed pliers are very good for making sharp or 90 degree angles.

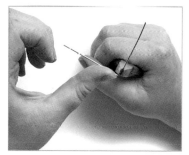

Straight pliers bending wire to 90 degrees.

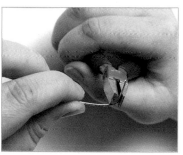

Half-round pliers bending wire into a curve.

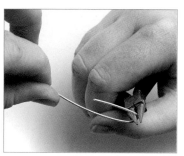

Round-nose pliers bending wire into a loop.

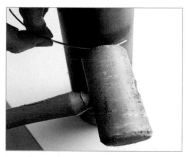

Wire being shaped around a mandrel.

filing
& finishing

Filing and finishing is used in the following projects: Bead brooch, Candle ring, Wood and willow pendant.

A number of the project chapters employ the technique of filing. Files are generally used for shaping and finishing metal surfaces and edges. You will need to file metal after you saw it because the teeth produce a rough edge. There are a wide range of files to choose from, with different shapes, sizes and coarseness for different jobs. Needle files always form part of a basic jewellery kit. They are small and you can usually purchase a set of about twelve. A round file is good for filing piercings, a flat for general purpose filing, including edges. An inside curve can be filed with an oval file and a groove with a triangle shaped file. Some files

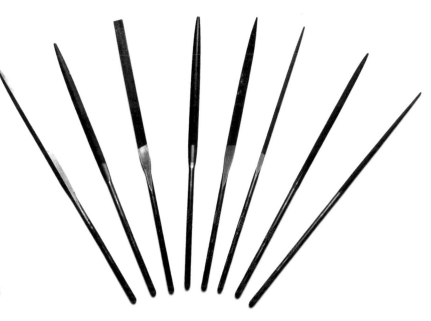

A selection of needle files showing different sections and shapes. Left to right: safety back, half-round, pillar cut, round cut, escapement half-round, square cut, triangle cut and round cut.

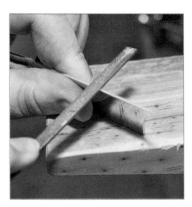

Filing silver, showing how to keep the file parallel to the work.

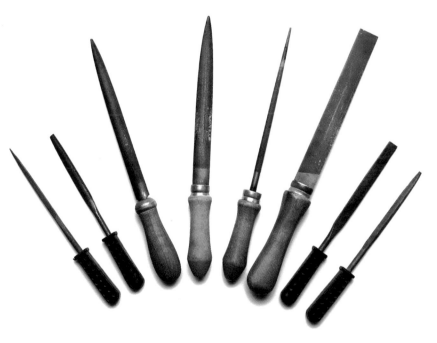

A selection of files. The outer, shorter files are larger needle files and the rest are all jewellery files in different sections and shapes.

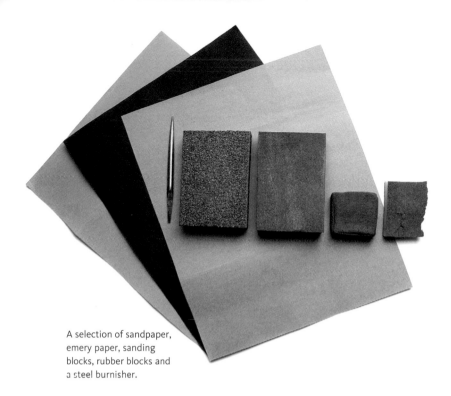

A selection of sandpaper, emery paper, sanding blocks, rubber blocks and a steel burnisher.

annealing

Annealing is used in the following project: Candle ring.

Annealing is the technical term used for softening metal by heating it. This often needs to be done before you work on the metal. I anneal silver wire and sheet using a hand-held torch which gives out a sufficient amount of heat for the jewellery I make. Larger and thicker pieces of metal may need a larger torch, but for the purposes of the projects in this book, the hand-held torch is adequate and a less expensive tool if you are just starting out in jewellery making.

Some metals can be purchased pre-annealed. Wire and thin sheet is often soft enough to work on without

have a smooth side and these are useful if you are filing one surface or edge next to an area you do not want to file.

When filing (unless you want a rounded edge) keep the file parallel or you will file a curve into the metal. Like a saw blade, the needle files will work in one direction so don't rub back and forth – you need to file in one direction. Hold the work in your hand as you file. If you need to, you can rest the item on your bench peg or desk.

After filing, you can clean the metal up even more using sandpaper, emery paper or sanding blocks. Again these can be found in different grades from coarse to fine. You should ideally have a variety of papers or blocks in your basic jewellery kit. Start with a coarse paper to remove

the file grooves and finish with a fine paper to achieve a smooth finish. Abrasive rubber blocks are also very good for cleaning and they can be purchased from most jewellery suppliers. Sanding blocks from hardware shops work equally well. Experimenting and trying out different methods is good to find out what works best for you.

After you have a smooth finish, you can leave it as a satin finish or you can polish the surface. An easy and low tech way to do this is to rub the surface with a burnisher. This is a shiny, hard steel tool that you can rub on the silver surface. You need to rub very firmly and be careful with your fingers. Larger files are also used in jewellery making, in the same way as needle files.

Annealing silver.

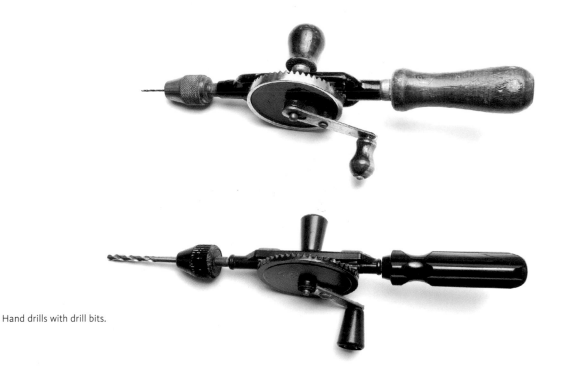

Hand drills with drill bits.

being annealed. Metal becomes work-hardened when worked on with hammers, etc. so a piece of metal may have to be annealed several times before you finish working on it.

Different metals have different melting points and thus have a variety of annealing temperatures. For the purposes of the project chapters we are focusing on the annealing of silver, which has a melting point of 1635°C, and an annealing temperature of approximately 1200°C.

To anneal silver, place it on a heat mat and heat with the flame tip 2–3cm (0.8–1.2 in.) away from the metal. Heat the silver by moving the flame across the surface until the metal looks a dull pink/red. Hold that colour for a few seconds before removing the heat and quenching in water.

drilling

Drilling is used in the following projects: Candle ring, Mudlarking pendant, Wood and willow pendant.

When drilling any material, it is important to mark out the position first with a pencil or pen. Using a centre punch or scribe held firmly onto the surface, use a general purpose hammer to hit the top of the centre punch or scribe. This will leave a deeper mark in the surface. When punching into the metal, you will notice that this makes the metal around the point move shape a little, but this will usually be removed by the drill. Sometimes the displacement of the metal around a punch

mark can be used in a calculated and deliberate way as a decorative surface.

There are many different types of drills for you to choose from. Hand drills, bow drills and electrical drills are commonly used by jewellers. I use an electrical drill in my studio most of the time but for smaller jobs where I need only a few piercings I frequently use a hand drill, as used in the Mudlarking pendant and the Candle ring.

When drilling, you will need to hold the item in place. If it is a large sheet of silver or plastic for example, you will be able to hold it with your hands. However, if you are working on smaller items, you will need to hold it in place with pliers, a vice or sticking tape. Always hold the item firmly to prevent the object

Using a centre punch on a silver surface, using masking tape and a wooden block to secure silver safely.

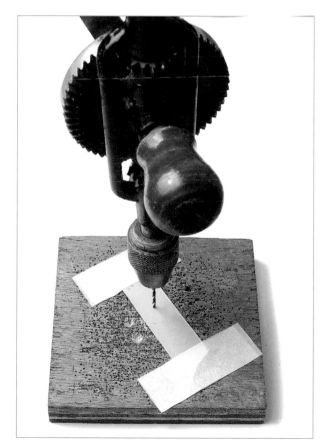

Drilling a hole through the silver.

from spinning. Generally, I use a wooden block to rest the item on and this could be an inexpensive off-cut.

Drill bits come in a variety of sizes and you can purchase them specifically for wood, metal, etc. Generally I would purchase drill bits from a jewellery suppliers.

When drilling into objects, they can heat up quite considerably, especially if you are using a pillar drill. I always use a hand drill for small items such as pebbles as I feel I have more control and if I can feel it getting hot I can dip the item in water before continuing.

If you are drilling into a curved surface, you will find that the drill bit will bump around and find it hard to rest. Whenever possible, you should try and flatten the surface first by filing a small piece from the surface. Drilling can be used for creating a pattern as well as for function.

When drilling, always make sure you wear safety goggles, tie back loose hair and make sure any dangling jewellery or garments are not in the way.

exploring design

Exploring design introduces you to the basic principles of designing. This chapter is intended to help you develop your design skills for making your own jewellery. It will also help you to develop your own variations based on the project chapters.

Each maker has a unique approach to designing and so the following information works as an overview. It simply suggests methods of working that you can, in time, make your own.

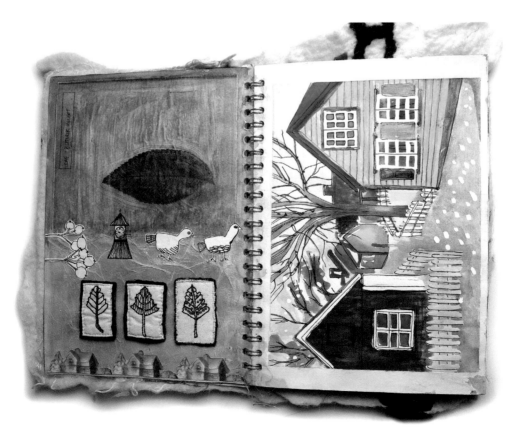

Collage, Joanne Haywood, England.

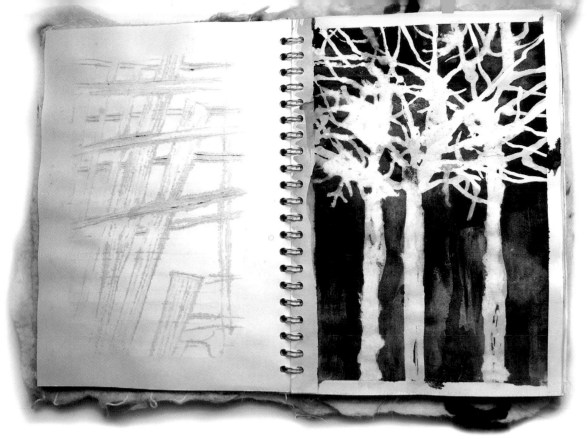

visual journals

Painting, Joanne Haywood, England.

Organic Forms, Paula Lindblom, Sweden.

Visual journals and artists' sketchbooks are fascinating as they encompass the character and passions of the maker. Everything that you find remarkable in the world around you can be included. Visual journals can include drawings, photographs, notation and found objects/collages. Each maker works differently and, like their final pieces of jewellery, each maker has a distinct voice. Don't try to emulate a particular style of visual journal. It is best to relax and enjoy the process of drawing and recording visually. The most successful journals appear when the maker is relaxed enough to make the odd mistake and not strive for the perfect page every time. Remember your journal is where your work will be born, so the more engagement with things that really interest you the better and the more your work will be interesting to others.

design books

For some makers, designing also happens in the visual journal. Often makers and students find it disconcerting to switch from one journal to another. However, it is a really good practice to keep them separate as it can help to compartmentalise each stage of working. Design books should include your initial ideas and drawings of your designs and their development. It is important to record your thought processes, which could be in the form of brainstorms, continuous written dialogue with yourself or lists of ideas and questions to address. Research might also be included, although initial research can always be added to your visual journal.

Like anything connected to drawing, practice will build your confidence and ability. The most experienced maker can still have an 'off day', so whatever happens, try and enjoy the process.

1

1 **A Series**, Ramon Puig Cuyàs, Spain.
2 **Charcoal and Paint Design**, Joanne Haywood, England.
3 **Mixed Media Designing**, Jo Pudelko, Canadian-British, lives and works in Scotland.
4 **Drawing and Paint Design**, Ramon Puig Cuyàs, Spain.
5 **Final Design**, Dionea Rocha Watt, Brazilian, lives and works in England.
6 **Pencil on Paper Design**, Jo Pond, England.

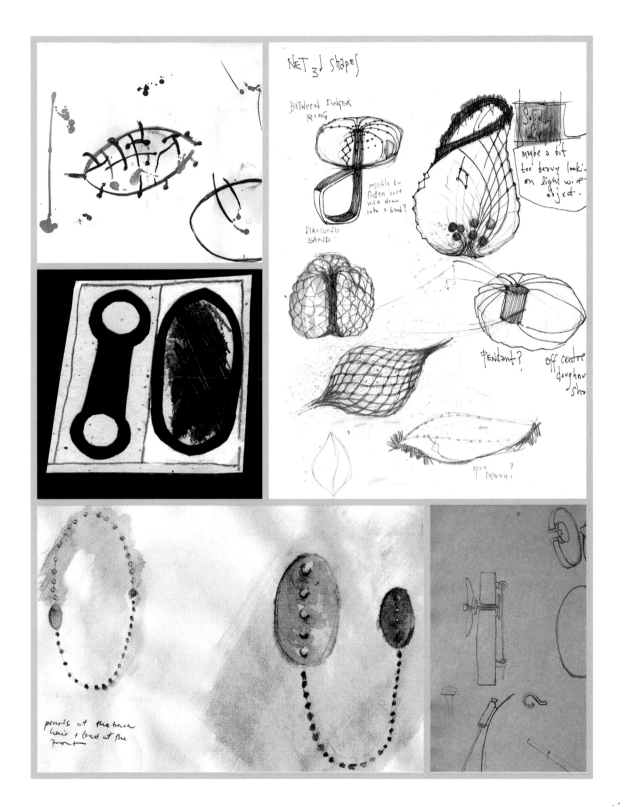

NET 3d shapes

BETWEEN FINGER
RING

possible to
flatten curl
wire down
into a band?

DIAMOND
BAND

maybe a bit
too heavy looki'
on light wire
object.

PENDANT?

off centre
doughnu
sha

open
cocoon.

pearls at the back
hair + lead at the
front

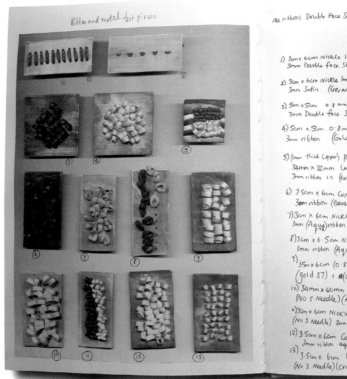

Ribbon and metal test pieces

All ribbons Double Face Satin 3501 Berisfords.

PoBox 2
Congleton
Cheshire
CW12 1EF
(Tel)-01260 274011
www.berisfords-ribbons.co.uk
office@berisfords-ribbons.co.uk

1) 3cm x 6cm Nickle 1mm thick
3mm Double face Satin ribbon 3501. (Geranium 680)

2) 3cm x 6cm Nickle 1mm thick
3mm Satin. (Geranium 680)

3) 5cm x 5cm 0.8mm thick Copper
3mm Double face Satin ribbon 3501 (Geranium 680) (No 5 Needle)

4) 5cm x 5cm 0.8mm thick Copper
3mm ribbon (Gold 37) (No 5 Needle)
All 1mm drilled hole

5) (1mm thick Copper) Pressed with 0.6mm wire brass
34mm x 32mm Copper.
3mm ribbon in (Gold 37 + Geranium 680) (No 3 Needle)

6) 3.5cm x 6cm Copper 0.8 thick
3mm ribbon (Geranium 680)

7) 3cm x 6cm Nickle
3mm (Aqua) ribbon (No 5 Needle)

8) 3cm x 6.5cm Nickle
3mm ribbon (Aqua 78) + (Geranium 680) (No 5 Needle)

9) 35m x 6cm (0.8 thick Copper
(Gold 37) + (Sky 3) 3mm ribbon. (No 5 Needle)

10) 34mm x 60mm Nickle 1mm thick.
(No 5 Needle) (Aqua 78) and (Gold 37)

11) 3cm x 6cm Nickle 1mm thick
(No 3 Needle) 3mm ribbon (Geranium 680)(Gold 37)(Cream 50)

12) 3.5cm x 6cm Copper 0.8 thick
3mm ribbon aqua 78 (Sky 3)(Cream 50)(5 Needle)

13) 3.5cm x 6cm Copper 0.8 thick
(No 3 Needle) (Cream 50)(Gold 37). 3mm ribbon

Ribbon and Metal Experiments, Joanne Haywood, England.

Metal Leaf and Silver Experiments, Joanne Haywood, England.

technical journals

I have always thought of technical journals as a kind of recipe book. When making jewellery, it is always good to record details of materials, measurements, production costs and supplier details.

Step-by-step instructions can be helpful. Imagine you are going to have to make the jewellery again in twenty years and ask yourself what you would need as a guide when you have forgotten how you first made the jewellery.

The layout and formatting is up to you. It is a tool to help you remember. If diagrams help you to remember a method or a photograph of a work in progress, then include them. Over time you will probably develop particular ways of recording information.

pattern test on tinplate. Antique rose noble, green, platinum, and New platinum.
- green
- Antique
- platinum
- New platinum

pattern/colour test on tinplate.
green, Antique rose noble,
platinum and platinum.
- old platinum
- Antique
- green - New platinum

- Antique rose noble
- green.
0.5 stirling silver pattern test. Pressed with 0.9mm silver pinwire.

0.5 stirling silver pattern test. Pressed with 0.9 silver pinwire as before.
- green
Antique rose noble

The silver takes the gold leaf really well. For smaller pieces it gives a heavier weight. It stays better on the surface and gives it a sparkling quality - Also findings could easily be attached - Maybe try pieces in gold too! It would probably press really well - Maybe green gold!

concepts & starting points

A brief or starting point is always needed in design and making. You will need to ask yourself important questions such as why are you making the jewellery and who is it for? Unless you are working on a commission basis, the chances are that you have control over most of the answers.

Concepts can spring from any source and might be something simple, such as inspiration from a found object, or could be based on an important event in your life. Like the materials you choose, the concept has an infinite number of outcomes. Shape, colour, texture and scale should all be explored when you are negotiating a brief.

For many makers the material offers strong inspiration, and the dialogue between the maker and material can generate sophisticated ideas that may or may not be apparent when looking at the work. Some makers choose weighty subject matters such as 'life and death' as a starting point. Human issues such as this can provoke ideas in most people and so can help you produce ideas for work.

However, you don't have to work around serious subject matters just for the sake of it or because you think you should. If you want to make jewellery from paper because you like the processes, then enjoy the process. Don't feel like you have to link it to a political idea or statement to make it worthy.

Sometimes multiple concepts and ideas might meet. You might want to make a brooch that explores the theme of family portraits and alongside it look at paper folding techniques. The more you design, the more you will develop ways of seeing and become more comfortable with ideas and how to translate them into a three-dimensional object.

Whatever concept you work to and whatever the brief suggests, always think what you are trying to achieve. Remember, there can be more than one outcome.

Drawing, Joanne Haywood, England.

life drawing /
observational drawing

Drawing is a really important discipline for all artists and designers. Drawing the body helps us to understand its construction and function. Understanding the way bodies are designed can be useful when making objects for the body, and equally many manmade products are influenced by nature.

Many designs begin with or are influenced by observational drawing; being able to understand shape, form, line, pattern and tone is really important. All these elements can be studied in life drawing and other observational studies such as still life.

Observational Drawing, Miranda Davis, England.

Observational Drawing, Miranda Davis, England.

1 **Visual Research**,
 Suzanne Smith, Scotland.
2 **Visual Research**, Mari Ishikawa,
 Japanese, lives and works
 in Germany.
3 **Visual Research**,
 Alessia Semeraro, Italy.
4 **Historical Research**,
 Dionea Rocha Watt, Brazilian,
 lives and works in England.

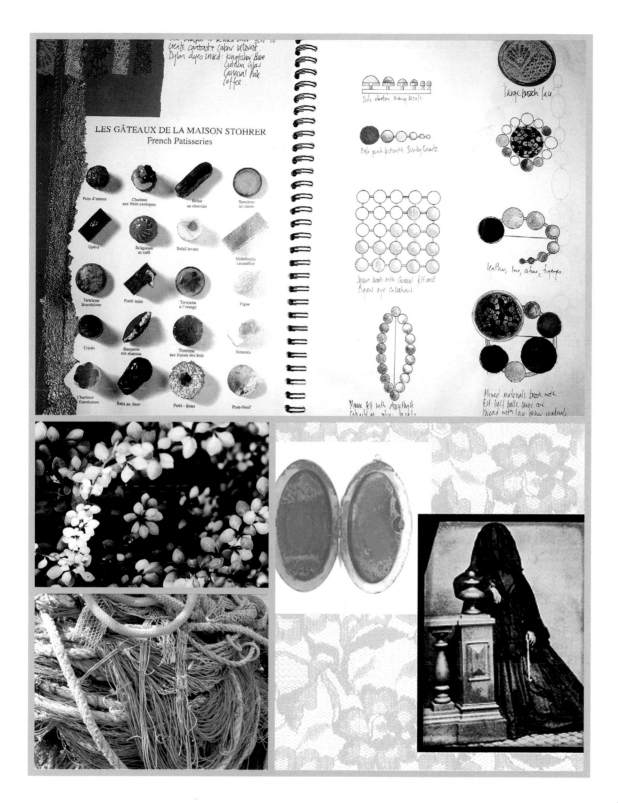

research

Your research will vary depending on your own brief. It should always be undertaken to support your work and should be of interest to you. It might involve looking at solutions that others have arrived at. For example, if you were designing a brooch, you might research different fastenings from different time periods and cultures.

You might be researching something more abstract. For example, if you were designing something that incorporated the texture or image of an avocado, you might then research what an avocado looks like and how it is looked at in different cultures (does it hold symbolism, how is it cultivated or eaten). It might also be useful to get an actual avocado to see what it feels like, how heavy it is and what it smells like. Researching might uncover something very interesting that you had not yet thought about, that could shape the direction of your work.

When you are researching, it is a good idea to sift through what is and isn't relevant to your work after a while so that you don't get bogged down with too much information. You can keep all the information, but just group it together or acknowledge what is useful to you. Other research might be useful in another piece of work, so if you find something interesting but it is irrelevant, keep hold of it in case you need it later.

experiments & test pieces

Experiments and test pieces are important as you never know exactly how your jewellery will look and feel from a two-dimensional design on paper. Experiments and test pieces can also throw up unexpected results and ideas that might warrant a return to designing on paper.

Material boundaries can be examined through test pieces. If you are making a bangle in cast paper, you might need to experiment with how fine to make the pulp or if it shrinks when drying. Experiments allow you to explore ideas in a physical way and recognise the characteristics of materials.

Many makers experiment and produce a series of test pieces that work towards a final piece with very little two-dimensional designing. This is appropriate if you are working in fairly inexpensive materials. Few makers could allow themselves to experiment extensively in gold, so fewer experiments and more designing would be more appropriate.

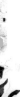

1 **Test Pieces in Polystyrene**, Leonor Hipólito, Portugal.
2 **Material Development**, Jo Pond, England.
3 **Test Pieces in Fabric And Threads**, Joanne Haywood, England.
4 **Paper Burning Experiment**, Joanne Haywood, England.
5 **Fabric Test Pieces**, Suzanne Smith, Scotland.

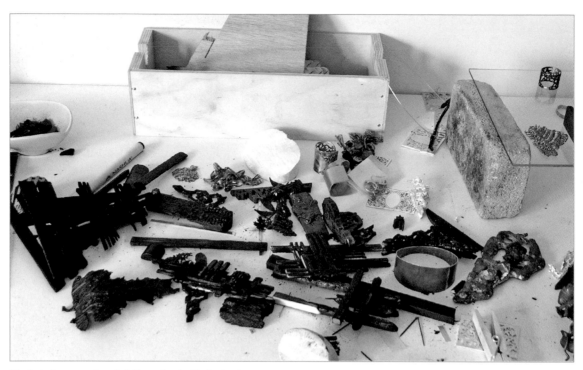

Works in Progress, Francis Willemstijn, the Netherlands.

Works in Progress, Ela Bauer, Polish, lives and works in the Netherlands.

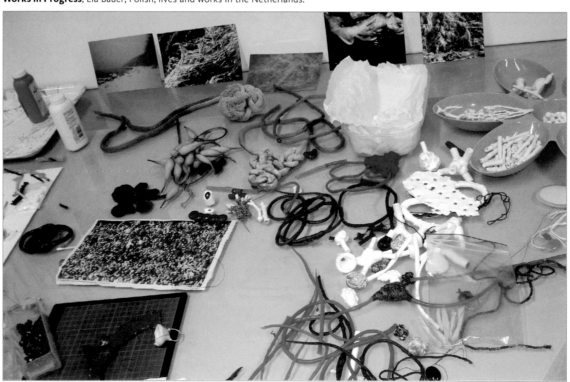

working towards a final piece

After testing out your ideas in three-dimensional test pieces, you will probably find you need to go back to your design book. The tests might have thrown a new design problem into the mix. For example, perhaps the earrings are too heavy in the material you have chosen, so you'll need to decide whether to make them smaller or keep the scale but change the material. Or perhaps an experiment gave you a new process that needs to be developed further in a two-dimensional design before you can progress. The moving back and forth between designing and testing is a natural part of the design process. Sometimes a design can be unsatisfying if you cut this process short. So always ask yourself if you have pushed the designing as far as you can and if there is anything you can do to add finesse to a piece. Once you are ready to make the final piece, enjoy the culmination of all the ideas and processes, and even when you have a finished final piece, it is still healthy to reflect on what you might improve or change next time.

Work in Progress, Jo Pond, England.

4. balloon flower neckpiece

MAKER RATING
beginner

WHAT YOU WILL NEED
MATERIALS
- six white balloons
- three green balloons
- tiger tail
- 25 cm (10 in.) strand of freshwater pearls
- 24 cm (9.5 in.) strand of mother-of-pearl beads
- 11 cm (4 in.) strand of white glass beads
- 10 cm (3.9 in.) strand of green glass beads
- 13 cm (5 in.) strand of pearlised green glass beads
- five 22 mm (0.8 in.) creative buttons (a craft item used to stitch into)

TOOLS AND OBJECTS
- scissors
- sewing needle
- end cutters
- epoxy resin glue

This project shows you how to make a neckpiece that utilises balloons. The childlike material associated with celebrations is re-formed into petal shapes. The flowers have an intriguing and playful quality that appeals to the senses.

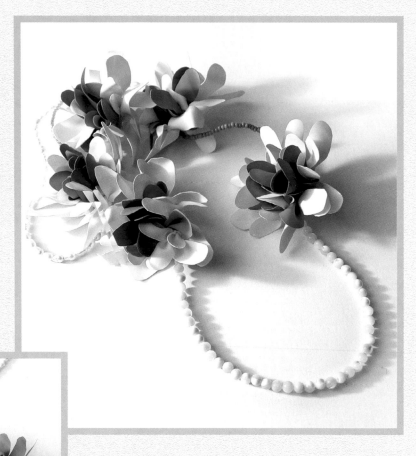

VARIATION
You could use one single flower as a pendant on a string of glass beads. The petals could be different lengths and thicknesses. The flowers might be a single colour or have many colours. All these variations can make the design look very different.

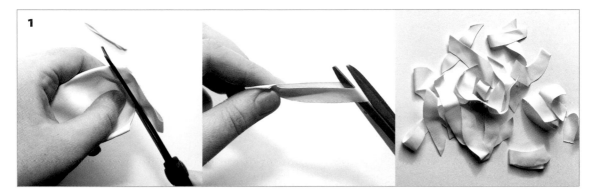

STEP 1 Take the white balloons and cut them into strips, measuring approximately 1 cm (0.4 in.) wide and a variety of lengths from 4–6 cm (1.5–2 in.). You will need 12 white pieces per flower. There are five flowers, so a total of 60 are needed. Once they are cut into strips, shape each end with the scissors into a rounded form.

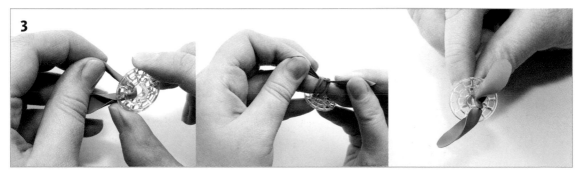

TIP

If you can't locate the creative buttons, you could use plastic binca as an alternative and cut discs from it.

STEP 2 Do exactly the same with the green balloons, but this time you need six pieces per flower; 30 in total.

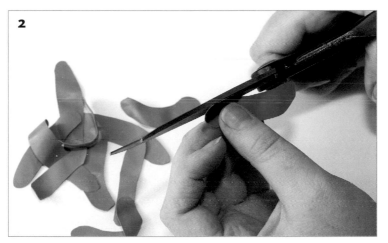

STEP 3 Take one of the creative buttons and pull each piece of green balloon through the inner holes so that both ends point out the same way (away from the fastening loop). Push them through with a sewing needle or pointed object if needed. Then knot the balloon piece, to hold in place.

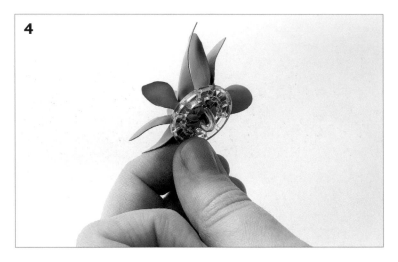

STEP 4 Repeat until all six green pieces fill the inner circle. Trim any that are too long or don't sit well.

HEALTH & SAFETY

Be careful when using tiger tail as it is very springy. Be aware of its proximity to your eyes and consider those working around you.

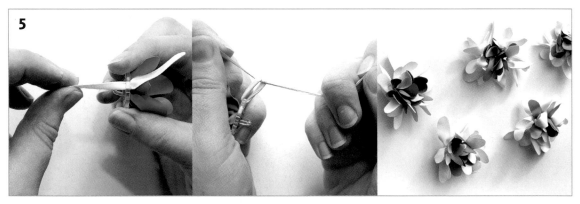

STEP 5 Next, take the white pieces and knot around the outer edge. Again you can trim or reshape any ends until you are happy with the overall form. Repeat steps 3–5 until you have five finished flowers.

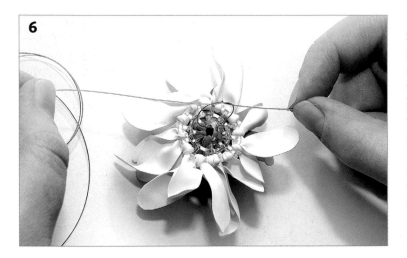

STEP 6 Take 100 cm (40 in.) of tiger tail and tie it onto the back of one of the flowers. This should be done as neatly and tightly as possible. Try and allow for an equal length of tiger tail on each side. The backs of the flowers should look as neat as the front.

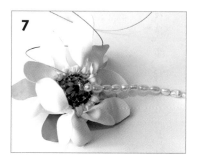

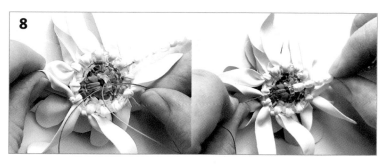

STEP 7 Take the freshwater pearls and string onto the tiger tail. You should find the tiger tail is rigid enough to do this freehand, without a needle.

STEP 8 Once you have strung on all of the pearls, wind the end into the back of the next flower (around the loop). Again you need to do this tightly and firmly.

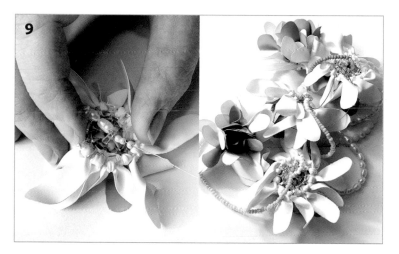

STEP 9 Add the pearlised green beads and attach another flower. Then add the dark green beads to the other side next to the pearls. Add another flower and the mother-of-pearl beads, then another flower. Then add the white glass beads next to the pearlised green beads.

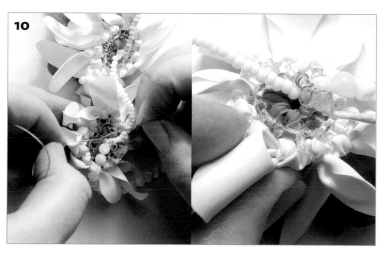

STEP 10 Fix the two ends together by passing the tiger tail ends through the loops (as before). Then knot them tightly three times and cut the ends with end cutters, leaving a few millimetres of the tiger tail. Then add a small amount of epoxy resin glue to hold it in place for extra security.

the gallery

	2	5	6
1	3		
	4	7	8

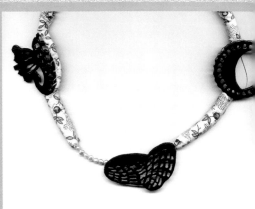

1 **Pectoral**, Marco Minelli. Drinking straws, plastic, mixed media. 2007. Italy.
2 **My Garden – Necklace**, Silvia Walz. Copper, enamel, silver, steel, textile. 3.5 cm x 50 cm x 1 cm. 2006. German, lives and works in Spain.
3 **Tulips – Necklace**, Ineke Otte. Wood, metal, paint. 25 cm x 25 cm. 2000. The Netherlands.
4 **The Gloves Dream – Necklace**, Min-Ji Cho. Rubber gloves, 18 ct gold, shell pearls, gold leaf, acrylic. 32 cm x 47 cm x 3.5 cm. 2007. Korean, lives and works in London.
5 **Dualism – Ring**, Mi-Mi Moscow. Melhior, paper, tips nail, manicure. 11.5 cm x 3.0 cm. 2006. Russia.
6 **Ruffle Bracelets**, Christine Dhein. Latex rubber, sterling silver. 7.5 cm x 7.5 cm x 2 cm. 2006. USA.
7 **Dipped Pin**, Lina Peterson. Copper, steel, Swarovski crystal, plastic. 8 cm x 5 cm x 1 cm. 2007. Swedish, lives and works in London.
8 **Necklace**, Ela Bauer. Silicone, thread, pigments. 35 cm x 4 cm x 2 cm. 2004. Polish, lives and works in The Netherlands.

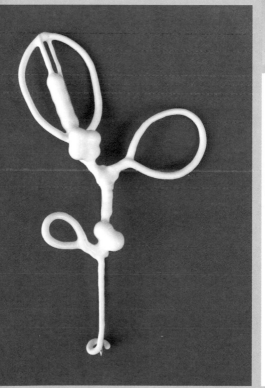

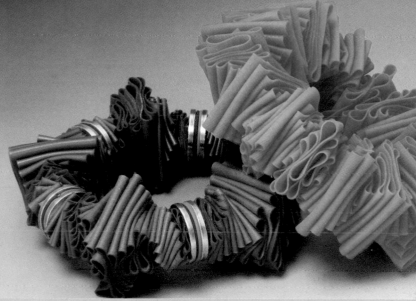

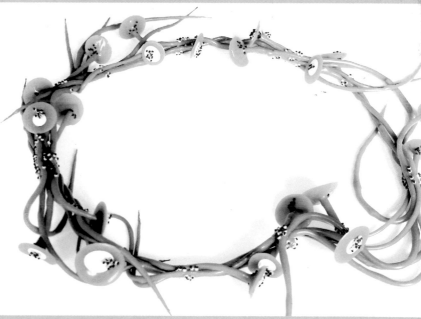

5. bead brooch

MAKER RATING
beginner

WHAT YOU WILL NEED
MATERIALS
▶ black glass beads
▶ white glass beads
▶ one 6 mm (0.2 in.) 9 ct gold bead
▶ silver pin wire 0.9 mm (0.04 in.) thick and 60 cm (24 in.) in length

TOOLS AND OBJECTS
▶ needle files
▶ end cutters
▶ safety glasses
▶ emery paper or sanding block
▶ reverse action tweezers
▶ round-nosed pliers
▶ pickle and water
▶ hand torch and general heating materials (listed in the *Basic jewellery techniques* chapter)

This project shows you how to make a winding coiled brooch using glass beads and pin wire. The addition of a single gold bead adds a precious material to the composition. This brooch is achievable for all levels of abilities and introduces two basic jewellery techniques.

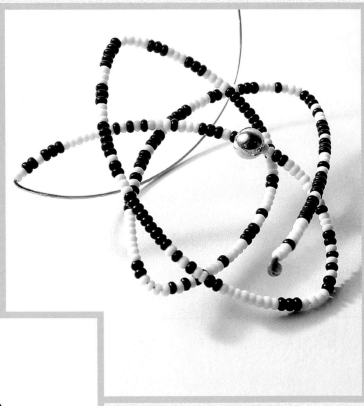

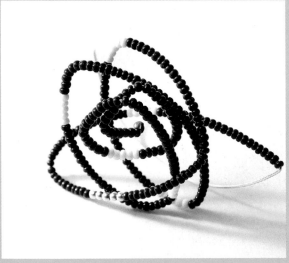

VARIATION
Try adding gold or silver beads the same shape and size of the glass beads. Place a few together for a big impact or scatter them in amongst the glass beads.

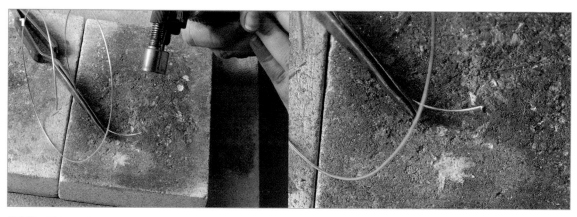

STEP 1 Take a 60 cm (24 in.) length of silver pin wire with a 0.9 mm (0.04 in.) thickness. If removing the length from a longer coil, cut with end cutters. Place the wire on your heat mat and hold it 5 cm (1.9 in.) from the end with your reverse action tweezers. Heat the tip with your hand torch until the end starts to melt into a ball. You can make the ball bigger by moving the torch along the wire as it starts to melt.

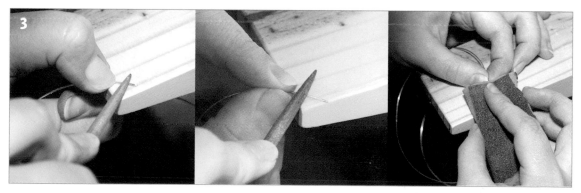

STEP 2 Quench the wire in water. At this stage you can clean the wire in pickle. Alternatively you can leave it, if you prefer a blackened surface.

TIP

Pins are often made from steel as it is a springy material that keeps its shape. This project uses silver pin wire which can be purchased specifically for its hardness. Standard silver which is not hardened in this way would bend easily when you repeatedly pin it.

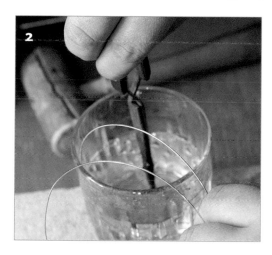

STEP 3 Next, you need to create a pin at the other end of the wire. Take a needle file and taper the end into a smooth point. Then smooth with emery paper or a sanding block to give a smooth surface. If you leave it rough, it will look unfinished and it will not pass easily though garments.

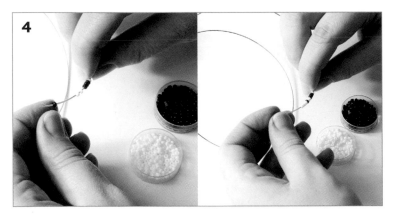

VARIATION
You could add other materials to the brooch. Try using small buttons, shells or discs of paper/fabric.

STEP 4 Take your black and white glass beads and thread them one by one onto the pin wire. The design element to this project allows an endless number of possible colour ways and rhythmic patterns. For my example I have left the pattern to chance and have randomly placed them on the pin wire. This is easier said than done as instinct makes us want to create patterns and order. You might like to design your pattern first, by playing with the actual beads on the wire, as you can simply take them off and start again. Or you could design the pattern on paper if you prefer.

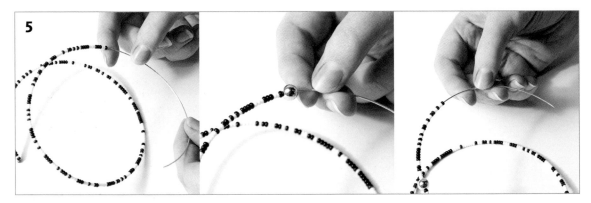

STEP 5 Continue threading the beads until you have 14 cm of pin wire left uncovered. Then add the gold bead and then more black and white glass beads until 8 cm of pin wire remains.

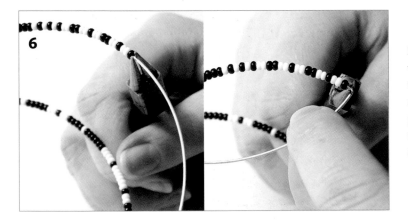

STEP 6 Hold the wire firmly with round-nosed pliers where the beads stop. Bend the wire round on itself. This will prevent the beads from moving along the wire and will also act as the brooch pin.

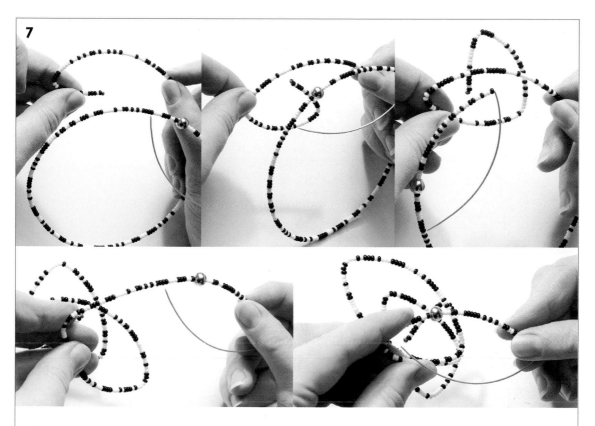

STEP 7 Next, hold the wire at the ball end. Using your hands, shape the wire by bending it round on itself into a spiral shape. Think carefully before each bend to consider the final form. Wear safety glasses when doing this as you will probably find some of the beads break away at the corners. Don't worry if this happens as they will easily fall away from the pin wire.

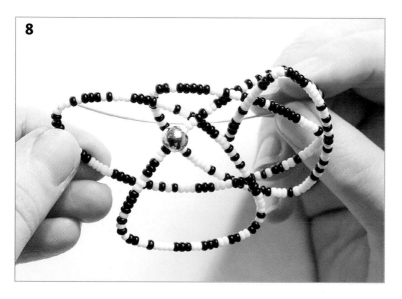

STEP 8 Play around with the final composition until you are happy. You might find it useful to move the structure around and have the ball end section at the front of the composition.

HEALTH & SAFETY

Make sure that the pin is not overly sharp as you will be wearing it close to your body.

the gallery

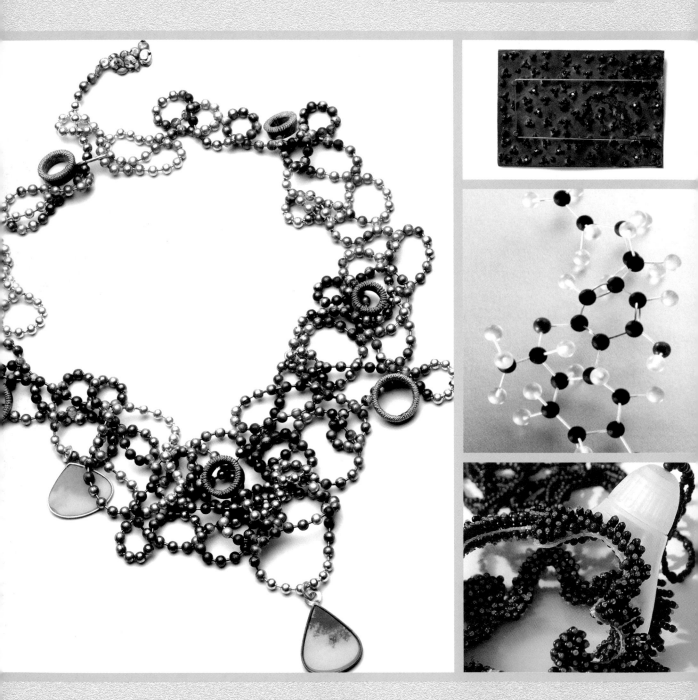

1. **Crown Jewels**, Åsa Lockner. Silver, silk, agate. 18 cm x 27 cm x 1.5 cm. 2007. Sweden.
2. **Duotone 2 – Brooch (Back)**, Stefan Heuser. Silver, enamel, one hundred spinel stones. 7 x 9 cm. 2007. Germany.
3. **Halo for St. Ray Gaurino: Patron of People with AIDS, Invoked by Gay Teachers**, Angela Gleason. Plastic, rubber, acupuncture needles, 14 ct gold. 14 cm x 6.5 cm x 4 cm. 2001. USA.
4. **Neckpiece**, Paula Lindblom. Plastic can, glass beads, nylon thread. Chain length 120 cm, pendant 9 cm x 11 cm approx. 2007.
5. **Necklace**, Ela Bauer. Silicone, jade, corals, glass beads. 38 cm x 7 cm x 3.5 cm. 2007. Polish, lives and works in the Netherlands.
6. **Torus – Neckpiece**, Joanne Haywood. Oxidised silver, textiles. 40 cm x 1 cm x 1 cm. 2006. England.
7. **Jade Banditos – Earrings**, Polly Wales. Silver, jade. 4 cm x 4 cm x 0.6 cm approx. 2007. England.
8. **Necklace**, Karin Seufert. Plastic, silver, glass, colorit, polyurethane, coral, PVC, photo, enamel. 22 cm diameter. 2006. Germany.

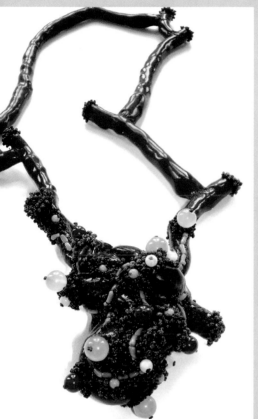

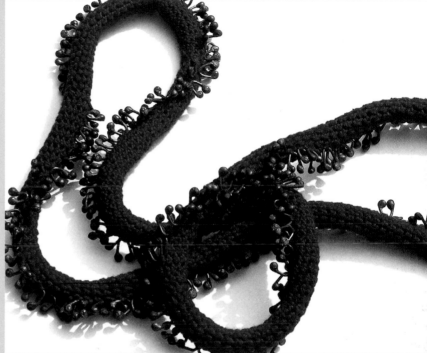

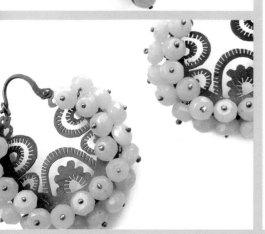

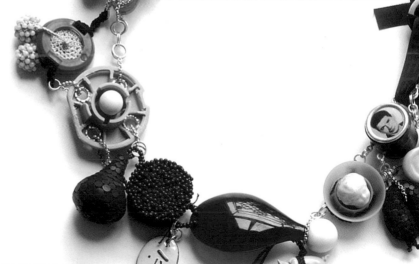

6. bluebird brooch

MAKER RATING
advanced

WHAT YOU WILL NEED
MATERIALS
- light blue cotton yarn
- white cotton yarn
- kilt pin 10 cm (3.9 in.) in length
- feet from an Easter chick toy
- one yellow rawlplug®
- blue merino felt
- two small blue beads
- cotton thread (same or similar colour to the beads)

TOOLS AND OBJECTS
- 2 mm (0.08 in.) crochet hook
- 2–3 mm (0.08–0.1 in.) knitting needles
- sewing needle (big enough for yarn)
- spray paint for metal in dark blue
- end cutters
- scrap paper or newspaper

This project shows you how to make a brooch with traditional knitting and crochet alongside altered everyday objects. Change the colour to suit your own taste or use the starting point to make a beaked creature of your own design.

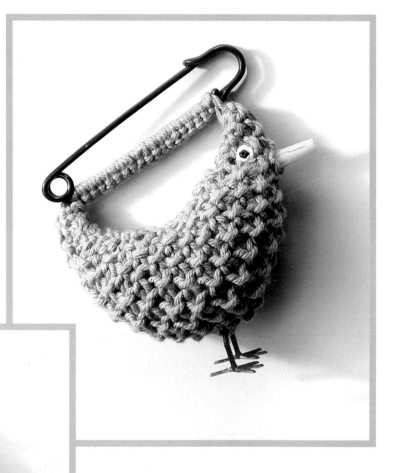

VARIATION
Changing the colour of the yarn can change the character of the bird brooch. Try using a black yarn to make a blackbird brooch or brown and red for a robin.

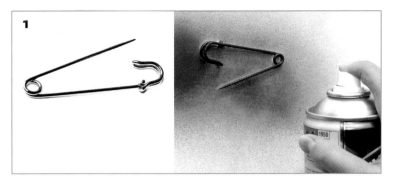

HEALTH & SAFETY

Take care when spraying the kilt pin. Make sure you use the paint in a well-ventilated area and always read the instructions on the can.

STEP 1 Undo the fastening on a 10 cm (3.9 in.) kilt pin. Place on a piece of scrap paper and spray one side with the metal spray paint. Leave to dry and then turn the pin. Spray the other side and leave to dry. Always follow the specific instructions on the spray can as drying times vary and you may also need to apply more than one coat of paint.

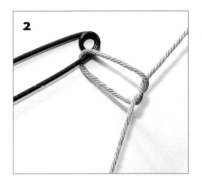

STEP 2 Take your light blue yarn and your 2 mm (0.08 in.) crochet hook. Tie a knot around the bottom section of the kilt pin next to the loop (not the side that will be pinning onto your garment). Make sure you leave a 10 cm (3.9 in.) piece of yarn to secure later. Ensure that the kilt pin is fastened when you are handling it.

VARIATION

You might like to use different thicknesses of yarns and needles and try using a plain knit or stockinette stitch to create a different surface.

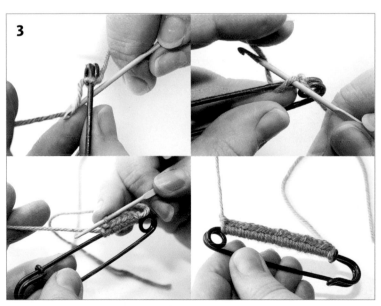

STEP 3 Hook the yarn around the pin, making a loop to crochet into. Hook the loop and wrap round the pin, drawing another loop through, until the whole lower section of the pin is covered.

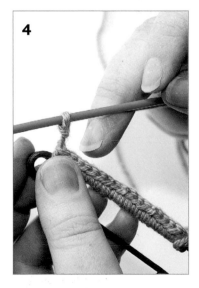

STEP 4 Next take your knitting needles and, where the crochet ends, use the yarn to put a slip knot onto the needle.

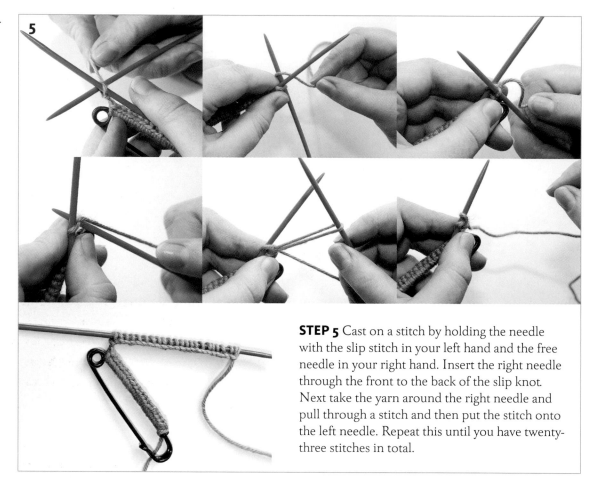

STEP 5 Cast on a stitch by holding the needle with the slip stitch in your left hand and the free needle in your right hand. Insert the right needle through the front to the back of the slip knot. Next take the yarn around the right needle and pull through a stitch and then put the stitch onto the left needle. Repeat this until you have twenty-three stitches in total.

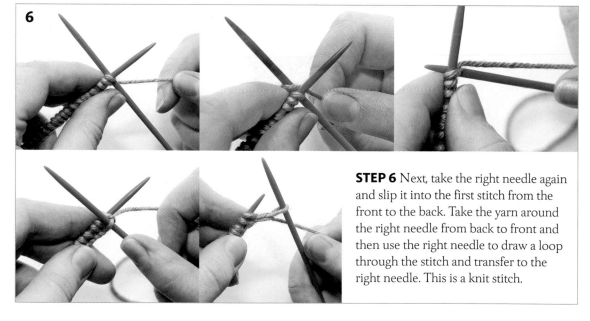

STEP 6 Next, take the right needle again and slip it into the first stitch from the front to the back. Take the yarn around the right needle from back to front and then use the right needle to draw a loop through the stitch and transfer to the right needle. This is a knit stitch.

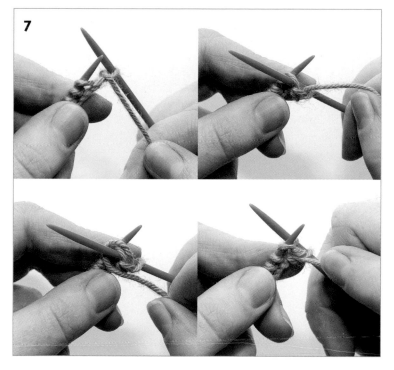

STEP 7 Take the yarn and place it in front of the right needle. Slip the right needle into the next stitch on the left, but at the front this time. Take the yarn and loop it around the right needle from the right to the front. Bring the right needle out, catching the loop of yarn through the stitch. Transfer this onto the right needle. This is a purl stitch.

VARIATION

Try making a different animal for the brooch, for example a sausage dog. It would be fairly easy to adjust the length and shape of the knitting to your own design.

STEP 8 Take the yarn to the back of the right needle and repeat the knit stitch. Continue alternating from knit to purl until all the stitches are on the right needle. Then take the right needle and transfer it to your left hand and stitch another row as before – knit, purl, knit, purl and so on.

STEP 9 Continue until your knitting grows in length to 5 cm (1.9 in.). By alternating the stitches you are creating a pattern known as moss stitch. This only works with an odd number of stitches. With an even number the pattern will look very different and is known as rib stitch.

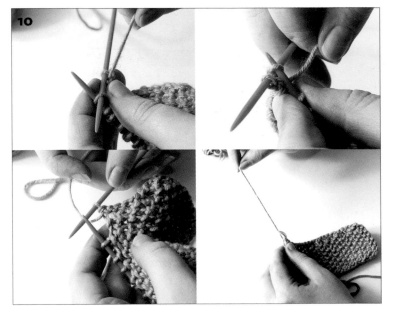

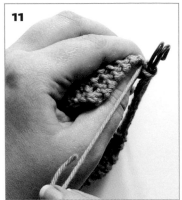

STEP 11 Cut off a 60 cm (24 in.) length of the yarn. Stitch the loose edge of the knitting around the kilt pin with the shorter length of yarn.

STEP 10 Cast off by knitting the first two stitches onto the right needle. Then use the tip of the left needle to hook the first stitch over the second, off the needle. Knit another stitch so you have two on the right. Hook the first over the second again. Continue until you have cast off all the stitches. When you are left with one you can pull the yarn through to knot in place.

STEP 12 Fold the bottom edge of the knitting in half and stitch together. Run the yarn back along where you have stitched.

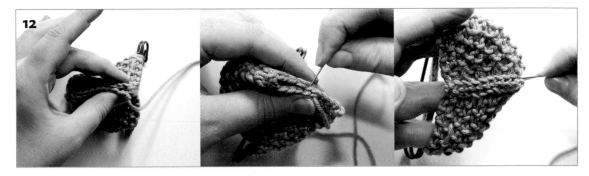

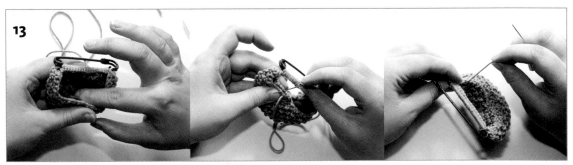

STEP 13 Fill the pocket you have created with blue merino felt and sew along the top to seal the felt inside.

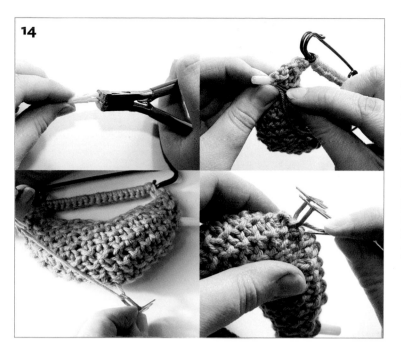

STEP 14 Stitch on the feet and rawlplug® beak with the same yarn. You may need to snip away some of the rawlplug® with end cutters if you find it too long. Both the feet and beak should stitch into place quite easily. You will be able to poke the beak into the knitting before you secure it with stitches.

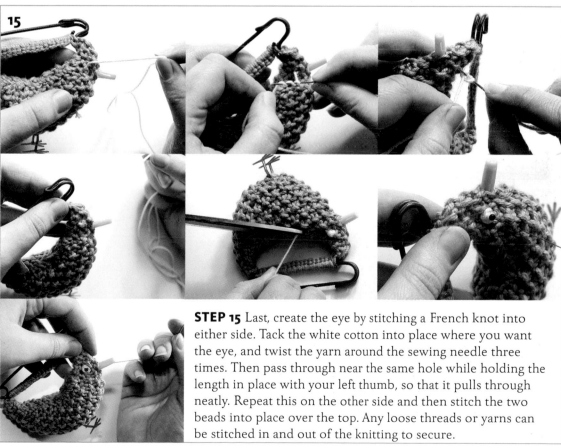

STEP 15 Last, create the eye by stitching a French knot into either side. Tack the white cotton into place where you want the eye, and twist the yarn around the sewing needle three times. Then pass through near the same hole while holding the length in place with your left thumb, so that it pulls through neatly. Repeat this on the other side and then stitch the two beads into place over the top. Any loose threads or yarns can be stitched in and out of the knitting to secure.

the gallery

	2		4	5	6
1	3		7	8	

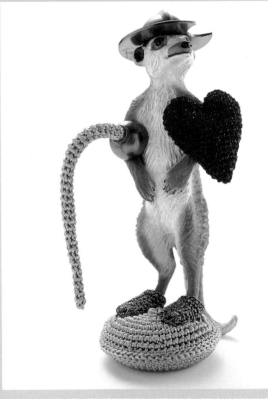

1. **Bone Necklace with Ribbon**, Tina Lilenthal. Polyester resin, silver. 5 cm x 2 cm x 2 cm. 2004. German, lives and works in England.

2. **Maui Birthdays – Bracelet**, Lynda Watson. Sterling silver, red, pink, yellow, green, 14/18 ct gold, pencil drawings, watch crystals, puka shells collected in Maui. 20 cm x 11 cm x 2 cm. 2002. USA.

3. **Meercat Don Q**, Felieke Van der Leest. Plastic, textile, silver. 10 cm x 4 cm x 5 cm. 2006. The Netherlands.

4. **Polka Dotted Chicken Brooch**, Marcia Macdonald. Carved wood, paint, sterling silver and recycled tin. 9 cm x 6 cm x 2 cm. 2005. USA.

5. **Book Box – Pendant**, Cynthia Toops and Daniel Adams. Polymer clay, hand-bound book (Toops), glass (Adams), pencils, glass beads, silver, rubber cord, pencil eraser, brush. 8.9 cm x 5 cm x 3.8 cm. 1999. USA.

6. **Orange Alert**, Angela Gleason. Maple wood, silver, eyeglass lens, objects. 9 cm x 6.5 cm x 1.5 cm. 2006. USA.

7. **Two Sides of Life – Brooch**, Tabea Reulecke. Coral, wood, enamel, copper, oil colour, garnets. 10 cm x 12.5 cm x 0.5 cm. 2006. Germany.

8. **Commuter Train Bracelet**, Kristin Lora. Silver, train set figures. 2.5 cm x 18 cm x 2 cm. 2007. USA.

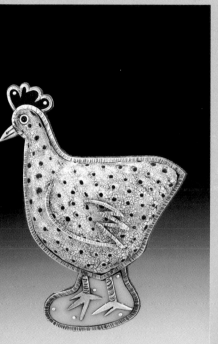

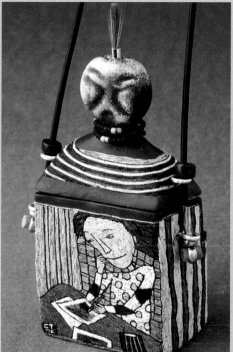

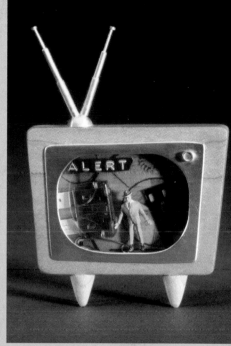

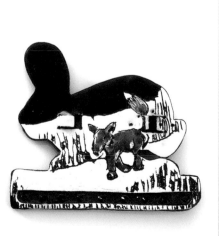

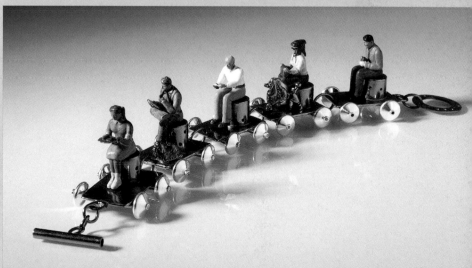

7. book & platinum leaf bangle

MAKER RATING
beginner

WHAT YOU WILL NEED
MATERIALS
▶ charity shop book
▶ platinum leaf on wax paper
▶ white shearing elastic
▶ general purpose glue
▶ finishing wax and a cloth

TOOLS AND OBJECTS
▶ velum spray adhesive
▶ long sewing needle
▶ cutting mat and scalpel
▶ steel ruler and pencil
▶ 2 mm (0.08 in.) knitting needle

TIP
Spray mount could be used instead of vellum adhesive spray.

Reinvent an unloved book to make a stretchy bangle. You can find paperback novels in charity shops which have a lovely bloom when aged. The accidental placing of words make interesting reading. Choose a murder mystery, sci-fi or romance novel to make your own.

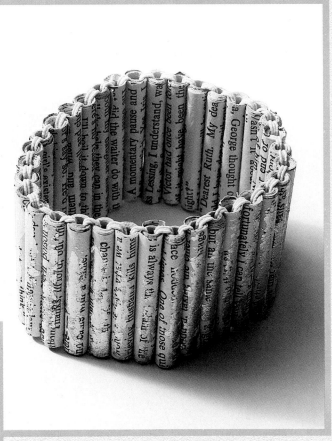

VARIATION
You could use newspaper from another country or make one as a gift for someone using a book specific to that person.

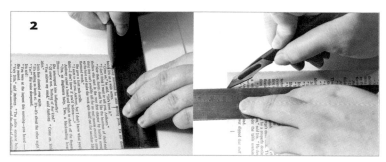

STEP 1 Take your paperback novel and carefully tear out five pages. Trim the stack of pages to neaten the edges and take off any blank margins. Trim them so the length is approximately 15 cm (6 in.). You can measure this using a pencil and steel ruler. Then cut the paper with a scalpel.

STEP 2 Cut out strips measuring 4 cm x 15 cm (1.5 in. x 6 in.).

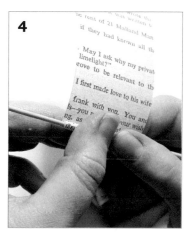

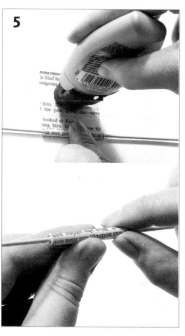

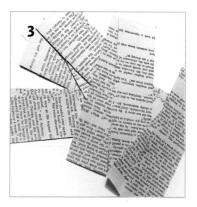

STEP 3 Continue steps 1 and 2 until you have thirty-four strips of paper.

STEP 4 Take a strip of paper and wind it tightly around a 2 mm knitting needle. Try and keep it square to the needle so it does not start to taper. If it docs, either start again, or take it off the needle and push it back into place before replacing it on the knitting needle.

STEP 5 When you have 4 cm (1.5 in.) left, apply a small amount of general purpose glue evenly to the end of the strip and continue rolling to form a bead.

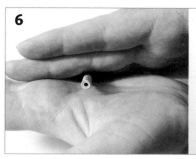

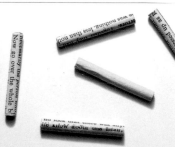

STEP 6 Remove the bead from the knitting needle and roll it in your hand to make sure it has adhered. Make all thirty-four and leave to dry thoroughly.

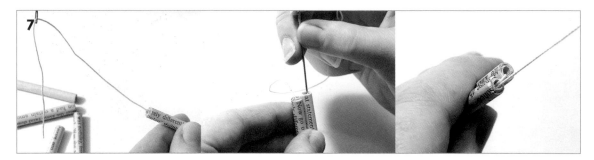

STEP 7 Take a 50 cm (19.6 in.) length of white shearing elastic and thread onto a long sewing needle. Pass the elastic through one of the paper tubes. Then pass the elastic through a second paper tube and back through the first. They should now sit together.

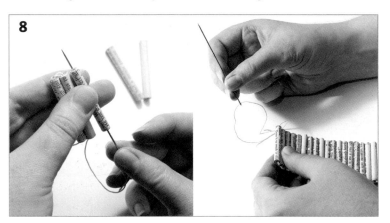

STEP 8 Pass the elastic through the two paper tubes two more times and then add another paper tube next to the second. Continue threading them until you have all thirty-four together. When your elastic gets too short, add another section by securing two ends with a knot. Try to make the knots stay unseen inside the paper tubes.

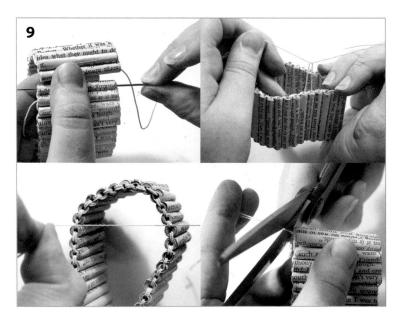

STEP 9 Attach the two ends together by stitching (as before), then secure them with three knots. Pull tightly before knotting and that way the elastic ends will be able to spring back into the last paper tube.

TIP

There are different coloured metal leaves you might try such as green gold, aluminium or copper.

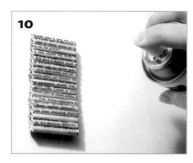

STEP 10 Place the bangle on a piece of scrap paper, tube surface down. Spray the surface lightly with vellum adhesive, making sure you follow the instructions for the distance from the object. Remember to shake the can.

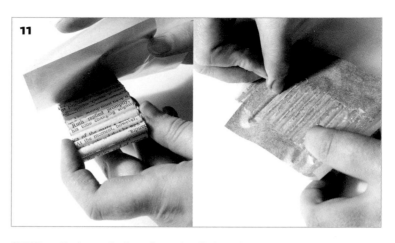

STEP 11 Pick up the bangle and roll the adhesive side onto the platinum leaf. Rub down and peel back. The platinum should adhere to the surface, but you can continue pressing the leaf onto the surface until you have the effect and coverage you like.

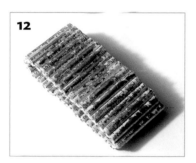

STEP 12 Repeat again with the opposite side of the bangle.

HEALTH & SAFETY

Place newspaper or scrap paper underneath the bangle to protect the work surfaces from glue.

Spray the adhesive in a well-ventilated area and always read the instructions before use.

Be careful when using a scalpel and steel ruler. Always keep your fingers away from the blade.

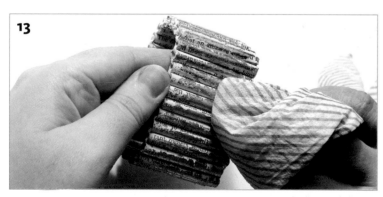

STEP 13 Leave to dry and complete the bangle by adding a protective layer of finishing wax to the surface. Not only will it protect the leaf but you should find it adds extra colour to the bloom of the book. Put a small amount of wax on a cloth and rub into the surface, buffing gently. Add a second layer if you think it's needed.

the gallery

1	2	4	7
	3	5	8
		6	

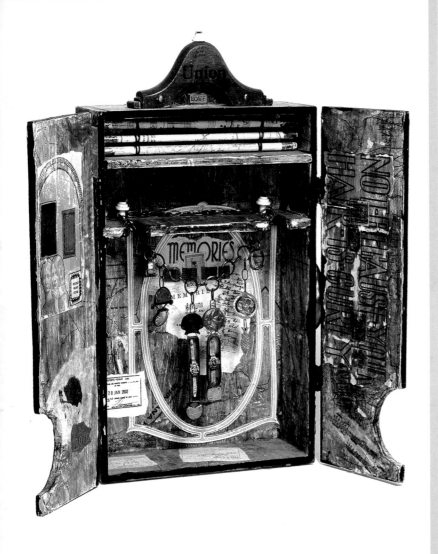

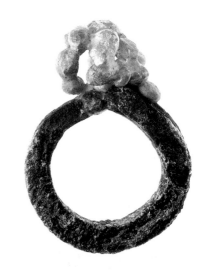

1 **Union 26 Years – Neckpiece, Nesting Case (shown with neckpiece displayed)**, Linda Kaye-Moses. Stirling silver, fine silver, 14 ct gold, found objects, found paper, leather. Necklace: 11.5 cm x 2.5 cm x 12.5 cm, nesting case: 37.5 cm x 22.5 cm x 10 cm. 2004. USA.

2 **Ring**, Stefano Zanini. Antique iron, gold. 4 cm x 2 cm x 0.7 cm. 2007. Italy.

3 **Book – Ring**, Fabrizio Tridenti. Silver, paper, acrylic. 8 cm x 2.6 cm x 1.7 cm. 2006. Italy.

4 **Untitled 6 – Brooch**, Hu Jun, Brass, silver, lacquer. 7.8 cm x 7.2 cm x 1 cm. 2007. China.

5 **Guilded Rosewood Bowl Ring and Double Dish Earrings**, Kate Brightman. Rosewood, 9 ct gold, gold leaf. Ring 6 cm diameter, earrings 2.5 cm diameter. 2007. England.

6 **Nº 979 – Brooch, Walled Garden Series**, Ramon Puig Cuyàs. Silver, plastic, tourmaline, coral, onyx, gold leaf. 7 cm x 5 cm x 1 cm. 2004. Spain.

7 **Martha – Brooch**, Rachelle Varney. Steel, flocking, found object. Case: 12 cm x 10 cm x 2.5 cm, brooch: 3.5 cm x 5 cm x 10 cm. 2007. England.

8 **Sat Alone – Brooch**, Jo Pond. Vellum, silver, paper, brush, steel. 12.5cm length. 2007. England.

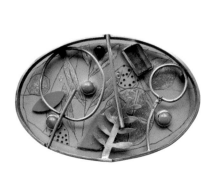

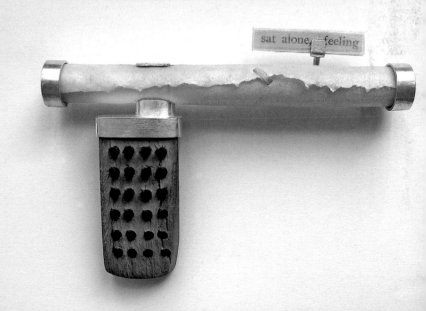

8. can & latex neckpiece

MAKER RATING
beginner

WHAT YOU WILL NEED
MATERIALS
- three empty and rinsed drinks cans in various colours
- latex fishing elastic

TOOLS AND OBJECTS
- 2 mm (0.08 in.) knitting needle
- tin snips or scissors
- a scribe
- round-nosed pliers

TIP
You can purchase fishing elastic in a variety of colours and thicknesses. The colours correspond to the thickness of the elastic.

This project shows you how to make a necklace using recycled drinks cans and latex elastic, more commonly used for fishing. Choose your own colours and length to design your own variation. This project needs very little equipment and can be achieved by complete beginners.

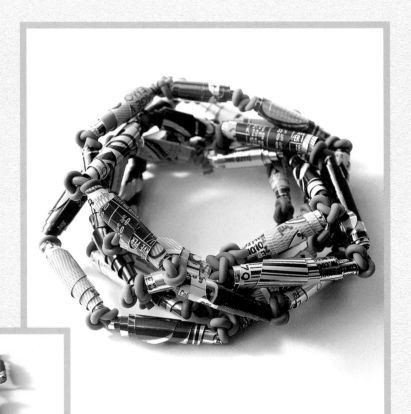

VARIATION
Try designing your own variation. You might use only one colour, make the necklace shorter or longer, make each bead smaller, tie more knots in between each bead or make the knots tighter.

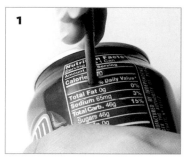

STEP 1 Take one of the empty drinks cans and make a hole in the surface near the top. Do this with the scribe. You need to be quite firm.

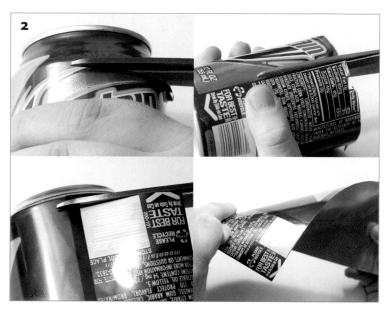

STEP 2 Cut along the top of the can to take off the rim, and then cut down the side. Cut off the other end so you are left with a single sheet of metal. Discard each end piece – you only need the sheet. Tidy the edges if they are uneven.

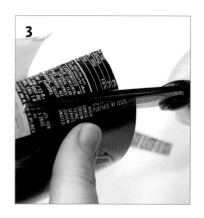

STEP 3 Using tin snips or scissors cut out tapering pieces of tin along the width of the sheet, measuring 2–3 cm (0.8–1.2 in.) at one end and tapering to 5–10 mm (0.19–0.4 in.). They can be a variety of sizes which you should be able to cut easily freehand.

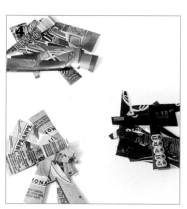

STEP 4 Repeat this process until you have cut out all three cans. Place these in individual piles.

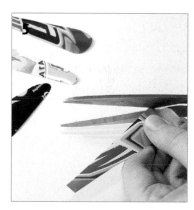

STEP 5 Next take each taper and round off the corners. This is done freehand. You do not need to make each corner match. Rounding off the edges is done for both aesthetic reasons and it also makes the metal safe to wear as the tin edge is sharp when left square.

6

STEP 6 Take a taper and the round-nosed pliers. Carefully hold the wider end of the taper with the pliers and roll the edge slightly.

7

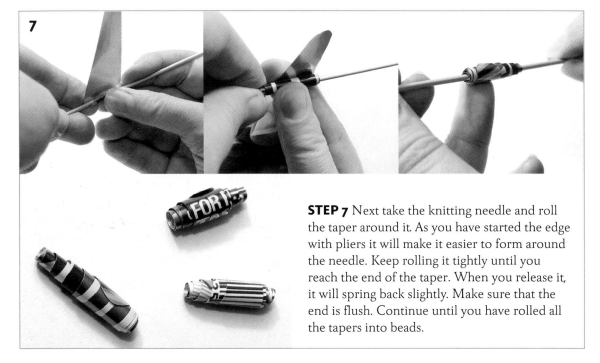

STEP 7 Next take the knitting needle and roll the taper around it. As you have started the edge with pliers it will make it easier to form around the needle. Keep rolling it tightly until you reach the end of the taper. When you release it, it will spring back slightly. Make sure that the end is flush. Continue until you have rolled all the tapers into beads.

8

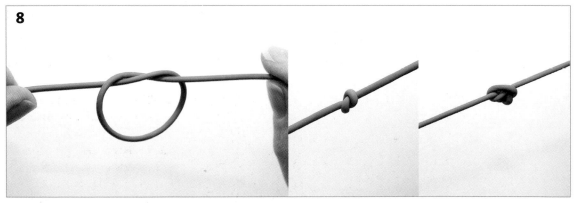

STEP8 Take a 230 cm (90.5 in.) length of the latex fishing elastic and make a knot in the middle. Then tie a second in the same place.

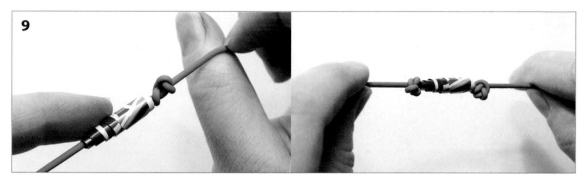

STEP 9 Slide on a bead and then tie two knots on the other side.

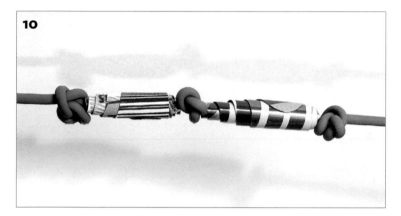

STEP 10 Continue adding beads and knotting either side until you have used all the beads.

HEALTH & SAFETY
Be careful when cutting out the cans as the edges can sharp. Be careful when disposing of cut-offs.

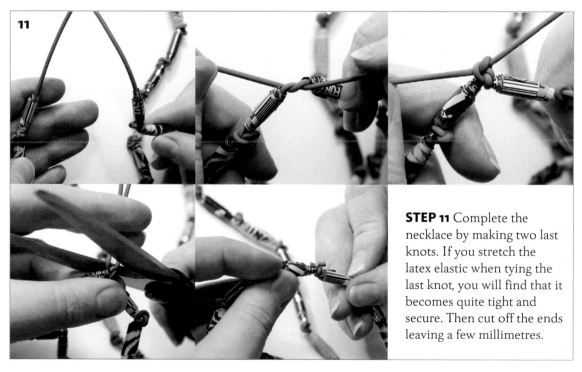

STEP 11 Complete the necklace by making two last knots. If you stretch the latex elastic when tying the last knot, you will find that it becomes quite tight and secure. Then cut off the ends leaving a few millimetres.

the gallery

	2	5	7
1	3		
	4	6	8

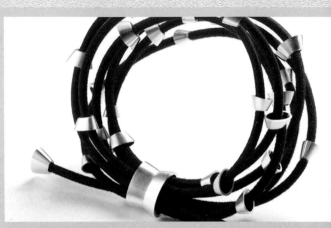

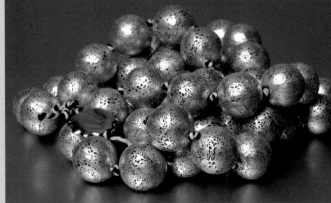

1 **Dempire – Brooches**, Ute Eitzenhöfer. Plastic lids, pearls, silver. Various sizes. The Netherlands. Courtesy of Galerie Marzee.
2 **Silver And Elastic Bracelet**, Gilly Langton. Silver, elastic. 10 cm x 10 cm x 2 cm. 2006. English, lives and works in Scotland.
3 **Bronzino – Pearl Necklace**, Carla Nuis. Silver, 9 ct gold, cotton cord. 2007. The Netherlands. Courtesy of Galerie Marzee.
4 **Travelling Rings**, Amandine Meunier. Aluminium, cord. 28 cm x 22 cm x 2.5 cm. The Netherlands. Courtesy of Galerie Marzee.
5 **Smiley – Brooch**, Alexander Blank. Iron, paint. 7.7 cm x 7.7 cm x 2.5 cm. 2007. Germany.

6 **Jeweler's Dozen: Andy Warhol – Brooch**, Ingrid Psuty. Sterling silver, museum buttons, nickel. 11 cm x 7 cm x 3 cm. 2003. USA.
7 **Distress**, Robin Kranitzky and Kim Overstreet. Brass, acrylic, copper, acetate, paper, lead foil, insect parts, decorative tin scrap, balsa, postcard fragments, metal Bingo game board, metal jar lid from an antique jar of toothpicks, metal box, beetle legs, lead foil from wine bottle, feather. 8.9 cm x 8.9 cm x 1.9 cm. 2005. USA.
8 **Garden Brooch**, Marcia Macdonald. Carved wood, sterling silver, recycled tin. 8 cm x 10 cm x 13 cm. 2005. USA.

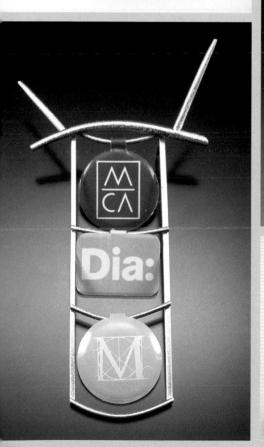

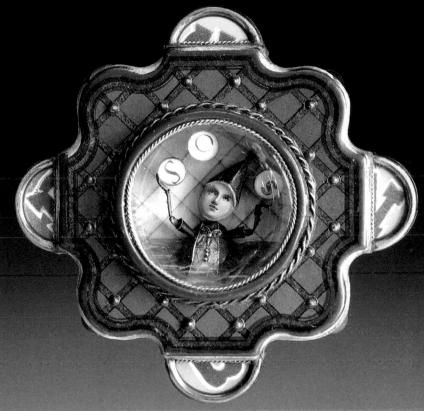

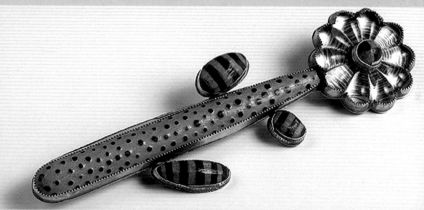

9. candle ring

MAKER RATING
intermediate/advanced

WHAT YOU WILL NEED
MATERIALS
- a yellow candle holder
- 3 mm (0.1 in.) silver tube 15 mm (0.6 in.) in length
- 7 cm (2.8 in.) of 2 mm (0.08 in.) round silver wire (this can be shorter or longer depending on the ring size)
- an interesting yarn
- 18 mm x 2 mm (0.7 in. x 0.08 in.) iolite beads (add more or less depending on your design)
- cotton thread (to stitch on the beads)
- 6 mm (0.2 in.) blue cabochon stone (this is to fit inside the candle holder so sizes may vary)

TOOLS AND OBJECTS
- basic soldering equipment
- pickle
- epoxy resin glue
- 2 mm (0.08 in.) crochet hook
- bead needle
- ring mandrel
- half-round pliers
- needle files
- sanding block
- sewing needle

This ring project uses a plastic candle holder and a cabochon stone where you expect to find the candle. It would make an ideal present for a friends' birthday.

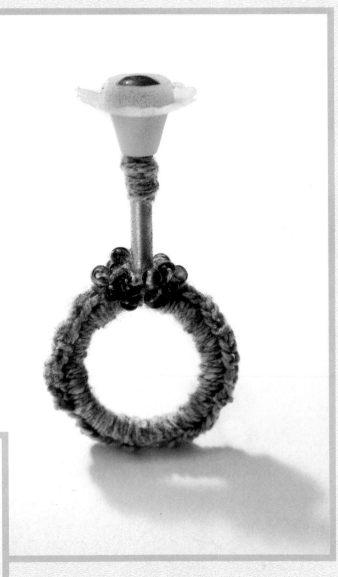

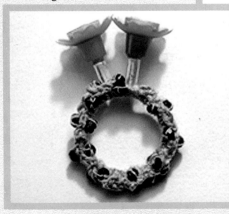

VARIATION
You could try adding more than one candle holder or use something else in place of the stones.

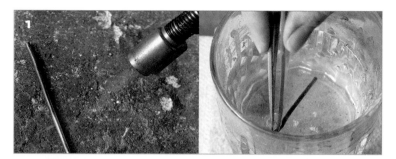

STEP 1 Take the round silver wire and anneal it by heating with your torch until it is pink in colour. Then quench in water.

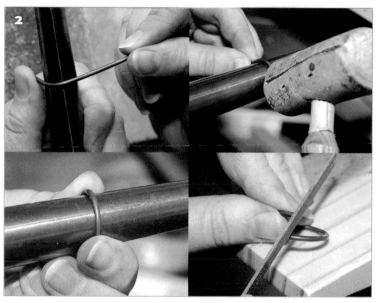

STEP 2 Shape the wire around a ring mandrel. It should be soft enough to do this with your fingers but if you find this hard you can shape it with half-round pliers. Make sure that the two ends sit flush together. If they don't sit perfectly, you can always adjust it by filing with a needle file, or shaping with half-round pliers or a hammer while it is still on the mandrel.

STEP 3 Clean in pickle.

TIP

I have used a bright plastic candle holder as a contrast to the silver and textiles. You might want to cast a candle holder in silver or gold to add a twist to the design.

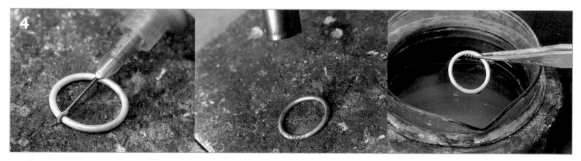

STEP 4 Solder the join and clean in pickle again.

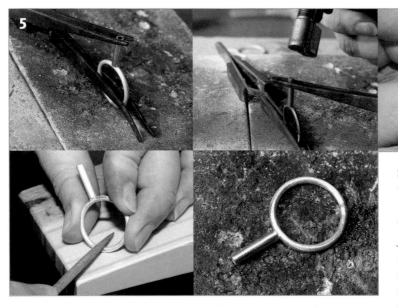

STEP 5 Solder the tube onto the ring. Position the tube and ring with reverse action tweezers so the tube is central. Join the tube away from the first join to avoid reheating it too much. Clean again in pickle and then file any excess solder or imperfections with a needle file. Next, clean up with a sanding block until you have an even, satin finish. You will notice that the tube does not fit flush to the ring. This is to compensate for the yarn you will be adding to the ring.

HEALTH & SAFETY

Remember to follow the advice for soldering and pickling in the Basic jewellery techniques chapter.

STEP 6 Glue the candle holder into the tube with epoxy resin and leave to set.

STEP 7 Glue the stone into the candle holder using epoxy resin.

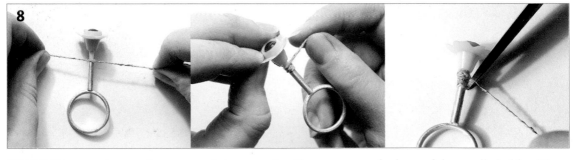

STEP 8 Take your interesting yarn and tie a couple of knots next to the base of the candle holder. Then wind the yarn around the base of the candle holder, up to the point where it meets the tube. Then cut the yarn leaving enough so that you can stitch it into place with a sewing needle. Try and stitch as neatly as you can so that you do not disrupt the continuous line of the binding.

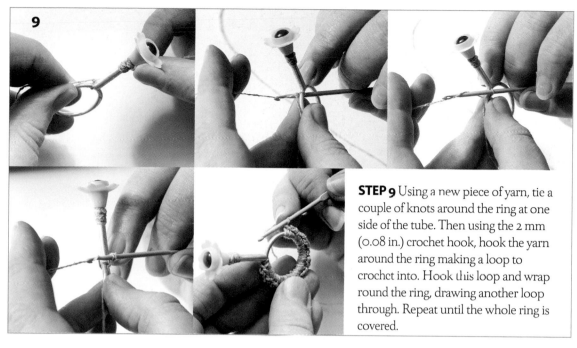

STEP 9 Using a new piece of yarn, tie a couple of knots around the ring at one side of the tube. Then using the 2 mm (0.08 in.) crochet hook, hook the yarn around the ring making a loop to crochet into. Hook this loop and wrap round the ring, drawing another loop through. Repeat until the whole ring is covered.

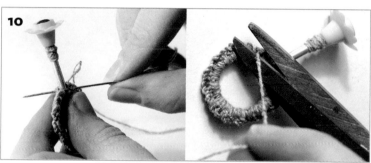

STEP 10 Cut the yarn but leave enough to be able to stitch the end back into the crochet, holding it in place.

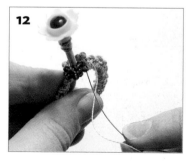

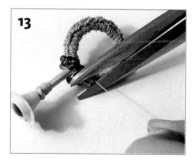

STEP 11 Take the cotton thread and bead needle. Tack the cotton into the crochet at the base of the tube and string on one of the iolite beads. Stitch back into the crochet to hold in place.

STEP 12 Stitch on the other seventeen beads or however many you think work well. You can re-adjust the placing of the beads a little by stitching back into them.

STEP 13 When you are pleased with the composition of beads, add a few more stitches to make sure it won't unravel.

the gallery

1	3	6	8
2	4 5	7	

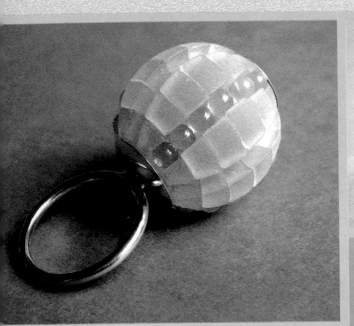

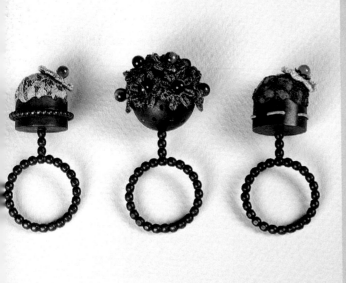

1 **Sphere Ring**, Ai Morita. Silver, resin, acrylic. 2.7 cm x 5 cm. 2006. Japanese, lives and works in England.

2 **Three Cake Rings**, Suzanne Smith. Oxidised white metal, hand made felt, vintage dyed lace, leather, amethyst, tiger's eye, aventurine. 5 cm x 2 cm x 2 cm; 5.5 cm x 2.5 cm x 3 cm; 5 cm x 2 cm x 2 cm. 2007. Scotland.

3 **Spring Green Flowerpot Ring**, Suzanne Potter. Grape green, Antarctica white corian and white precious metal. 3.8 cm x 2.2 cm x 1.3 cm. 2007. England.

4 **Unicated - Ring Series**, Kirsten Bak. Wood, plastic. 2 cm x 3 cm x 3 cm approx. 2006. Denmark.

5 **Music Box Rings**, Anastasia Young. 18 ct yellow gold, ebony, rubies, sapphires. 3.5 cm x 3 cm x 1.5 cm. 2006/7. Scottish, based in England.

6 **Ring**, Kathleen Taplick and Peter Krause (Body Politics). Polyester, silver, gold. 4.5 cm x 3.5 cm x 5.0 cm. 2007. Germany.

7 **Balance – Ring**, Heeseung Koh. Sterling silver, pearl, coral, glass beads. 2.5 cm x 3 cm x 1.5 cm. 2007. Korea.

8 **Dark Blue Felted Ball Ring**, Shana Astrachan Stirling silver, mohair, silk, 5 cm x 2.5 cm. 2005. USA.

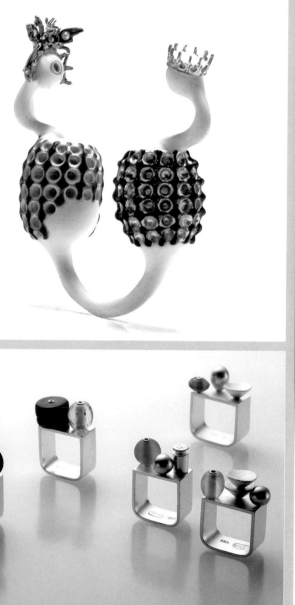

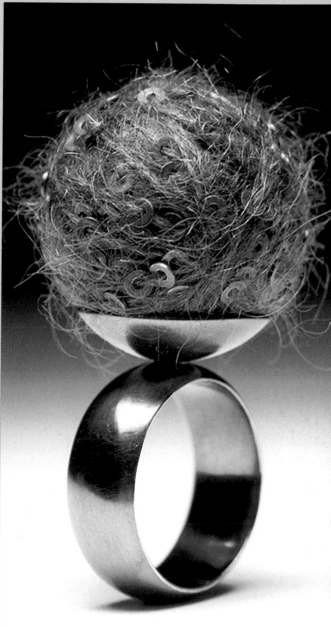

10. mudlarking pendant

MAKER RATING
intermediate/advanced

WHAT YOU WILL NEED
MATERIALS
▶ a found ceramic shard
▶ a piece of clay pipe
▶ 1 mm silver sheet approximately the same size as your ceramic shard
▶ cotton yarn
▶ sewing needle with a rounded end
▶ emulsion paint in yellow or other colour
▶ a piece of A4 cartridge paper
▶ garnets (optional)

TOOLS AND OBJECTS
▶ jewellers saw and blades
▶ needle files
▶ filing block or emery paper
▶ epoxy resin glue
▶ cocktail stick
▶ marker pen
▶ paper towels
▶ sanding block (coarse)

This pendant incorporates found objects into a single composition. A piece of jewellery made with found materials is unique and there is always enjoyment in designing around a one-off piece of treasure.

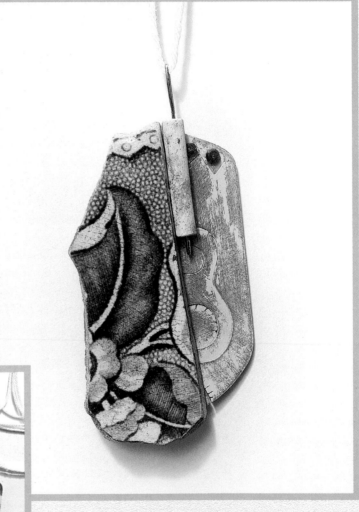

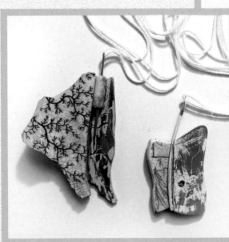

VARIATION
You can use silver chain or ribbon instead of thread. The compositions would work equally well as a brooch.

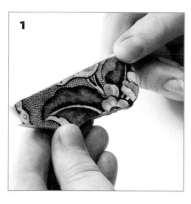

STEP 1 Take your ceramic shard and spend some time considering it. Notice the colours, the curves and straight sides, the patterns and truncations.

STEP 2 Place it onto a piece of cartridge paper and extend the object by drawing out from it, creating an overall shape. Allow for a little extra silver to attach it to the back of the ceramic. Take the clay pipe fragment and add this to your design, make sure you are pleased with the composition.

STEP 3 Draw the extended shape onto the surface of the silver sheet, either by using your drawing as a template or working again directly from the ceramic shard.

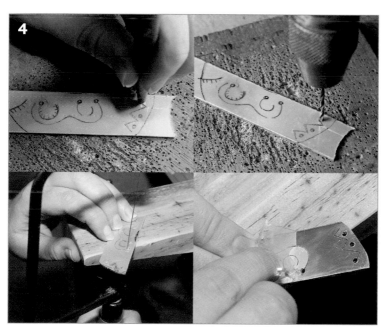

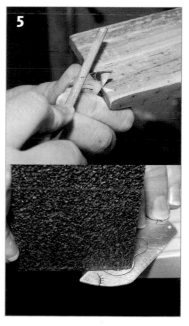

STEP 4 Cut out the shape and pierce any additional pattern or line details. You can drill piercings for details and also drill a hole as a starting point for removing areas in the middle of the silver. Remove the green plastic protecting the silver. Refer to the saw piercing and drilling instructions in the *Basic jewellery techniques* chapter.

STEP 5 File the edges of the silver with a needle file and apply a scratched finish with a coarse sanding block. This will also help to finish the edges.

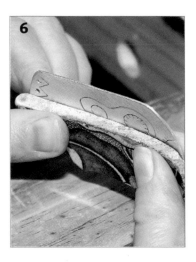

STEP 6 Check that the silver fits the ceramic shape. Shape with round-nosed pliers and a hammer if needed. Anneal the silver if it is difficult to work with.

TIP

Don't be afraid to use glue in your work when it's needed. Learning traditional techniques and craftsmanship is vital to anyone serious about becoming a jeweller, but don't be put off using less traditional materials or techniques if it works well and has the longevity you need.

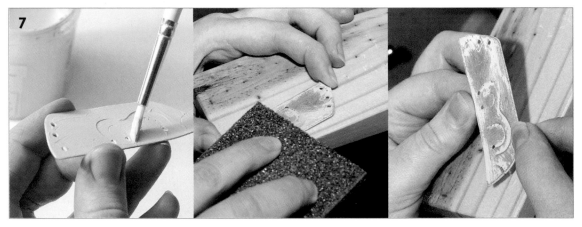

STEP 7 Paint a layer of yellow emulsion onto the surface of the silver and leave to dry. Rub back some of the surface, revealing the silver below. If you have any pierced lines, some of these should retain the paint. Be as random or as calculating as you like when rubbing back the paint. You can apply a few layers if you rub away too much the first time.

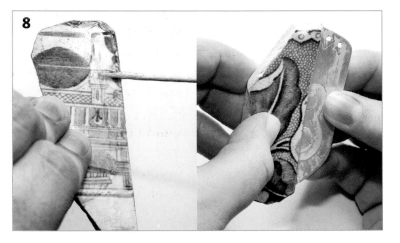

STEP 8 Glue the silver element to the ceramic shard with epoxy resin glue. This is the cleanest and strongest way to fix the materials together. Mix and apply the epoxy resin glue with a cocktail stick. Clean any of the glued elements with a paper towel if there is any excess showing. Do this before it sets hard.

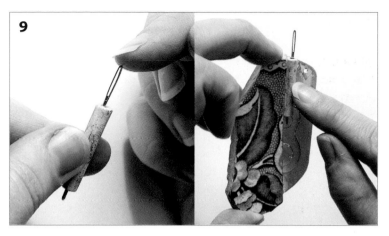

STEP 9 Glue the sewing needle into the piece of clay pipe and leave to set. Then carefully glue this onto the silver surface.

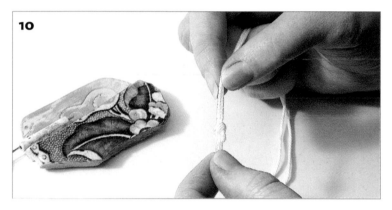

STEP 10 Take an 80 cm (31 in.) piece of cotton yarn and feed through the eye of the needle, knotting the ends together.

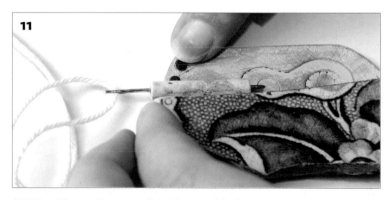

STEP 11 You will notice that I have added some garnets to the surface where the piercings were. This is optional; I felt my composition needed them, but your design may vary. I used epoxy resin to fix the stones in place.

HEALTH & SAFETY

You may need a mudlarking licence to hunt for objects on some foreshores. If in doubt, check with your local authorities or hunt for objects on an organised trip.

Make sure there are no sharp edges on your found objects. Remember the object is to be worn, so it needs to be safe to wear.

Always read health and safety instructions when using glue. They all have different drying times and risks to take into consideration.

TIP

You don't have to use the specific found object listed. Try using other objects specific to your environment, such as old keys, shells, fossils, pebbles, plastic containers, pieces of old bicycle tyres and unwanted computer parts.

Try making a piece only using found objects, including your fastenings.

the gallery

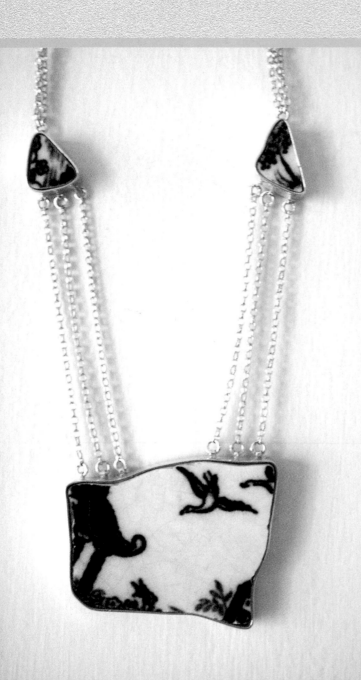

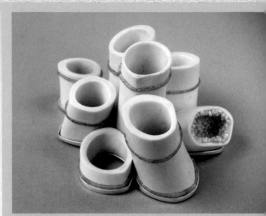

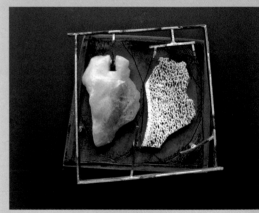

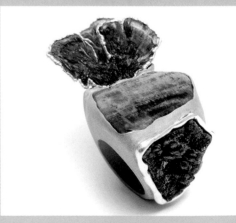

1. **Large Pottery Pendant**, Rosie Bill. Pottery, silver. 4.5 cm x 3.5 cm x 5 cm. 2006. England.
2. **Jade City – Brooch**, Andrea Wagner. Meerschaum, jade, pearl and silver. Various sizes. 2006. German, lives and works in the Netherlands.
3. **Binae Insula – Brooch**, Ramon Puig Cuyàs. Silver, nickel silver, plastic, amber, bone, acrylic colour. 5.5 cm x 5.5 cm x 1 cm. 2006. Spain.
4. **The Forest – Ring**, Ornella Iannuzziln. Silver, moss with bark, petrified wood, mushrooms. 4 cm x 2.3 cm x 4.5 cm, 2007. French, lives and works in England.
5. **Stucco – Necklace**, Evert Nijland. Mahogany, silver, porcelain. Length 70 cm. 2006. Netherlands.
6. **Doll Head – Ring**, Steffi Kalina. Ancient doll's head (porcelain), fimo, silver. 4 cm x 3 cm x 4 cm approx. 2006. Vienna.
7. **Stethoscope**, Ami Avellán. Found porcelain, electrical isolation parts, silver 999, agate, plastic coated wire. 5.5 cm x 90 cm, 2006. Finland.
8. **Pipe Flower Neckpiece**, Joanne Haywood. Clay pipe, textiles. 4 cm x 3 cm x 70 cm. 2008. England.

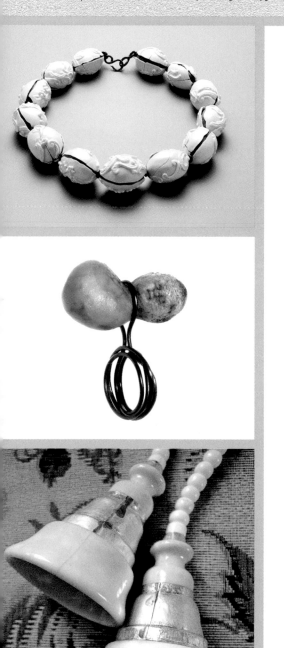

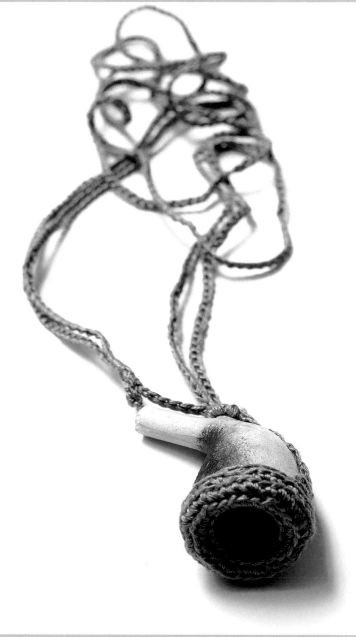

11. polymer clay & button necklace

MAKER RATING
beginner

WHAT YOU WILL NEED
MATERIALS
- three packs of soft Fimo®
 polymer clay (56g/1.9oz), red
 colour
- 25 black plastic buttons
- a ball of black wool (2 ply)

TOOLS AND OBJECTS
- 2 mm knitting needle
- domestic oven
- oven tray
- greaseproof paper
- sewing needle
- nylon sieve

In this project you will learn to make a long neckpiece that focuses on contrasting surfaces and textures. This project can be adapted for your own colour tastes and is suitable for every level of ability.

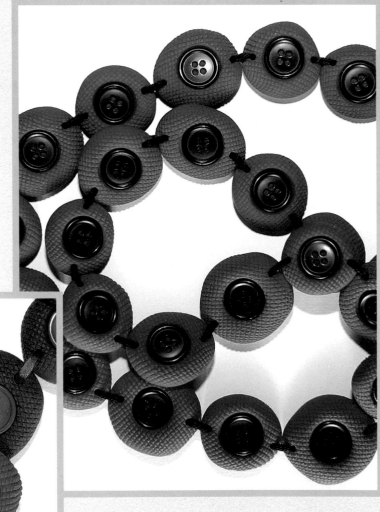

VARIATION
You might want to change the colour of the polymer clay or buttons. You could use patterned buttons or a variety of colours together.

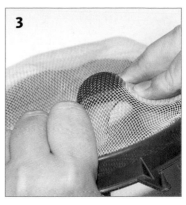

STEP 1 Making sure your hands are clean, take three 56g/1.9oz blocks of soft red Fimo® and divide into 25 pieces. Place on a clean surface such as a piece of paper. The pieces don't need to be equal sizes and in fact it is better to have a variation of sizes.

STEP 2 Take each piece and roll it in the palm of your hand to form a smooth ball without any creases. Place these back onto your clean surface.

STEP 3 Press each form into a nylon sieve, pushing with your thumb until the pattern of the weave appears on the underside. Be careful not to press too hard or it will adhere to the sieve and be difficult to release with the pattern intact. You might need to try this technique a few times to get an effect you are happy with. If you don't like one particular form, you can roll it back into a ball and begin again.

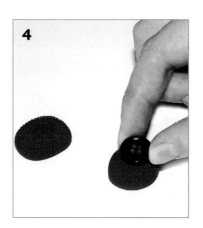

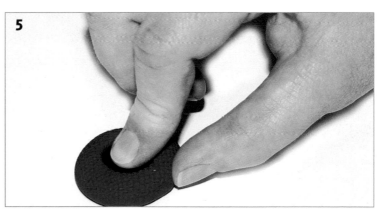

STEP 4 Once all 25 pieces have been pressed, take a button and press it into the middle of the textured surface until it feels secure. The edge of the button will be secured by the polymer clay surrounding it.

STEP 5 Repeat step 4 until all 25 pieces have a button in place. Check that they work together as a group of objects and see if you need to adjust any of them by pressing a button in further or re-pressing it.

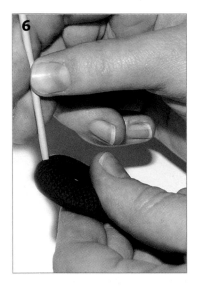

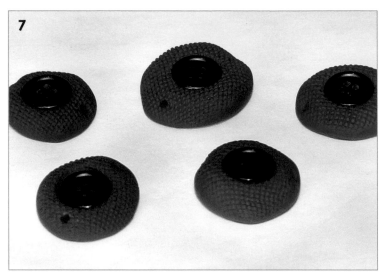

STEP 6 Take the 2 mm (0.08 in.) knitting needle and pierce two holes in each form at the opposite ends. You should pierce through the front 'pressed' surface to the other side. Carefully press the back with your fingers if the piercing has left the surface broken.

STEP 7 Line the oven tray with greaseproof paper. Place the 25 forms on the tray and follow the directions on the Fimo® packaging to heat.

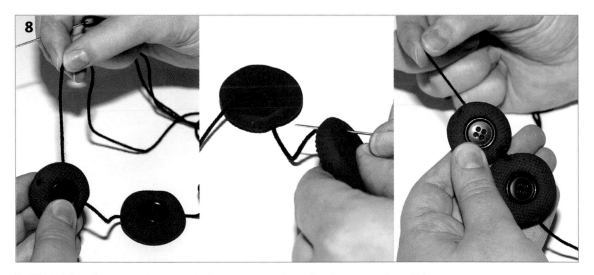

STEP 8 After the pieces have cooled, you are ready to fix them together. Take a one metre length of black yarn. Using a sewing needle, pass the yarn through the back of one of the piercings, leaving a 10 cm (3.9 in.) piece of yarn to fasten at the end. Stitch the yarn onto the front of the second form. Pass through the back of the first form and then back again through the front of the second.

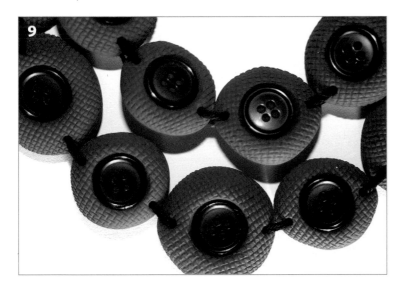

STEP 9 Stitch a third piece to the first two as before and then continue until all 25 pieces are joined.

VARIATION

As an alternative to wool, you could use ribbon. You could make the necklace shorter, and design and make a fastening.

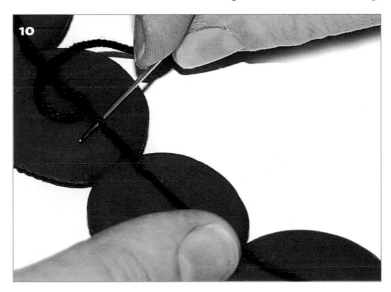

STEP 10 The back will now have a continuous line of yarn running across it. To complete the neckpiece, stitch the end pieces together as before and run the yarn through the back thread a number of times. You can also knot it into place until it feels secure.

HEALTH & SAFETY

Make sure the buttons are plastic. Do not use wood or any flammable materials. Fimo® hardens at a low heat which means you can set a number of materials within it by heating, including most plastic buttons. If you are not sure then check the pieces during the heating process. You can press the Fimo® with a round object, like a cork, and glue on the buttons after heating.

Wash the sieve thoroughly with washing-up liquid after use. You could purchase a spare sieve and retain it for future projects.

the gallery

1	3	5	7
2	4	6	8

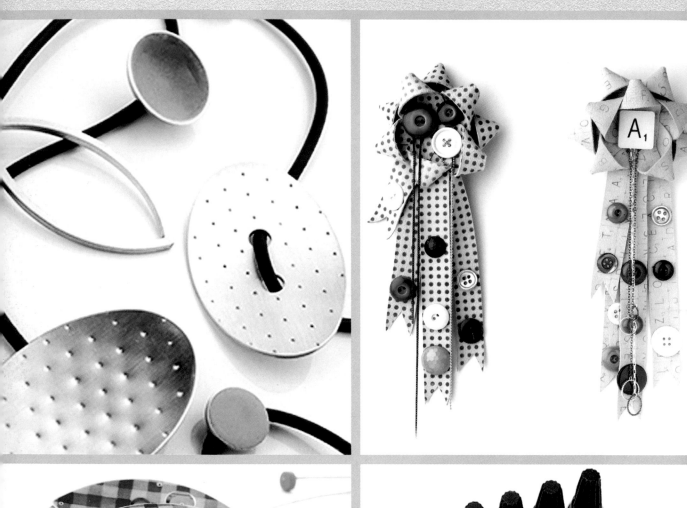

1 **Necklace**, Gilly Langton. Silver, elastic, enamel. 60 cm x 5 cm. 2006. English, lives and works in Scotland.

2 **Spinning Propeller Pendants**, Lindsey Mann. Printed anodised aluminium, precious white metal, found plastics. 6 cm x 3 cm x 5 cm. 2004. England.

3 **Imprint – Suede Rosettes**, Anna Lewis. Suede, silver, vintage buttons, scrabble piece. 20 cm. 2005. Wales.

4 **Continuum – Brooch**, Katja Prins. Silver, sealing wax. 8.5 cm x 6.1 cm x 3.1 cm. 2007. The Netherlands. Courtesy of Rob Koudijs Galerie.

5 **White Tea Bangle**, Claire Lowe. Resin, tea leaves. 10 cm x 2 cm x 2 cm approx. 2005. England.

6 **Entropus Atropos – Brooch**, Mark Rooker. Stirling silver, 14 ct yellow gold, buttons, threads, yellow brass. 5 cm x 5 cm x 5 cm. 2006. USA.

7 **Flora – Neckpiece**, Cynthia Toops and Daniel Adams. Polymer clay (Toops), glass (Adams), silver (Toops and Adams). 51 cm long, each bead approx. 3.2 cm diameter. 2007. USA.

8 **Vertical Ring Ball**, Marco Minelli. Buttons, mixed media. Various sizes. 2007. Italy.

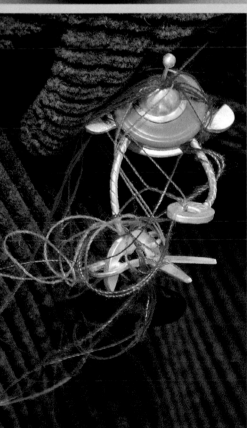

12. polypropylene & stitched button bangle

MAKER RATING
intermediate/advanced

WHAT YOU WILL NEED

MATERIALS

▸ two A4 sheets of polypropylene
(one blue and one green)

▸ a tape measure, double-sided
with centimetres and inches

▸ 10 cm x 10 cm (3.9 x 3.9 in.) piece
of calico

▸ black embroidery silk

▸ three 19 mm (0.7 in.) cover buttons

TOOLS AND OBJECTS

▸ vellum adhesive spray
▸ sewing needle
▸ steel ruler and scalpel
▸ cutting mat
▸ felt tip pen
▸ HB pencil
▸ scissors
▸ scrap paper

VARIATION

You can use other items for
inside the polypropylene.
Maybe you could try using a
page from an A-Z map book.

This project explores the layering of materials and contrasts plastic with a soft textile surface. There are many possible design variations for this bangle which perhaps you will investigate for yourself.

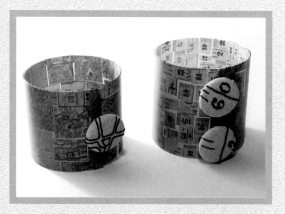

HEALTH & SAFETY

Use vellum adhesive spray in a well-ventilated area and always read the instructions.

Be careful when using a scalpel and steel ruler. Always keep your fingers out of the way.

It may be fiddly piercing the polypropylene with a sewing needle, so be aware of where your fingers are placed.

STEP 1 Take the blue sheet of polypropylene and cut out a long rectangle measuring 6 cm x 25 cm (2 in. x 10 in.). Plan out the measurements with a water-soluble felt tip pen, which will wipe away afterwards. Cut out with a scalpel and steel ruler.

STEP 2 Repeat with the green polypropylene. You will have two pieces measuring the same.

STEP 3 Next, take the tape measure and, using the scissors, snip out 1 cm (0.4 in.) pieces using the measurements as a guide. You can cut up more if needed, so to start with cut out 50 cm (19.6 in.) worth of tape.

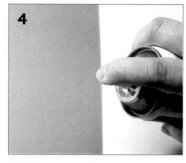

STEP 4 Spray the surface of the blue polypropylene with vellum adhesive spray, making sure you protect the work surface with scrap paper.

STEP 5 Transfer the polypropylene to a clean piece of scrap paper and mosaic all the pieces of tape measure together. Don't keep the numbers in sequence, mix them up and have some facing you and some the other way, so that you have a mix of centimetres and inches. This works especially well if you can find a tape measure with one yellow side and one white side.

STEP 6 Continue to mosaic the whole section, until the whole surface is filled. If you have any gaps you can snip smaller pieces of the tape measure to size. If the vellum adhesive spray dries out you can always spray on more. It depends how quickly you work. The pieces can be repositioned for a while so you don't need to rush this process.

STEP 7 Leave the surface to dry and then cover the green sheet of polypropylene with adhesive spray and stick to the other piece, trapping the tape measure inside. Leave this to dry.

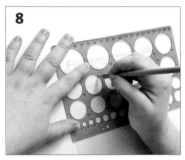

STEP 8 While you are waiting for the polypropylene to dry, you can make the buttons. Take the calico and draw three circles, either free hand with a pair of compasses, or a stencil. Make sure the circles measure 25 mm (1 in.) across. Use an HB pencil for this.

STEP 9 Now look at the tape measure pattern under the polypropylene and select three small details. Draw these inside the three circles with the pencil, making sure the drawing continues a little outside the circle.

STEP 10 Take your black embroidery silk and, using three strands, stitch over the pencil drawing using a back stitch. This is where you run the stitch back on itself to make a continuous line.

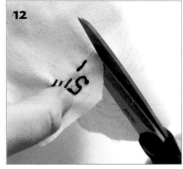

STEP 11 You can also add other types of stitches. I have included French knots on the 'number five'. A French knot is achieved by winding the thread around the needle three times and then carefully stitching back whilst holding the thread taut. I have also included a slipped stitch where I have stitched in and out of the back stitches. The amount of detail and types of stitching is up to you. You might prefer to use old pieces of lace, or vintage fabric, instead of stitching them yourself.

STEP 12 Cut out the circles and make sure that you leave 10 mm (0.4 in.) surplus material around the outside line.

VARIATION You can purchase cover buttons in a variety of sizes. You could use two medium sized buttons or one large. You might also try changing the width of the bangle too.

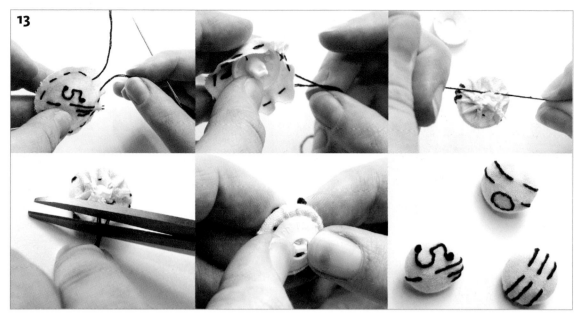

STEP 13 Take three strands of embroidery silk and stitch in and out around the edge of the circle. You should now be able to place the fabric around the cover button and pull the ends of the embroidery silk to shape around the button. There are also usually instructions for cover buttons in the form of a diagram when you purchase a set of them.

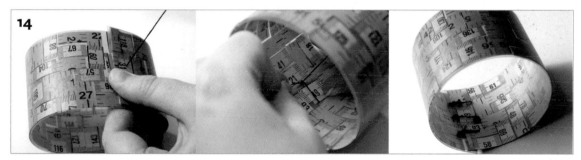

STEP 14 Next you need to assemble the bracelet. Start by folding the polypropylene into a bangle shape. Next take another three strands of the embroidery silk and tack the bangle into place with an overhang of 1 cm (0.4 in.). Stitch the back to the front and knot into place at the back. Repeat this stitch another two times so that you have three evenly spaced, with about 15 mm (0.6 in.) between them.

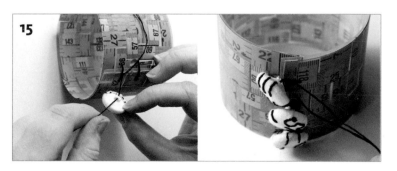

STEP 15 Stitch the three buttons onto the existing stitches and secure in place with two or three knots. Then trim away the extra threads.

the gallery

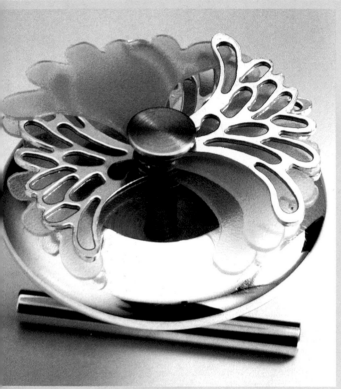

1 **Kinetic Ring**, Shelby Fitzpatrick. Silver, 18 ct gold, polypropylene. 4 cm x 4 cm x 4 cm. 2001. American, lives and works in England.

2 **Ring**, Ermelinda Magro. Polyurethane, paint, thread, resin, silver. 3 cm x 4 cm. 2005. Switzerland.

3 **Black and Red Coral Necklace**, Sarah Keay. Antique coral, enamelled wire, silver monofilament, enamel. Various sizes (detail). 2006. Scotland.

4 **Brooch: 334**, Fabrizio Tridenti. Recycled plastic, steel wire, electric wire, moplen, correction fluid. 12 cm x 6 cm x 1.5 cm. 2007. Italy.

5 **Growth Series – Brooch**, Natalya Pinchuk. Wool, copper, enamel, plastic, waxed thread, stainless steel. 10 cm x 6 cm x 6 cm. 2006. Russian, lives and works in the USA.

6 **Bangle**, Gill Forsbrook. Polypropylene sheet, PVC sheet, silver. 13 cm x 11 cm x 10 cm approx. 2005. England.

7 **Polypropylene Bangles**, Rachel McKnight. Polypropylene, silver. 12 cm x 12 cm x 2 cm. 2005. Northern Ireland.

8 **Lime Green Scatter Brooch**, Jo Pudelko. Oxidised silver, acrylic, agate. 6.5 cm x 8 cm x 1.5 cm. 2007. Canadian/British, based in Scotland.

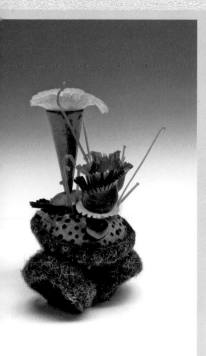

13. popper & thread earrings

MAKER RATING
beginner

WHAT YOU WILL NEED
MATERIALS
- ▶ 12 black 9 mm (0.35 in.) dressmaking snap fasteners
- ▶ two 6 cm (2 in.) lengths of 2 mm (0.08 in.) silver belcher chain
- ▶ blue embroidery silk
- ▶ two silver bead and ring earring fixings and scrolls

TOOLS AND OBJECTS
- ▶ sewing needle
- ▶ flat pliers
- ▶ scissors
- ▶ oxidising solution
- ▶ cleaning pickle
- ▶ water and washing liquid

VARIATION
You could try designing different objects with the snap fasteners, for example, a continuous length for a bracelet or necklace.

These articulated drop earrings utilise snap fasteners, an object commonly used in dressmaking. The snap function is removed from the object and used in multiples to disguise the origins of the material. Oxidised silver elements blend with the popper to work as a fluid piece of jewellery.

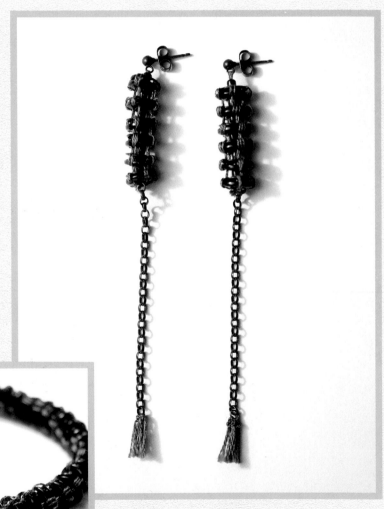

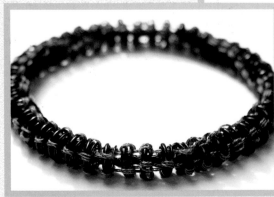

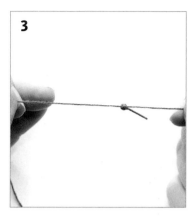

STEP 1 Take the silver bead and ring earring fixings, scrolls and lengths of belcher chain. Clean in safety pickle, following the instructions in the *Basic jewellery techniques* chapter.

STEP 2 Oxidise the above items, again using the instructions in the *Basic jewellery techniques* chapter.

STEP 3 Take a 50 cm (19.6 in.) length of the embroidery silk (three strands) and tie onto the silver bead and ring earring fixing. Both lengths should be equal. Use the flat pliers at this stage if you need to even out the ring so the ends lie together.

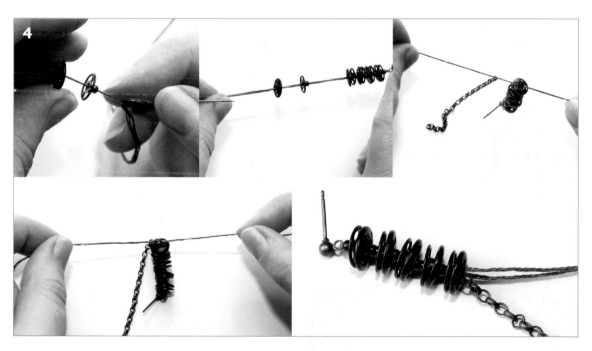

STEP 4 Put the six strands of embroidery silk on the sewing needle and thread on six sets of poppers back to back, starting with the back popper. Once the six sets are pushed up to the earring fixing, tie the belcher chain onto the end with a single knot.

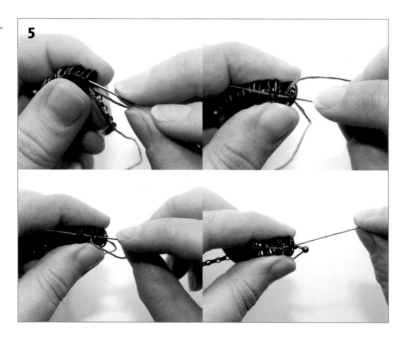

STEP 5 Take three strands of the embroidery silk and pass through the first set of poppers. Then stitch through the first set again. Pass the thread through the next set and back through, as before, until you have stitched along all six sets.

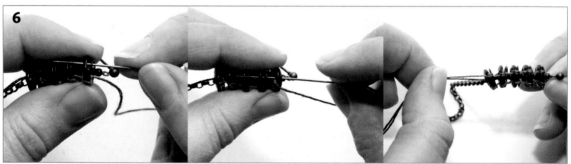

STEP 6 Pass the embroidery silk into the next piercing and stitch back down in the same fashion as before, passing the thread out of the piercing that holds the chain.

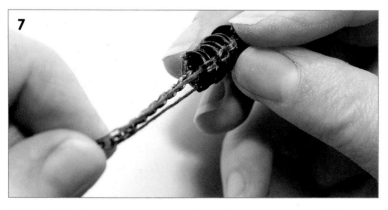

STEP 7 Take the other three strands and repeat steps 5 and 6 so that you have both threads together again.

HEALTH & SAFETY

Remember to follow the health and safety instructions for safety pickle and oxidising solutions. You should read and follow the instructions when you purchase any new product as the instructions may vary with different brands.

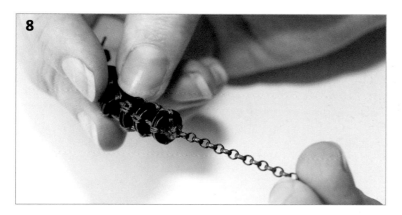

STEP 8 Pass the strands through the chain in the centre. Knot the two lengths together three times securely. Cut the ends so that you have a few millimetres that won't unravel.

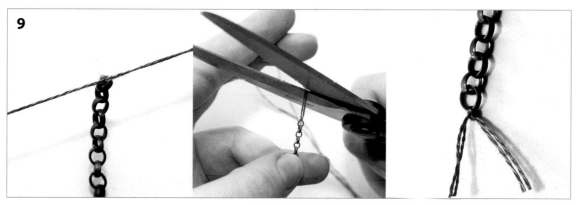

STEP 9 Take a 30 cm (11.8 in.) length of embroidery silk, two strands thick, and thread onto a sewing needle. Pass through the last link of the belcher chain and tie three times. Cut the ends so you are left with a 1 cm (0.4 in.) tuft.

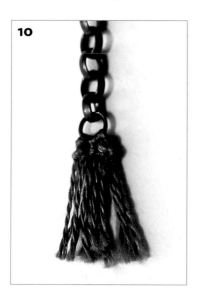

STEP 10 Repeat step 9 twice using the rest of the embroidery silk. You will have three tufts tied to the end of the chain. Check that the tufts are the same length and trim if necessary.

TIP

You might try using a mixture of snap fastener sizes, possibly of graduating length. Different chain types will give different effects and a shiny or satin finish on the silver elements could give a contrast against the snap fasteners.

the gallery

1		3	5		7
2		4	6		8

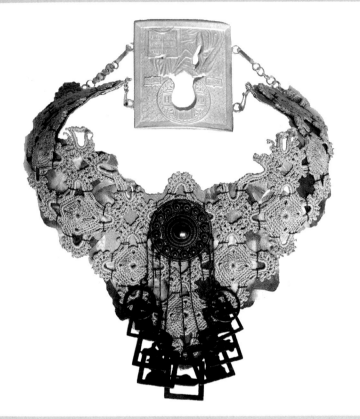

1 **Collar**, Machteld Van Joolingen. Felt, cotton, transfer print, Turkish needlework, silver. 2003. Netherlands.

2 **Silver and green silk pendant**, Deepa Taylor. Silver, green silk. 6 cm x 5 cm approx. 2007. England.

3 **Leaf Fairytale Earrings**, Alison Macleod. Silver, aventurine, bra bits, antique mother of pearl button. 8cm long approx. 2005. Scotland.

4 **Pendant**, Sonia Morel. Silver, polyester thread. 8 cm height. 2004. France.

5 **Loin Du Train Train Quotidien**, Juliette Megginson. Steel, gold, wool, cotton, silk. 8 cm x 5 cm. 2007. French, lives and works in England.

6 **Identity Tags**, Åsa Lockner. Silver, silk. 2 cm x 31 cm x 0.2 cm. 2007. Sweden.

7 **Converge – Necklace**, Adele Kime. Silver, textiles. 5 cm x 5 cm x 2 cm. 2006. England.

8 **Pure Gold – Brooch**, Sebastian Buescher. Stone, crystal, fossil, lead, safety pin. 5.5 cm x 3 cm x 2.8 cm. 2007. German, lives and works in England. Courtesy of Rob Koudijs Gallery.

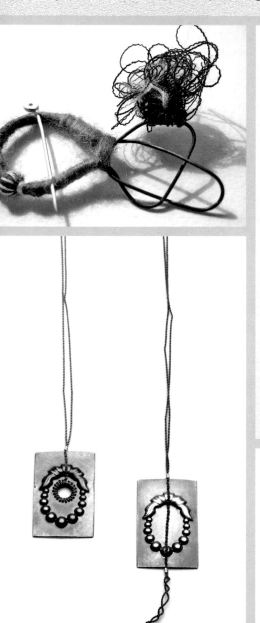

14. wood & willow pendant

MAKER RATING
beginner/intermediate

WHAT YOU WILL NEED
MATERIALS
▸ willow approx. 8 mm thick
▸ a piece of balsa wood measuring approx. 11 cm x 6 cm x 0.5 cm (4 x 2 x 0.19 in.)
▸ white emulsion paint
▸ natural hemp yarn
▸ black cotton thread

TOOLS AND OBJECTS
▸ jeweller's saw and blade
▸ pencil sharpener
▸ sewing needle
▸ 4 mm (0.15 in.) crochet hook
▸ HB pencil
▸ hand torch and heat mats
▸ sandpaper or sanding block
▸ flat file
▸ round file
▸ hand drill and 5 mm drill bit
▸ wooden block and sticky tape
▸ wood glue
▸ pair of compasses or round object

This natural materials pendant combines a variety of elements, carefully amalgamated to achieve a piece that marries together subtle colours and a variety of natural textures.

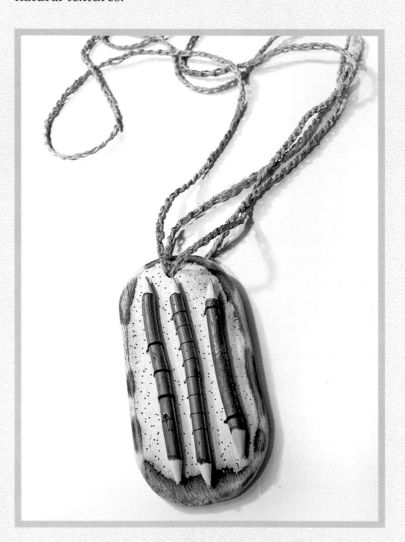

VARIATION
The scale of the balsa wood and willow can change the design dramatically, as can introducing a coloured emulsion paint or coloured yarn.

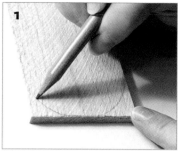

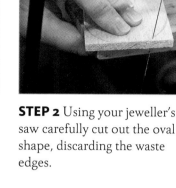

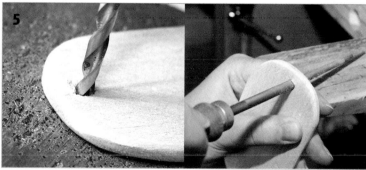

STEP 1 Take your piece of balsa wood and draw an oval shape using the majority of the surface. You can draw this freehand as I have, so it gives the appearance of a natural form, like a piece of driftwood. Or if you prefer each edge to be exactly the same, you could use a pair of compasses or a round object as a guide.

STEP 2 Using your jeweller's saw carefully cut out the oval shape, discarding the waste edges.

STEP 3 File the edges with your flat file to give a rounded look. Then smooth the edges with sandpaper or a sanding block until you are happy with the finish. Remember to work on both the front and back edges.

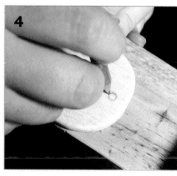

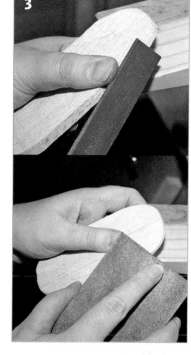

STEP 4 Mark a hole with your pencil 1 cm (0.4 in.) from the top of the balsa wood in the middle, on the shortest side.

STEP 5 Hold it in place on a wooden block with sticky tape and then drill a 5 mm (0.19 in.) hole through the marked point. The drill will pass easily through the balsa wood as it is very soft. Finish the hole by smoothing with a round file and sandpaper.

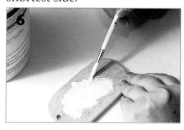

STEP 6 Paint one surface of the balsa wood and leave to dry. Then turn over and paint the other side, making sure the edges are also painted.

VARIATION

The pitted texture, shown on page 111, does not have to be random. You might draw a line of dots or concentrate the pitted surface to one area.

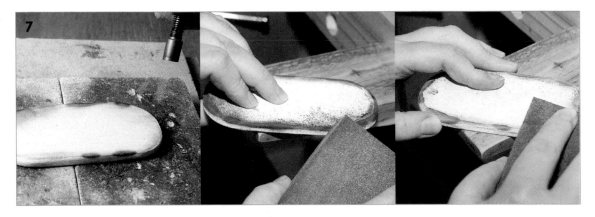

STEP 7 Once dry, take your hand torch and, with a gentle flame, pass around the edge of the surface of the wood until it is singed. Finish the surface by taking off the singed layer around the edge with sandpaper or sanding block to reveal the balsa wood underneath.

HEALTH & SAFETY

When burning the edge of the wood, make sure you only singe it. It does not have to catch alight. As a precaution, make sure you have water available in case of fire.

VARIATION

Try making a variation of this pendant, individual to your own taste. As well as designing your own pendant on paper with pencil or pen, you might try designing with a series of test pieces to experiment with the techniques. Very often, new ideas emerge from experimentation. As the materials are fairly inexpensive, you can experiment extensively and really push alternative ideas.

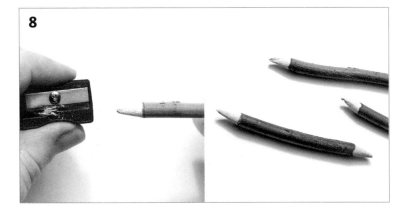

STEP 8 Next, take your willow and saw three pieces measuring between 7–9 cm (2.8–3.5 in.) in length. Sharpen each end with a pencil sharpener in exactly the same way you would sharpen a pencil.

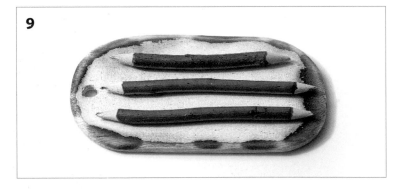

STEP 9 Arrange the willow onto the surface of the balsa wood. Play around with the configuration until you are pleased with the layout, then glue to the surface with wood glue and leave to dry.

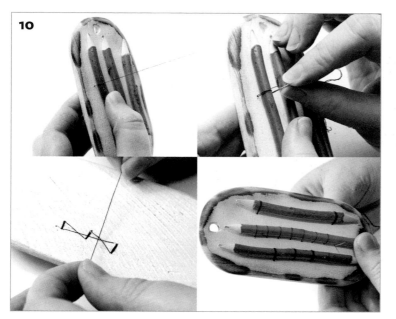

STEP 10 Stitch the willow onto the balsa wood using the black cotton. The wood glue will hold the willow in place but it will have the appearance of being held in place with stitching. Think about designing your own stitching pattern. It could be evenly spaced or different for each piece of willow. Stitch some with one strand and some with multiple strands. You can see clearly where I have added single or multiple stitches.

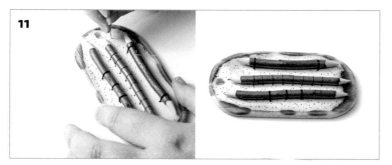

STEP 11 Take your sewing needle and randomly prick the surface of the balsa wood to give a pitted texture. Be careful just to prick about halfway into the wood so that the wood does not split apart.

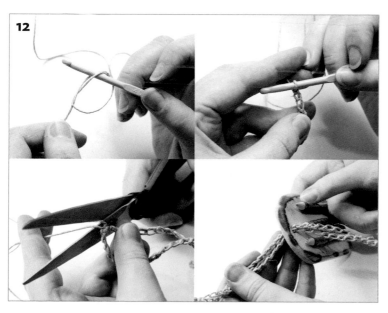

STEP 12 Finally make the natural hemp chain by chain stitching the yarn with a 4 mm (0.15 in.) crochet hook until it measures 200 cm (78.5 in.) in length. (If you are not familiar with the technique you can look at the images in the Image transfer brooch project, page 114). Knot one end to the other, making a continuous chain. Lastly, feed the chain through the piercing at the top of the balsa wood until it is half way through and an even length when being worn.

the gallery

1	3	6	
	4		8
2	5	7	

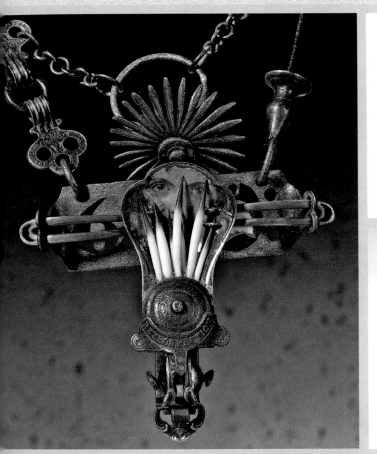

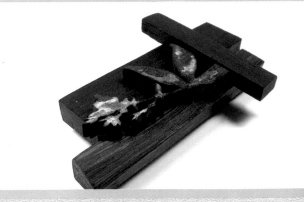

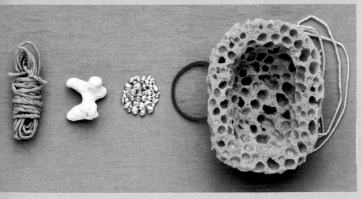

1 **Retrospection – Neckpiece**, Keith Lo Bue. Steel animal leg trap, medieval spur, Victorian spoon and fork, porcupine quills, Roman horse boss, dichroic marble, copper, Victorian keys and brass door latch, bronze artefacts, steel wire, brass, chandelier crystal, steel-point engravings, leather, soil. 13 cm x 11 cm x 3 cm, chain 95 cm. 2007. USA.

2 **Neckpiece**, Iris Bodemer. Gold, coral, serpentine, sponge, string, textile. 19 cm x 19 cm x 3 cm. 2004. Germany.

3 **Rosario di Carbone – Necklace**, Alessia Semeraro. Burnt wood, 24 ct gold, iron, cotton. Various sizes. 2006. Italy.

4 **ERIKA 05 – Necklace**, Stefanie Klemp. Apple wood, plastic, thread. 97 cm x 2.5 cm. 2005. Germany.

5 **Double Cross – Brooch**, Francis Willemstijn. English bog oak, silver, paper. 10 cm x 6 cm x 3 cm, 2006. The Netherlands.

6 **In the Shade of the Tree – Brooch**, Mari Ishikawa. Plant cast and forged, silver. 6 cm x 4.5 cm x 2.5 cm, 2006. Japanese, based in Germany.

7 **Oval Bonsai – Brooch**, Terhi Tolvanen. Silver, pear wood, felt, textile, ceramics, ceramic made in EKWC. Height 10 cm. 2007. Finnish, lives and works in the Netherlands.

8 **Duality – Brooch**, Robin Kranitzky and Kim Overstreet. Wood veneer, copper, Micarta, brass, acrylic, silver, balsa, postcard fragments and found objects. 11.4 cm x 7 cm x 3.2 cm. 1995. USA.

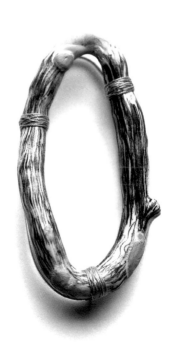

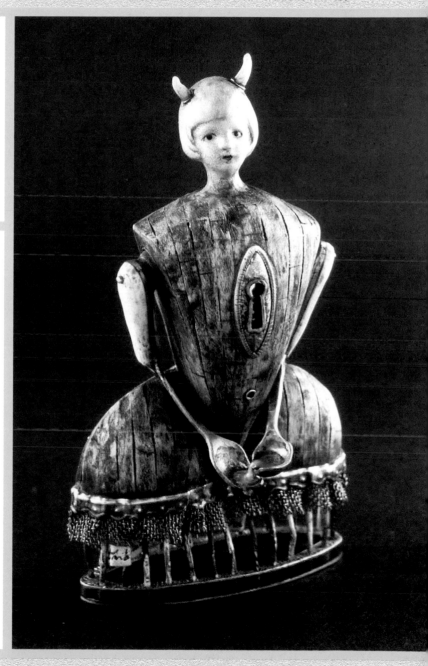

15. image transfer brooch

This chapter will show you how to make a tactile brooch using a wide range of materials and techniques. You can make this piece of jewellery unique by using your own photography, drawings or collages.

MAKER RATING
intermediate

WHAT YOU WILL NEED
MATERIALS
- 6 mm (0.2 in.) diameter disc of wood
- wood priming paint (white)
- image printed from a computer onto standard photocopier paper
- blue wool (2 ply)
- a safety pin
- black merino felt
- acrylic gel medium
- black embroidery silk
- soap flakes
- finishing wax

TOOLS AND OBJECTS
- 2 mm (0.08 in.) crochet hook
- sewing needle
- a bowl
- a spoon or printing roller
- paper towels

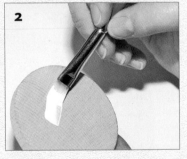

STEP 1 Take a disc of wood purchased from a craft shop. For my example I am using a disc that is 6 cm (2 in.) in diameter and 0.7 cm (0.28 in.) thick. If you can't find this item, it would be quite simple to cut one yourself or ask your local hardware store to do it for you.

STEP 2 Prime the surface with an all-in-one wood primer. Ensuring the surface is smooth, paint according to the instructions on the tin. The edge of the disc must be painted, but the back can be left plain.

STEP 3 Print out a photograph or image. The image can be anything you like. My image is a photograph I took at Monks House, where Virginia Woolf lived. Remember you will be using a 6 cm (2 in.) circle, so you might like to enlarge or reduce the image size accordingly.

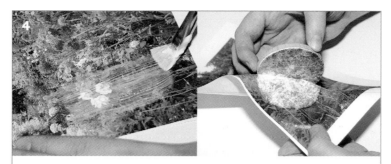

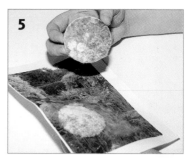

STEP 4 Paint the surface of the image with acrylic gel medium. A smooth thin layer is needed to enable you to print a clear image. While the surface is still wet stick the wooden disc, primer side down, onto the area of image you want to print. Rub and press the paper onto the wood using your fingers and the back of a spoon or printing roller. After rubbing the image for approximately one minute, peel back the paper and your image will be transferred onto the wood. Peel back a small piece at first to make sure it has worked. If the image is still on the paper then you need to continue the rubbing process.

STEP 5 Leave the image to dry for two hours. At this stage there will be surplus paper fixed to the image, so you will not see the image clearly yet.

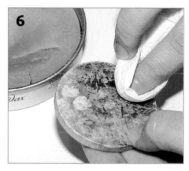

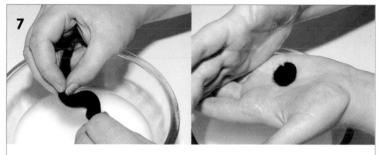

STEP 6 Take a piece of paper towel and apply a small amount of finishing wax. Rub gently into the surface. This will remove the surplus paper, revealing your image. Leave the wax to dry and then rub back. Repeat this process with a clean piece of paper towel another two or three times until your image becomes crisper. The wax will also protect the image. Don't rub too hard or you will rub your image away.

STEP 7 To make the felt balls that surround the image, fill a bowl with hot tap water and add a sprinkling of soap flakes. The soap flakes should dissolve in the hot water, but you can stir the water to speed this up. Take a small piece of black merino felt and dip it in the water until saturated. Roll the wool in the palm of your hand, dipping it into the water to re-saturate when needed. Keep rolling the felt in the palm of your hands and the fibres will lock together creating a ball. You can add pieces of felt to the ball as you go to make it bigger if needed.

STEP 8 Rinse each felt ball and squeeze out any excess water. Each ball should measure between 1 cm (0.4 in.) and 1.5 cm (0.6 in.). You should make eleven, although you can vary the number and make a smaller amount of larger balls, or a larger group of smaller balls, depending on your design. Place all eleven felt balls in a washing machine on a quick wash programme, adding another sprinkling of soap flakes. This helps the felt fibres pull together even more and become smaller and more compact.

9

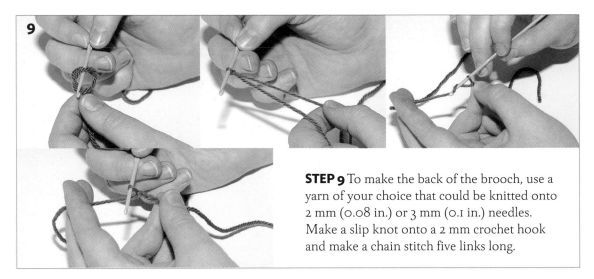

STEP 9 To make the back of the brooch, use a yarn of your choice that could be knitted onto 2 mm (0.08 in.) or 3 mm (0.1 in.) needles. Make a slip knot onto a 2 mm crochet hook and make a chain stitch five links long.

10

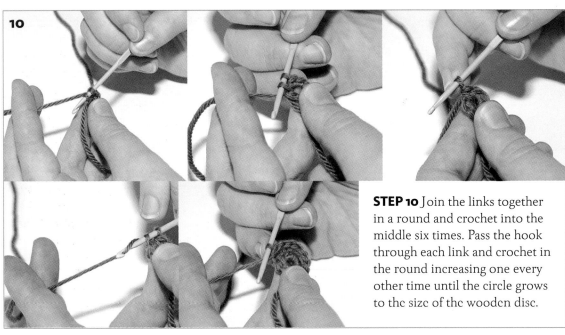

STEP 10 Join the links together in a round and crochet into the middle six times. Pass the hook through each link and crochet in the round increasing one every other time until the circle grows to the size of the wooden disc.

11

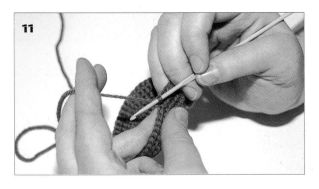

STEP 11 Once you reach the required size, decrease every other stitch until the crochet fixes around the wooden disc. Check the wooden disc regularly when decreasing to make sure you are not making the crocheted part too small. Depending on your own tension, you might need to decrease more or less times to get it just right.

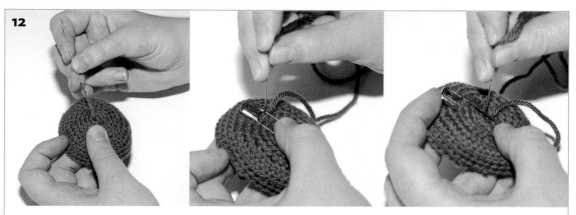

STEP 12 Cast off once you have finished and cut the yarn leaving 40 cm (15.5 in.) of excess. Take a sewing needle and pass the yarn through the crochet until you reach the hole in the middle. Pass the yarn through and stitch the safety pin into place by tacking it onto the crochet in a central position using the hole as a guide.

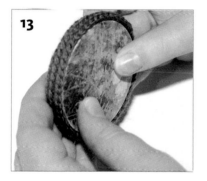

STEP 13 Check that the crochet backing still fits around the wooden disc. Paint a thin layer of fabric glue onto the back of the wooden disc, being careful not to get any glue on the visible surface. Now put the fabric over the wooden disc and leave to dry.

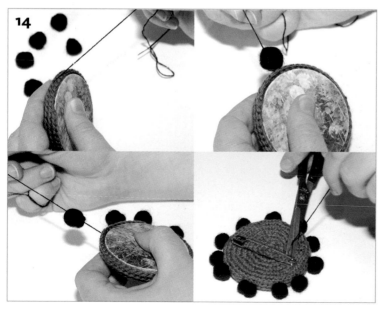

STEP 14 Now stitch the balls into place with a thread of the same colour as the felt. I used three strands of embroidery silk. Run the thread with a sewing needle through the crocheted surface at the back and thread it through to the top of your image in order to fix the first felt ball. Stitch the felt ball by stringing it into place like a bead and then stitch back into the crocheted surface a few more times until it feels secure. Pass the thread under the surface of the crochet and re-emerge 1 cm along. Fix the next felt ball in the same way. Keep going until you have fixed all the felt balls into place. If you are not sure about spacing, set them out around the wooden disc before you begin stitching to ensure you like the arrangement. Finally, stitch the thread in and out of the crochet to make sure it is fixed well and cut off any loose threads.

the gallery

	4		
1	5	6	7
2	3		8

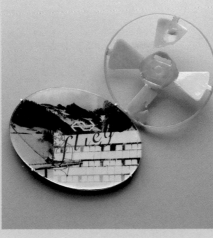

1 **Growth Series – Brooch**, Natalya Pinchuk. Wool, copper, enamel, plastic, waxed thread, stainless steel. 6 cm x 9 cm x 8 cm. 2006. Russian, lives and works in the USA.

2 **Brooch**, Lisa Walker. Ceramic, gold, wood, glue, silver, lacquer. 6.5 cm diameter, 3.5 cm high. 2006. New Zealander, lives and works in Germany.

3 **Try Flying – Brooch**, Jantje Fleischhut. Gold, print, epoxy, plastic, varnish. 10 x 5 cm x 5 cm. 2007. The Netherlands. Courtesy of Galerie Rob Koudijs.

4 **Fragments – Brooch**, Cilmara de Oliveira. Silver, wood, citrine, lace. 7.5 cm x 4.5 cm x 3 cm. 2006. Brazilian, lives and works in Germany.

5 **Poetry – Neckpiece**, Paula Lindblom. Plastic can, porcelain figure, glass beads, nylon thread, book mark. Various sizes. 2007. Sweden.

6 **Necklace**, Ermelinda Magro. Polyurethane, paint, photo taken by maker, resin, silver. 20 cm x 30 cm. 2005. Switzerland.

7 **Violet**, Antje Illner. Cast optical glass, linen. 3 cm x 6 cm x 3 cm. 2007. German, lives and works in England.

8 **I Give You My Heart – Brooch**, Nicolas Estrada. Silver, glass, photographic paper, illustration by Catalina Estrada. 4 cm x 4 cm x 0.7 cm. 2007. Columbian, lives and works in Barcelona.

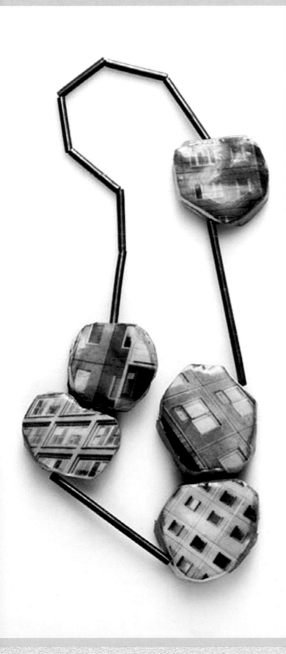

17. meet the makers

This chapter introduces you to some of the makers whose work is shown in the gallery pages. These Jewellers give you a generous insight into how they work, where their ideas originate and what shapes their art, presenting you with a unique perspective into the world of mixed-media jewellery. The overriding factor is how passionate each maker is about their work. Reading about the makers and seeing examples of their drawings, designs and works in progress, will no doubt awaken your own creativity.

alessia semeraro

Where did you train to be a jeweller? Did you enjoy your time learning to be a maker? I began to study jewellery in my thirties after several years as a communication graphic designer in business consultancy. Mine was a mature choice of life change. Starting to study again together with students at least ten years younger was challenging and exciting at the same time, like being born again. The selection of schools was made on the basis of the direction my life took at that time. My training began with a BA course at the London Guildhall University, then I moved to Florence and attended courses at Alchimia.

Have you always used the materials you use now in your work, or has there been a varied path to get to where you are now? Since the beginning of my profession, all the materials I used, and still use, have in common the concept of pureness. This is why I have always experimented with materials that are found in nature.

Do you think the country that you work in has any bearing on your work? Having travelled and lived in different countries and situations, I have noticed that there is influence in terms of climate, spaces, light and colours, surrounding culture, and people to connect with, in the art, the design and the making too. During the first stages of development of my work as it stands now, I was living in the North East of Italy. Living in this flat, rainy countryside, of a rural and rough nature and people, surely influenced my work and the use of basic materials.

How would you define the term 'mixed media jewellery'? I do not consider mixed media another kind of jewellery. I rather see it as a definition based on different particular techniques. Clearly, mixed media jewellery goes beyond traditional formats: traditional jewellery is made by using ancient and well known techniques, whereas mixed media jewellery needs experimentation and creative skills on behalf of the maker, who is the real artist and unique inventor of 'that' mixed media jewel.

Seeing where a maker works is always intriguing. Can you describe the space in which your work is made? My workshop is a small room with a wood floor, in the first floor of my nineteenth century country house where I stay in Italy. I have everything I need in the same room; books, computer and tools. Here I design and make the pieces. I work on a traditional Italian workbench, and draw and study on a white Ikea table. The white old walls are a canvas for my drawings, samples, found objects and memories.

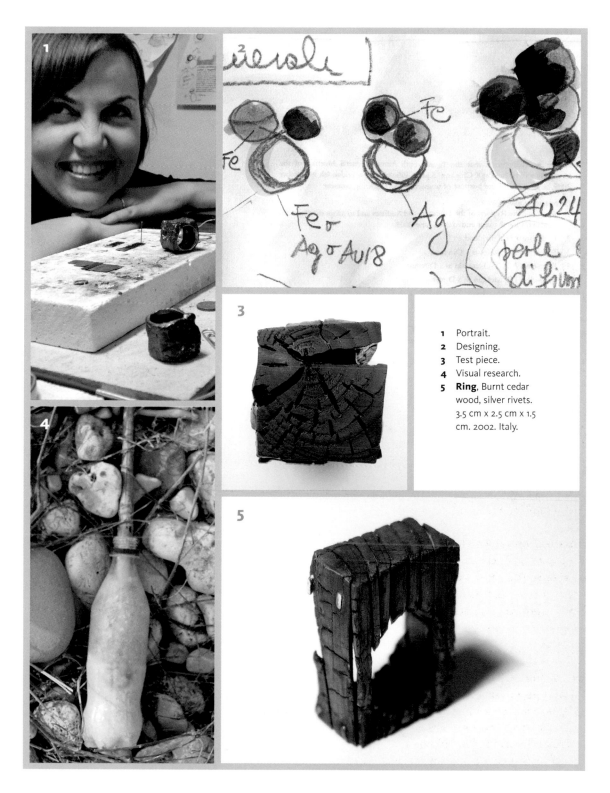

1 Portrait.
2 Designing.
3 Test piece.
4 Visual research.
5 **Ring**, Burnt cedar wood, silver rivets. 3.5 cm x 2.5 cm x 1.5 cm. 2002. Italy.

dionea rocha watt

How would you define the term 'mixed media jewellery'? Jewellery that does not make exclusive use of precious metals and stones and allows the maker to cross the threshold of 'preciousness'. I find it interesting to mix precious and non-precious materials to highlight this tension.

When you were learning to design and make jewellery, were there any makers who were influential to your development? Ramon Puig Cuyàs, who teaches at the Escola Massana in Barcelona. I did an exchange there and found his teaching truly inspiring. He encourages the students to develop a personal language and to experiment with different processes and materials. I suppose I've learned to allow myself to work in a more intuitive way.

When mixed media is used in jewellery, there are an infinite number of possibilities and outcomes. Why do you use mixed media in your work? Different materials have different physical and symbolic qualities. For me the idea comes before the material. However, the material can also inform the development of the piece if you are receptive to what it is saying to you.

How do you physically design? Do you use sketchbooks and create test pieces? I sometimes use sketchbooks and sometimes make models straight away or even work with the final materials. I also think it is important to be open and collect inspiring visual and literary material; so that the 'sketching' can also happen in the mind. This 'sketching in the mind' for me is like keeping a visual journal that does not exist as a single entity, but is a collection of thoughts and images that become interwoven because connections happen all the time. It is like daydreaming with a purpose; that of finding how to materialise ideas and 'seeing' possibilities. The difficult part for me is to edit this rich source and make decisions. This is where the physicality of sketching or making comes in to help.

Have you always used the materials you use now or has there been a varied path to get to where you are now? No, I chose these materials as a way of expressing certain concerns that were particular to that time in my life. For instance, how could I represent the fragility of life and the contrast between permanence and transience? In the case of hair, there is the perspective of both history and experience. The historical examples of its use in mourning jewellery helped to inform the work, but the experience of handling the material and understanding it was crucial. By combining hair with other materials, such as lead, a dialogue emerged. This kind of dialogue is something that I hope to achieve in each new piece.

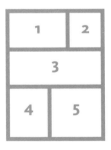

1 Portrait.
2 Sketchbook.
3 Research.
4 Sketchbook.
5 **Loss – Brooch**, Lace, human hair, silver, lead, freshwater pearl. 6.5 cm x 8 cm. 2006. Brazilian, lives and works in England.

ela bauer

When mixed media is used in jewellery, there are an infinite number of possibilities and outcomes. Why do you use mixed media in your work? Mixing media is for me the natural way to work. Even though I enjoyed working in the classical techniques and materials of jewellery, I never had the feeling that jewellery begins or ends there. I suppose that I want my expression to be as direct as possible, not a 'translated into metal' expression, and that is why I use techniques and materials that express or associate with what I want to express in the most direct way.

Do you always know what a final piece will look like when you start it? No, but often I do have a certain form in my head. I learned from experience that an imagined form has a very different expression when actually executed. So I work in a certain direction, towards a certain feeling/thought/form. At the same time, during my working process I am open to discoveries. It happens regularly that while working on 'plan A', I see that a completely unexpected atmosphere/feeling emerges from my work, and so I change my 'goal', and 'plan A' goes on hold, and I work towards a new plan.

Have you always used the materials you use now in your work, or has there been a varied path to get to where you are now? I suppose that every period has its 'perfect' medium; a material that dominates the picture in my work. Even though I always combine all sorts of materials, there was a period that latex rubber meant everything to me. I guess it expressed perfectly my ideas at that time. I experimented a lot with all sorts of rubbers and plastics, and at the moment I often use a silicone rubber that answers many of my needs.

When you were learning to design and make jewellery were there any makers who were influential to your development? Daniel Kruger and Otto Künzli were always very important jewellery makers for me, very different in their approach, but both very 'pure' and intense. They treat their materials in completely different ways but in both cases material is used both as what it is, and as a metaphor. I was also very influenced by artists from other disciplines: Louise Bourgeois, Anish Kapoor, Matthew Barney, for instance.

Seeing where a maker works is always intriguing. Can you describe the space in which your work is made? My atelier feels great; it gives me the feeling of unlimited possibilities. It's cosy and spacious (surely in jeweller's terms), and has a good temperature (I feel I can't concentrate when it's chilly in a space). On one wall hangs all sorts of pieces of works that I made through the time, and some pictures. They inspire me, and are a kind of a reminder of an aspect that I feel I still didn't handle enough. I also have a collection of objects that are meaningful to me, and books. In my atelier are five big tables which enable me to work on a few projects simultaneously, without having to tidy up. Sometimes it feels a bit chaotic. I have all the necessary equipment and a big arsenal of materials that I gathered throughout the years. It's really a lovely space!

1 Portrait.
2 Drawing.
3 Works in progress.
4 Works in progress.
5 **Brooch**, Silicone rubber, glass beads, thread, gold. 7 cm x 4 cm x 3 cm. 2007. Polish, lives and works in The Netherlands.

francis willemstijn

Where did you train to be a jeweller? Did you enjoy your time learning to be a maker? Around 1996 I went to the academy to be a teacher in arts and crafts. During that period of study I also started a technical evening course in jewellery. Then for a while I shared a workshop with other jewellers in the heart of Amsterdam. But 'something' was missing. I taught for a year and I missed the making, and I wanted to do more jewellery. So in 2001 I went to college again to the Gerrit Rietveld Academie in Amsterdam and there I found what I was searching for.

Who do you think is the most interesting mixed media jeweller working today? Terhi Tolvanen. She can mix wood and porcelain, textile and glass, stones and even sand, to create the most beautiful and strong pieces I have ever seen. The power of these pieces is that they seem that they have always been there, and that there is just no other way that the pieces can exist. Looking closer they are all so perfectly made, like they have been grown that way, like they are made by Mother Nature itself.

Explain your starting point for a new piece of work. Do you begin with perhaps an idea, photograph, museum trip, a material, etc? First I have the idea, the subject for a collection. Then I gather a lot of material that suits the subject. With them I start making and creating. I have loads of materials that will not be used in final pieces, but I guess that is the process. Also, when making, I use photographs and take pieces out of them and work with them on the computer.

Do you always know what a final piece will look like when you start it? Hardly ever. I sometimes make little sketches, but when working I gather piles of unfinished pieces and also photographs of some unfinished pieces. After that I rearrange them. A lot of them never make it as final pieces, and many of them end up differently than I had expected. If I had to make things exactly as planned I think I would lose the joy of making.

Do you think the country that you work in has any bearing on your work? Maybe it's the academy you go to that has the influence. A lot of Dutch work is not made by jewellers that are born here, but by those that went to the Rietveld Academie. In my collection 'Jerephaes' the subject was the Dutch seventeenth century, and in 'Heritage' the traditional clothing in The Netherlands was the subject, so they are both Dutch, and my country was the influence. But with my next collection that will be different.

1		2
3		
4	5	

1 Portrait.
2 Drawing.
3 Works in progress.
4 Works in progress.
5 **Tree of Life – Brooch**,
 Silver, bog oak. 9.5 cm x 5 cm
 x 2.5 cm. 2007.
 The Netherlands

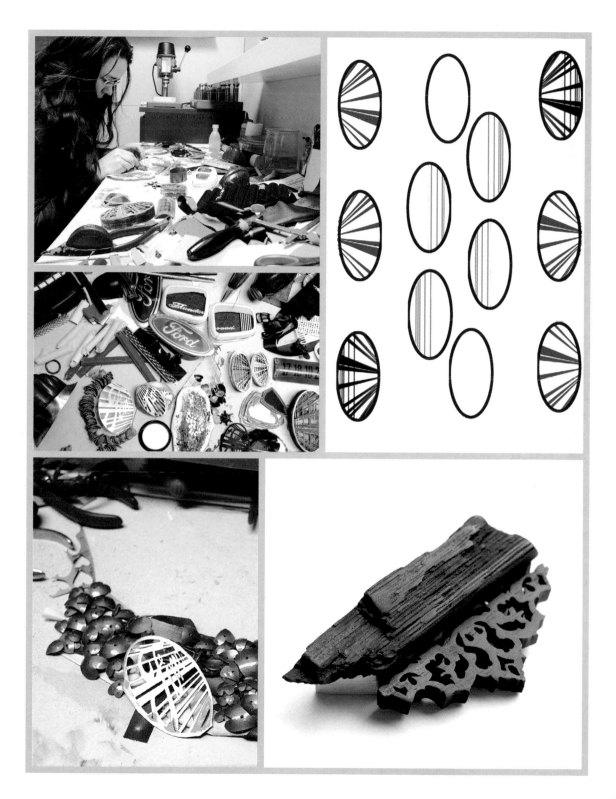

jo pond

Where did you train to be a jeweller? Did you enjoy your time learning to be a maker? I started making at 15. My mother enrolled me on an evening class with Valerie Mead at South Hill Park Arts Centre. After a two-year diploma at Berkshire College of Art & Design, I studied for my BA (Hons) Degree at Loughborough College of Art and Design, graduating in 1990. In 2005 I graduated with an MA distinction in Jewellery, Silversmithing and Related Products, from The School of Jewellery, Birmingham. Learning the traditional skills during my diploma was very rewarding. My Masters degree was my most stimulating year of study, undertaking this training as a mature student enabled me to commit 100% to following my personal enquiry.

When mixed media is used in jewellery, there are an infinite number of possibilities and outcomes. Why do you use mixed media in your work? My passion for old and discarded items stems from my childhood, when I used to go metal detecting with my father. Every find was a treasure, no matter how rusty or insignificant. I am also interested in Wabi Sabi, the Japanese aesthetic of things imperfect, impermanent and incomplete. Incorporating unusual, discarded or seemingly inappropriate items within my work can evoke a sense of nostalgia and generate thought. By incorporating items, which have no monetary value, I am urging the viewer to reconsider their preconceptions.

Do you think the country that you work in has any bearing on your work? I believe so. The found objects I incorporate are predominantly English. I am drawn towards objects my grandparents or my ancestors may have owned or used. Some components I have incorporated were discovered in the Thames, others were 'dug up' by my father in the south of England. Sometimes I use off-cuts discarded by other jewellers. Antique items tell a story and I am particularly drawn to old-fashioned British traditions. I also often incorporate text from well-thumbed, musty English novels.

Do you always know what a final piece will look like when you start it? No. I always draw my initial idea for the final piece when I start my design process and then I put that drawing to one side. I feel it is very necessary to discard the obvious first solution and to move forward. Occasionally a detail from the first solution may come to me later during the design process. However, I will have travelled through many options of composition and form before I allow that detail to be utilised.

Seeing where a maker works is always intriguing. Can you describe the space in which your work is made? I currently work from the spare room in my tiny cottage. I have minimal equipment, a workbench and a large design table. I have the basic hand tools, a polishing motor, a ring stretcher and a blow-torch. I am rather untidy, needing more space to display my many found objects and I have shelves and drawers packed with finds. My walls are covered with sketches, photographs of previous pieces and notes regarding the sizing of certain components. My cat Dotty shares the room, sleeping on the futon behind me.

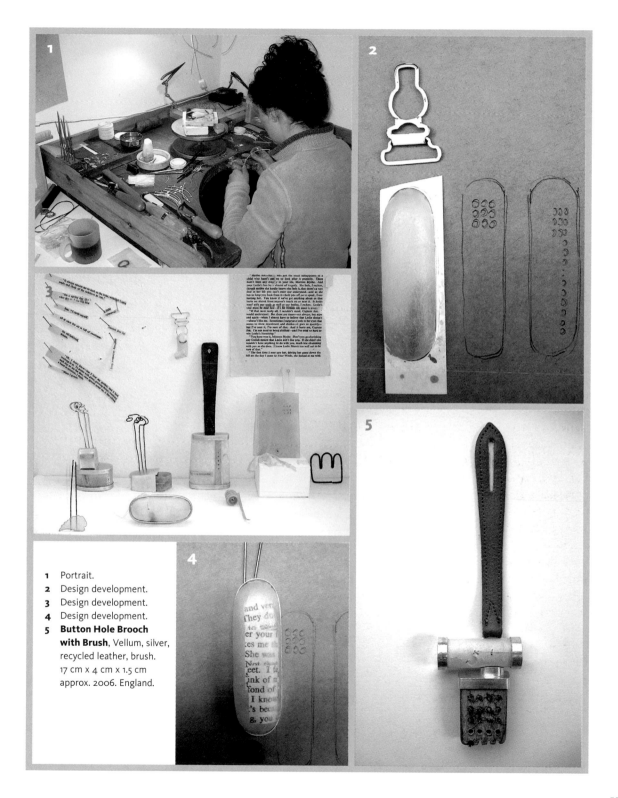

1 Portrait.
2 Design development.
3 Design development.
4 Design development.
5 **Button Hole Brooch with Brush**, Vellum, silver, recycled leather, brush. 17 cm x 4 cm x 1.5 cm approx. 2006. England.

jo pudelko

Where did you train to be a jeweller? Did you enjoy your time learning to be a maker?
I studied at Edinburgh College of Art under Dorothy Hogg and Susan Cross. When I applied to the college my choice was mainly down to geography; I was living in Edinburgh. It was much later that I discovered the esteem that Dorothy and the department are held in. The course was amazing, the tutors have very high expectations but as a student my choices regarding what materials to work in, or processes to use were always encouraged. When I started working in resin and needed some advice, Dorothy arranged for Kaz Robertson to come in to tutor me for an afternoon. I loved my time at college. I'd happily do it all again.

When you were learning to design and make jewellery, were there any makers who were influential to your development? A summer school class with Anna Gordon was a real light-bulb moment for me as previously I had been working in retail management. I quit my job soon after that class and applied to Art College. Obviously Dorothy Hogg and Susan Cross as my main tutors at college had a huge influence on my development, as did my peer group. We were a very close year group, there were only eleven of us and we are all still in constant contact with one another. I can always rely on them for an honest opinion, advice and a cup of coffee when I need it.

What is the most enjoyable part of your job as a maker? I really enjoy the opportunity to talk to people about the work I make. People are often unsure what materials I have used in a piece and I love explaining about the reclaimed/recycled aspects of my work. After working for many years in retail management I know that I'm also really lucky to be doing something now that I love.

What is the least enjoyable part of your job as a maker? I'd love to spend more time at my bench making but being a recent graduate I'm finding that in addition to being a jeweller, I'm a photographer, sales person, and book keeper.

Do you think the country that you work in has any bearing on your work? Definitely, the contemporary jewellery scene in the UK is diverse and vibrant. Edinburgh, where I live and work, has seen a huge increase in galleries and shops that are stocking interesting contemporary jewellery from Scottish makers. Edinburgh also affords me the feeling that I am part of a community of makers; it's small enough to be friendly and intimate but offers all the culture and opportunities of a much bigger city. I moved to Edinburgh from Canada ten years ago and Edinburgh's architecture, atmosphere and history are still a constant source of inspiration.

1 Portrait.
2 Sketchbook.
3 Sketchbook.
4 Sketchbook.
5 **The Devil Loves Dust – Pendant**, Acrylic, silver, found materials, plastic netting and black sand, rubber. 9 cm x 9 cm x 1 cm, 2007. Canadian/British, lives and works in Scotland.

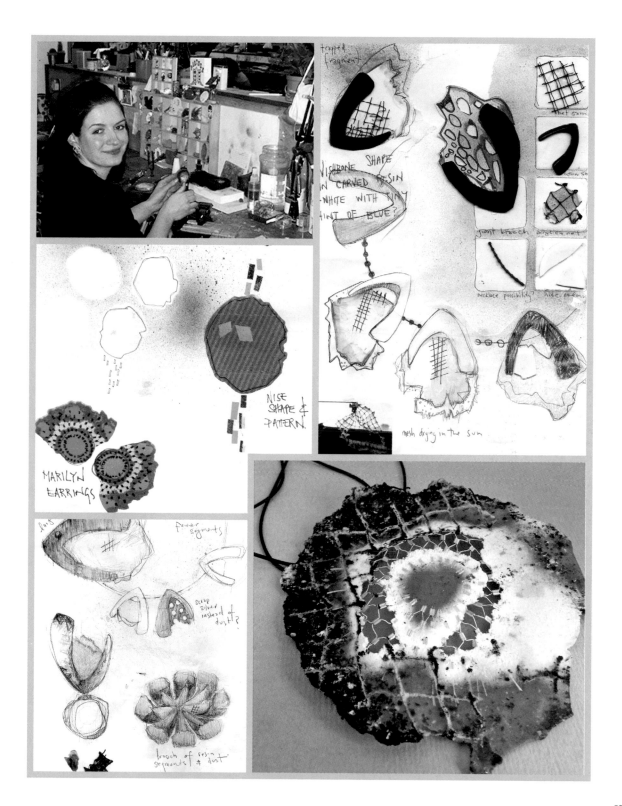

leonor hipólito

Where did you train to be a jeweller? Did you enjoy your time learning to be a maker? Between 1994 and 1995 I studied on a technical course in the School Contacto Directo, in Lisbon. In 1995 I decided to go abroad and I entered the Jewellery Department at the Gerrit Rietveld Academy, where I completed my studies in 1999. At the same period in 1998, I followed an exchange programme at the Parsons School of Design in New York. This period of learning was crucial for my personal development.

When mixed media is used in jewellery, there are an infinite number of possibilities and outcomes. Why do you use mixed media in your work? Mixed media is a consequence of ideas. I rarely take materials as a starting point, unless the material is by itself something more than just material, for example, raw wood. I usually look for materials that best translate the idea I wish to project. Most of the time, it happens to be the combination of several for the best solution, because their contrasts create some tension or because they mingle intensifying the form.

Explain your starting point for a new piece of work. Do you begin with perhaps an idea, photograph, museum trip, a material, etc? I usually begin with an idea. That idea is, however, my reflections about things that have particularly touched me and from which I feel driven to explore and to trace my viewpoint. It can happen to be an image, a living being, a culture, an environment, a feeling, to mention just a few.

Do you always know what a final piece will look like when you start it? Most of the pieces I make mainly develop in series. They are previously planned and visualised because they emerge from a very clear intention; a wish to pass on a message which I identify myself with. Most of the times I can visualise the final product before it gains three-dimensionality. That doesn't mean, however, forms won't grow and deviate from the previous plan. It is all part of an experimental process. I also don't skip important previous steps such as drawings, maquettes and notes.

Have you always used the materials you use now in your work or has there been a varied path to get to where you are now? Once in a while I pick up a material that is new for me but over the years I have realised that I have some to which I always return, such as silver, resins, rubber, fabric or wood.

1 Portrait.
2 Design process.
3 Material process.
4 Design process.
5 **Camouflage – Necklace**, Wood, paint, silver. Closed: 29 cm x 3.3 cm, opened: 97 cm x 3.3 cm. 2007. Portugal.

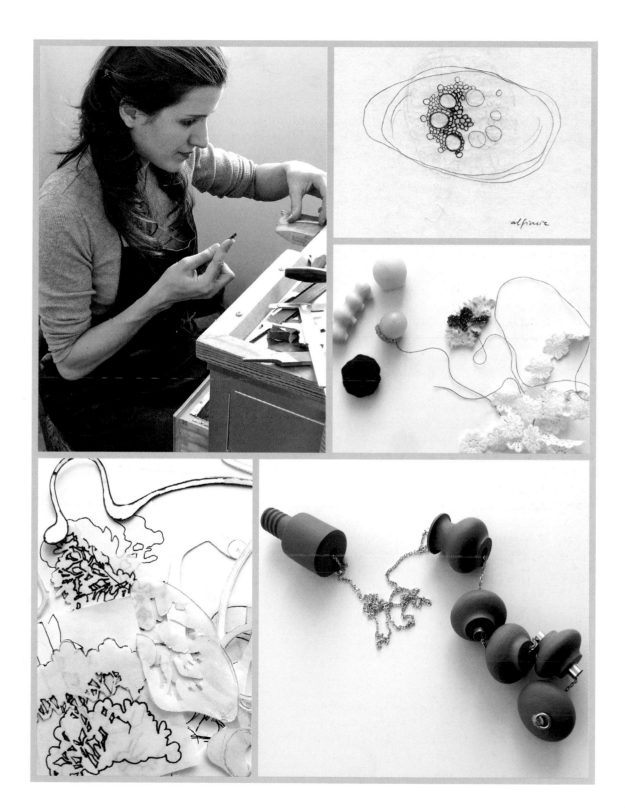

lina peterson

Do you think the country that you work in has any bearing on your work? I think that studying and working in another country from the one where I was brought up, Sweden, has sometimes made me feel more free in how I approach my work. I also think it makes me reflect more on origin and the idea of belonging. Material choices are sometimes influenced by these thoughts. I have, for instance, used my grandmother's tea towels in previous pieces. But mostly I don't think it matters very much.

How do you use colour in your work? I am interested in colour, and in my jewellery I use it quite intuitively. I use colour in my work both as a single unit as well as combining different colours in the same piece. I am also interested in how colour can be used when displaying several pieces together.

Do you always know what a final piece will look like when you start it? I very rarely know what a piece will look like when I start it. I will have an idea of what I want it to look like, or feel like, but the act of making will change it. I often use materials I haven't used before, or try to assemble something in a new way. I never quite know what the end result will be and for me that is part of the pleasure.

When you were learning to design and make jewellery, were there any makers who were influential to your development? I remember finding it difficult to find a balance of how much to look at other jewellers because I was aware that whilst I was finding out what jewellery I wanted to make, I was quite impressionable and I did not want to make jewellery that looked like someone else's. I think it's good to look beyond the jewellery world, to look at painters, photographers, product designers, to read, to go to the cinema.

Seeing where a maker works is always intriguing. Can you describe the space in which your work is made? I have a long desk and a jeweller's bench in my shared studio. I try to keep my desk clean, but most of the time it is covered with wax, papers, fabric, my computer and cups of tea. I've just moved studio and I've only got two postcards up on my wall, one of a piece of Indian textile with a bird print and one with an assortment of traditional varieties of apples. Leaning against the wall is a small piece of fluorescent fibreglass. The kettle is in the other end of the studio, and so is the coffee. Outside there is a cobbled yard and pot plants.

MIXED MEDIA JEWELLERY

1	2
3	4
5	6

1 Portrait.
2 Sketchbook.
3 Sketchbook.
4 Work in progress.
5 Sketchbook.
6 Flattened Brooch,
 Gold plated silver, textiles.
 11 cm x 8 cm x 1 cm, 2007.
 Swedish, lives and
 works in England.

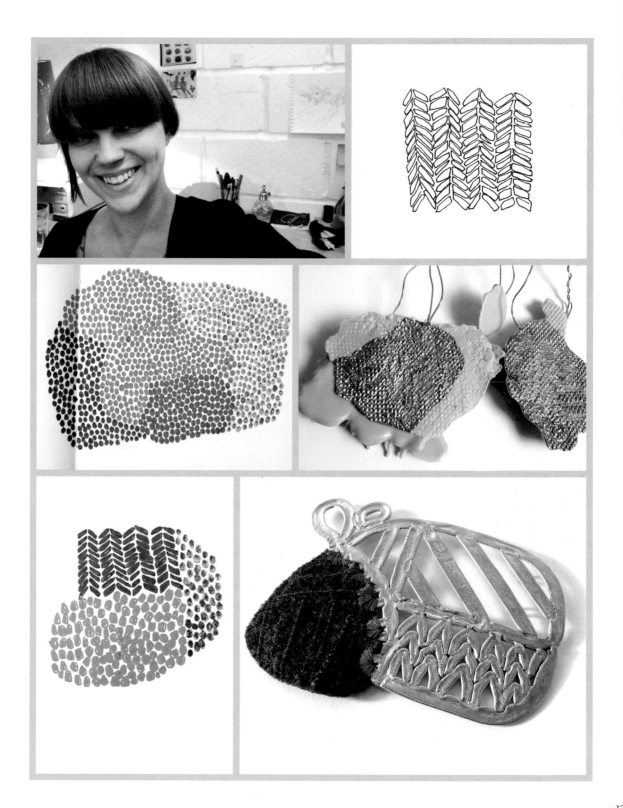

maike barteldres

Where did you train to be a jeweller? Did you enjoy your time learning to be a maker? I did my BA at Middlesex University, where tutors like Pierre Degan and Caroline Broadhead, apart from teaching metal techniques, also encouraged the use of other materials in jewellery. Being a sandwich course, it included a practical year which I spent in Australia and Germany, studying and working with jewellers as well as a stonemason. Here I discovered my love for stone. I went on to the Royal College of Art where I endeavoured to answer every project using stone and learning more about the material, as well as making invaluable contacts for my later career.

Do you always know what a final piece will look like when you start it? When I use the technique of sand casting, the result is very unpredictable. I try to imagine but can never tell exactly what a piece will look like until I open the mould. I would not want to miss that excitement in my work where I keep experiencing the awe of new unexpected sights.

What is the most enjoyable part of your job as a maker? I love the lonely hours of drilling and carving and filing while my mind is perfectly still. Only occasionally it occurs to me to marvel at the ease and certainty with which my hands know the correct angle, pressure or speed to achieve this. And then there is the moment when a piece is finished and it works and I am amazed that I really have made this.

What is the least enjoyable part of your job as a maker? I am a jeweller because I like hiding in the hollow of my bench. I hate having to go out there and sell my work, asking someone to pay money for it and then letting it go. I have boxes full of pieces that I will not part with.

Have you always used the materials you use now in your work or has there been a varied path to get to where you are now? I first started working with stone when I did a work placement with a stone carver in Germany. Whenever there was time between learning to carve letters and animals or trips to the cemetery to help clean and put up headstones, I collected off-cuts and combined them with metal to make them into jewellery. I discovered that natural stone like granite and marble, usually used for large sculpture or buildings, can become as intriguing as precious stones. Back at college I continued to explore stone as a material. Having grown up in Germany with few beaches and fewer pebbles, I was intrigued by the naturally shaped stones so readily available and so intriguing and sensuous. Although I love carving other types of stone, I always come back to the humble pebble.

1 Portrait.
2 Sketchbook.
3 Sketchbook.
4 Sketchbook.
5 **Slate Pebble Necklace**, Slate pebbles from Cornwall, sterling silver. 18 cm x 18 cm x 1 cm. 2007. Germany.

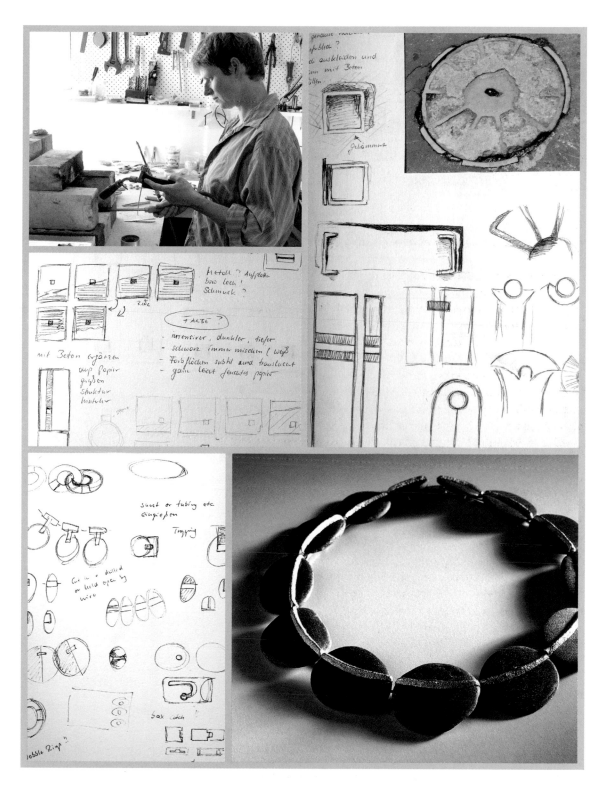

marcia macdonald

How would you define the term 'mixed media jewellery'? Mixed media jewellery is work that involves the use of more than one medium or material, often many. And in my opinion, it has to be done well, with good craftsmanship and attention to detail. The most successful pieces of mixed media jewellery are when the materials are chosen to support the idea and the materials are not used just for materials sake.

Who do you think is the most interesting mixed media jeweller working today? The work of Robin Kranitzky and Kim Overstreet is by far the best mixed media jewellery I have ever seen. They symbolise the ultimate mixed media artist. Their collaborative pieces draw in the viewer as they have such an amazing attention to detail and wonderment. Their ability to work well with varied materials while also creating complex narratives is impressive.

How do you physically design? Do you use sketchbooks and create test pieces? I generally start with a drawing or from some found object I have that inspires me. I am drawn to our material culture and the debris and stuff of life that I find on streets that tell of the people who live here. Paper, rusted steel, eggshells, rusted screen, glass from a broken window, etc. I can work right from an object that inspires and build the idea around that, or I can have an idea and try to find the material that will best suit the idea. It is a constant moving back and forth between the two and sometimes a combination of both. I rarely do test pieces. I am too impatient. My drawings can be very detailed so I don't feel the need to do models or test pieces.

How do you use colour in your work? I use colourful recycled tin from old tin cans and also paint, both acrylic and milk paints. I also use old steel signs and materials such as dyed fur, feathers and found objects that have assorted colours too numerous to list.

Seeing where a maker works is always intriguing. Can you describe the space in which your work is made? Most recently I am working in an old southern (North Carolina) mill building that has been converted to studio and work spaces. It has 60 windows and is a well lit space with high ceilings and wood floors that have seen a lot of foot traffic, very weathered and worn. It is a great space. My last space was in Oregon, an old warehouse with high ceilings with old wooden beams. Working in old buildings suits me just fine.

1 Portrait.
2 Sketchbook.
3 Sketchbook.
4 Studio space.
5 **Different...But Equal – Brooch,** Carved wood, sterling silver, broomstraw, colour core, rusted steel. 13 cm x 4 cm x 1.5 cm. 2005. USA.

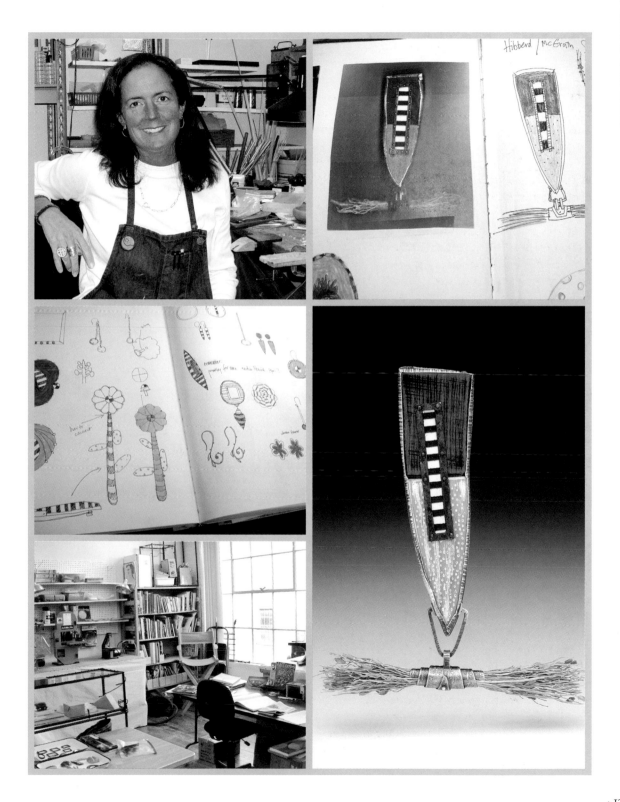

mari ishikawa

Where did you train to be a jeweller? Did you enjoy your time learning to be a maker? At first I studied at Hiko Mizuno College in Tokyo. After that, I moved to Munich and studied at the Akademie der bildenden Künste in Otto Künzli's class.

Do you think the country that you work in has any bearing on your work? Yes, especially in Munich, as it has an important jewellery scene. On the other hand, the influence of my home country, Japan, is now stronger for me since I lived in Germany because I'm thinking more about its traditions and my memories from there.

How do you use colour in your work? In my series 'EN' red is the main colour. It has a strong symbolic meaning and is a strong part of my memories about my childhood and home country. The 'EN' series was mainly made of red Japanese Kozo Paper. I also used Japanese red lacquer. It was interesting for me to see the difference between the soft and rough surface of the red paper and the hard and reflecting surface of the lacquer. Now I'm hardly using colours except the various grey tones of silver, from bright or soft reflecting up to a black surface. Sometimes I also use gold, especially to set accents. Actually I focus more on the shape then the colour.

How do you physically design? Do you use sketchbooks and create test pieces? Sometimes I make a paper model to get an impression about forms and dimensions but I don't work in sketches. The main design process is happening in my imagination.

When mixed media is used in jewellery, there are an infinite number of possibilities and outcomes. Why do you use mixed media in your work? At first I take some pictures in black and white. I'm fascinated by the various colours of green which appear as different tones of grey in the pictures. The shape of plants attracts me also. Their various shapes and their perfection is fascinating to me. I am trying to realise shape and tones of grey in my jewellery. The plant's shape is cast in silver. I want to show both the picture with its various greys and the three dimensional perfect shape.

1	2
3	4
5	

1 Portrait.
2 Black and white photograph.
3 Sketches.
4 Sketches.
5 **In The Shade Of The Tree – Rings**, Silver, gold, cast plants. Various sizes, 2006. Japanese, lives and works in Germany.

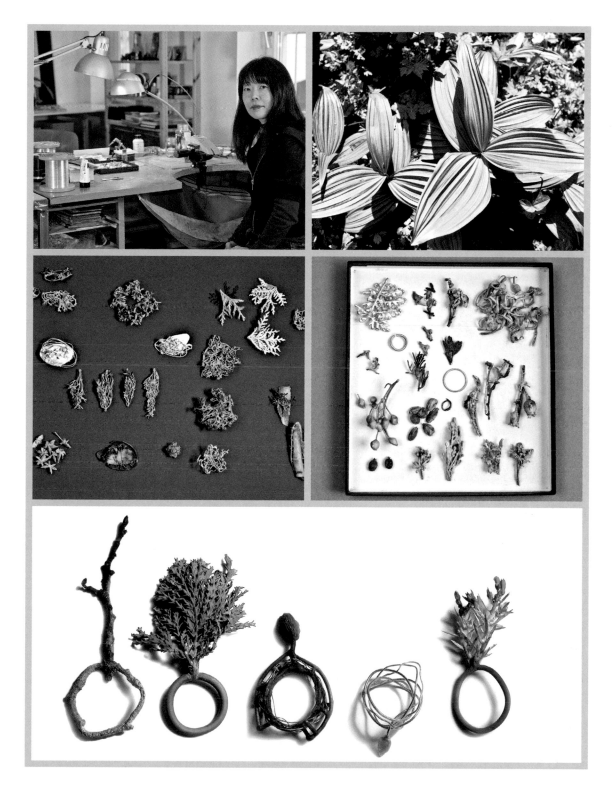

paula lindblom

Where did you train to be a jeweller? Did you enjoy your time learning to be a maker? I began by taking an evening class in an Art and Silversmithing school. I was then offered a place on the Jewellery Course at HDK, Gothenburg University. I have studied jewellery and silversmithing for eight years. I loved the process of learning how to work with silver and making jewellery.

Do you always know what a final piece will look like when you start it? I have an idea from the beginning, but quite often start with materials and I experiment with it, melting, burning or drilling. I see what occurs from these experiments and from that point I design with it. Often I don't have the final idea until I start to work on a piece. Sometimes I sketch, I use the digital camera a lot and I make lots of test pieces. I often collect flea market finds to work with.

When mixed media is used in jewellery, there are an infinite number of possibilities and outcomes. Why do you use mixed media in your work? I like the idea of reusing materials and have always used mixed media. I like to put objects and materials in other contexts. I think that something 'new' and interesting happens when I mix materials.

Have you always used the materials you use now in your work or has there been a varied path to get to where you are now? I work a lot with recycled materials. I started this body of work about four years ago, however I have always used everyday domestic materials as part of my jewellery and it is a large part of my way of thinking of jewellery. I don't really think about what others think or how others work. I am naturally curious and like to see what happens when I experiment.

Seeing where a maker works is always intriguing. Can you describe the space in which your work is made? I have my workshop in my apartment; I work in my small kitchen. Why? Because I can't make a living on my jewellery making and rent a studio. Therefore, I use my kitchen table and try to do things in a way that fits my workshop/kitchen. I like the versatile way I can use the space.

1 Portrait.
2 Sketchbook.
3 Sketchbook.
4 Materials.
5 **Necklace,** Found objects, glass beads. 60 cm length. 2007. Sweden.

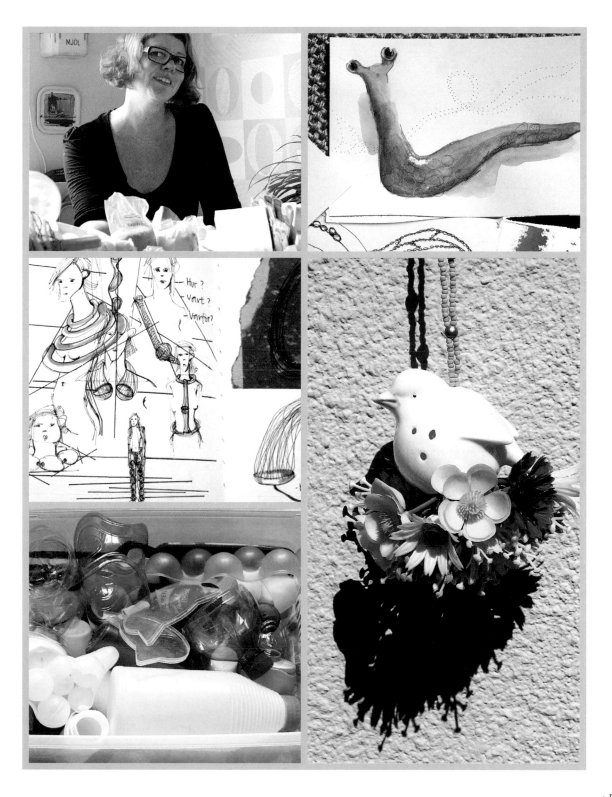

polly wales

Where did you train to be a jeweller? Did you enjoy your time learning to be a maker? I trained at London Guildhall for the second two years of the BA then studied for an MA at the Royal College of Art. I enjoyed my BA, as I found a medium with which I could best communicate. My time at the RCA however was unique for what it provided in opportunities, skills, confidence, friendship, access to equipment and time to really investigate my practice. I now share my studio with other RCA graduates.

Explain your starting point for a new piece of work. Do you begin with perhaps an idea, photograph, museum trip, a material, etc? I am still exploring one fundamental theme in my work, which primarily is an investigation of memory. I'm intrigued by the differences between how a precious and sentimental object is perceived by the wearer and the reality of how that object actually looks. Much of my work is an investigation of making objects that change and evolve through wear and time. It is about creating strata that can be examined and referenced almost like archaeology, revealing pasts and histories.

Do you always know what a final piece will look like when you start it? Mostly never. My work relies on experimentation and the accidental; the idea of making something inevitable doesn't hold my attention. This often leads to disappointment, but also leads to outcomes that surpass expectation and keep a momentum in my practice. Even the production work I make, such as the crystal rings, always have an unknown outcome, and the pierced filigree earrings, although they may have the same carcass, I find virtually impossible not to work on in different ways every time.

To what extent is design part of what you make? Certainly at college we are all taught to use a specific design process to reach a final piece. Do you religiously follow that learnt process, or have you found a different way? I think that time limitations become the strictest design tool forcing what would be sketchbook work to become internalised. Thoughts and ideas are constantly being refined and distilled until the time and space can be created to produce the actual work, a filtration process that can take months.

How do you physically design? Do you use sketchbooks and create test pieces? Due to the nature of how I work, I prefer responding directly to materials. The sketchbook work I do tends to verge on diagrammatic, resolving the structure of an object and then leaving the materials to resolve the aesthetics.

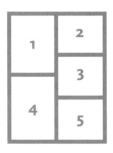

	2
1	3
4	5

1 Portrait.
2 Work in progress.
3 Test piece.
4 Drawing.
5 **Battenberg brooch**, Pink topaz, yellow cubic zirconia, black agate, silver, resin. 7 cm x 4 cm x 3 cm approx. 2006. England.

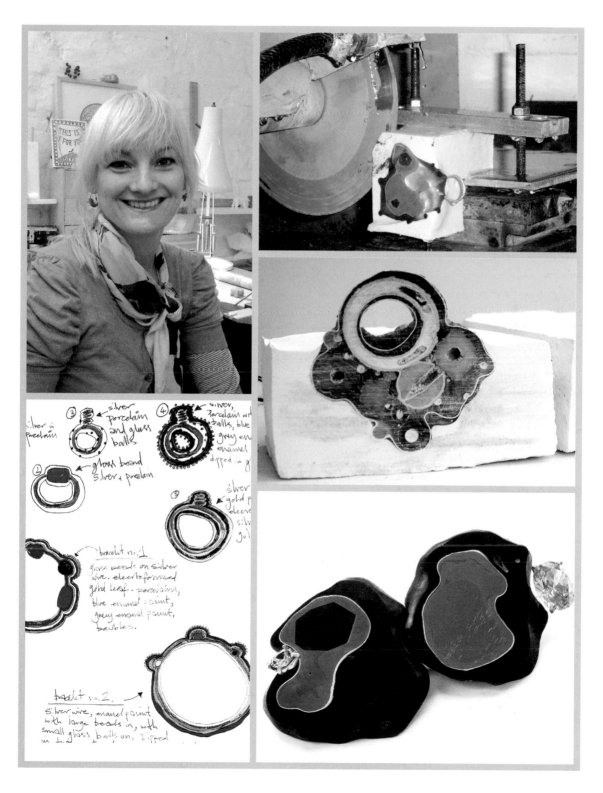

ramon puig cuyàs

Do you always know what a final piece will look like when you start it? I start new works without a project or plan; I draw and make schemes, exploring the possibilities of the composition, but I have a mental image, nothing defined. I have something like a pre-feeling. When I start constructing, I like improvising, in a dialogue between my hands and the materials. When it is concluded, I want to have a disturbing feeling to recognise myself in the new piece. I want to see something new and unexpected in the work.

To what extent is design part of what you make? Certainly at college we are all taught to use a specific design process to reach a final piece. Do you religiously follow that learnt process, or have you found a different way? I use the sketches and drawings to explore new ways and variables in the composition. I prefer to improvise from the model of the last finished work. Normally, I start and finish one piece but sometimes I work on different pieces at the same time. Jewellery is a three-dimensional expression, and for me, the best way to approximate this language is to work directly with the material.

When you were learning to design and make jewellery, were there any makers who were influential to your development? I studied in the Massana School of Arts and Design in the 1969–1970 class, and my lecturer from this time was Manuel Capdevila. He used silver and pebbles for his works. Hermann Jünger, Friederich Beker, from Germany, Anton Cepka, Bruno Martinatzi and many other colleagues were working at the time.

How do you use colour in your work? The colour is a fundamental part of my work from years ago. I need to use colour because I want to make enjoyable jewellery. In the Mediterranean countries, the light and colour is present in many cultural aspects of everyday life. I feel my work is closer to painting and the language of sculpture. The colour gives me the possibility to accentuate and express ideas. I can use coloured materials, like plastics, or apply colour by painting with acrylic colours or enamel.

Seeing where a maker works is always intriguing. Can you describe the space in which your work is made? I work in a small room in my apartment, together with my wife Silvia Walz, where we can see a spectacular view over the Mediterranean Sea. Over the harbour we can see the changing lights of the passing day, the coming sun and the red sunsets. It is not only a place for working, it is a place for living. Always in the middle of organised chaos of eclectic objects.

1 Portrait.
2 Materials.
3 Drawing.s
4 Works in progress.
5 **Brooch**, Silver, plastic, enamel, silver nickel, acrylic painting. 5.5 cm x 5.5 cm x 1 cm. 2007. Spain.

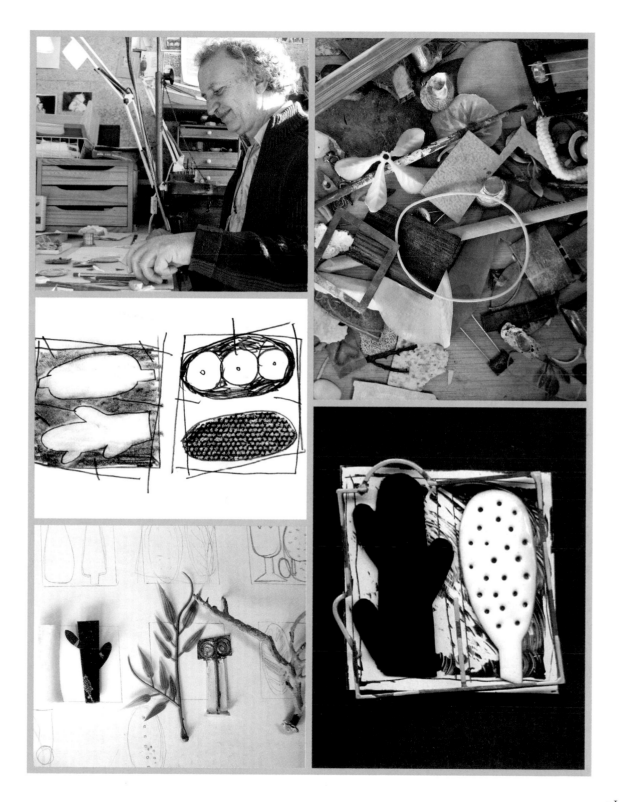

suzanne smith

Where did you train to be a jeweller? Did you enjoy your time learning to be a maker?
I studied Jewellery and Silversmithing at Glasgow School of Art and graduated in 2006. The time spent on the course was both challenging and rewarding. I learned a great deal including the obvious technical aspects, but also valuable things such as time management, presentation skills and computer aided design. The time at art school provided a period of great personal development for me and the opportunity to experiment in a creative environment with inspirational people.

To what extent is design part of what you make? Certainly at college we are all taught to use a specific design process to reach a final piece. Do you religiously follow that learnt process, or have you found a different way? The process that I follow now has not really changed since being a student. I like to research and investigate my original ideas through sketching and photography, then begin refining and experimenting both in sketchbooks and with test pieces. Occasionally I may return to ideas I discarded earlier on in the process and I think that every creative person finds their own way to work, as what may work for one person may be less effective for another.

How do you physically design? Do you use sketchbooks and create test pieces? Sketchbooks are something that I enjoy creating and are almost an ongoing, never ending task, as I will often continue to reuse, amend and update them. I like to make collages of materials and record on the pages in that medium as it allows me creative freedom. After recording source material, I will then begin to develop ideas and use samples and test pieces to explore ideas. These pieces are very important as you can then begin to draw out the best solutions and highlight any problems early on.

What is the most enjoyable part of your job as a maker? I most enjoy the creative side of making, the thinking up of new ideas and then actually making these come alive, creating three-dimensional objects. It is exciting to see something that was once an idea in your head become a reality. I often find that ideas just come out of nowhere, when I least expect it, and so it is a challenge to keep up with them all and try to develop them into pieces of jewellery. The design process from initial research through to development and final pieces is my most enjoyable time when working.

What is the least enjoyable part of your job as a maker? Keeping up with administrative tasks and the paperwork would be the least favourable part of the job. However, it is necessary to keep that side of a business in good shape and the more organised I am, the more time is available for creating and making.

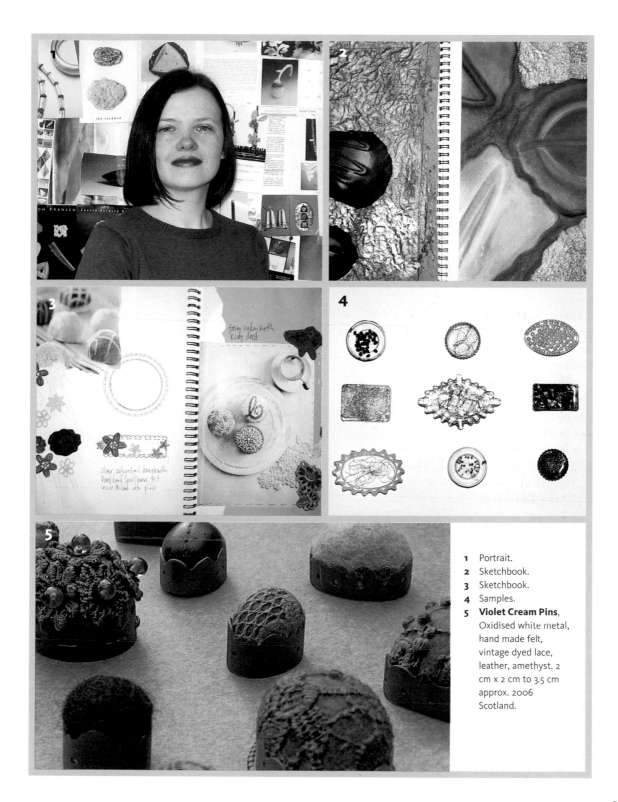

1 Portrait.
2 Sketchbook.
3 Sketchbook.
4 Samples.
5 **Violet Cream Pins**,
Oxidised white metal,
hand made felt,
vintage dyed lace,
leather, amethyst. 2
cm x 2 cm to 3.5 cm
approx. 2006
Scotland.

tabea reulecke

To what extent is design part of what you make? Certainly at college we are all taught to use a specific design process to reach a final piece. Do you religiously follow that learnt process, or have you found a different way? I've always tried to go my own way. Of course you don't always succeed in doing this at the beginning of your studies. You need role models. Beate Klockmann is one for me. She tutored me during my studies from beginning to end. I had a tendency to realise a hundred ideas simultaneously. It was my way of working, but it can have fatal consequences. Beate taught me to focus on what is important and to take decisions. I was asking myself 'who am I?' Professor Theo Smeets gave me room for free development. No chains impeded my work. Slight encouraging nudges have pushed me forward.

When mixed media is used in jewellery, there are an infinite number of possibilities and outcomes. Why do you use mixed media in your work? For my works I mainly use natural materials, rarely artificial ones like plastic for example. I create my own world with them. Certain materials happen to become synonyms of other words so that there is a story you can only read if you know the necessary vocabulary.

How do you physically design? Do you use sketchbooks and create test pieces? I never make models. From my experience I know that models are always better than the second piece. In the studio, one-offs are being made, i.e. many materials only exist once or in small amounts. Natural materials especially are very likely to be scarce. Therefore, if I am convinced of an idea, I invest all my power and my energy into it. In a second attempt there would only be half the power or none would be left at all. It can also be boring to do something again. Sketch books are beautiful and I started a few. However, if the ideas are written down and sketched, I have realised them already somehow and I rarely think I need to realise them again in 3D.

How would you define the term 'mixed media jewellery'? It is like cooking. If you have different ingredients, there is more variety in preparing the dishes and the pleasure is longer and more exciting.

Seeing where a maker works is always intriguing. Can you describe the space in which your work is made? At the moment I have got two workplaces. One at the University of Applied Sciences and the other at home. My studio at home is where I'm getting my ideas. I listen to detective novels or to good music. My materials are stored in different boxes and shelves. Only my two rabbits are keeping me company. At my workplace in the University, where the big machines and tools are, I do routine work when I already know exactly what I'm going to do.

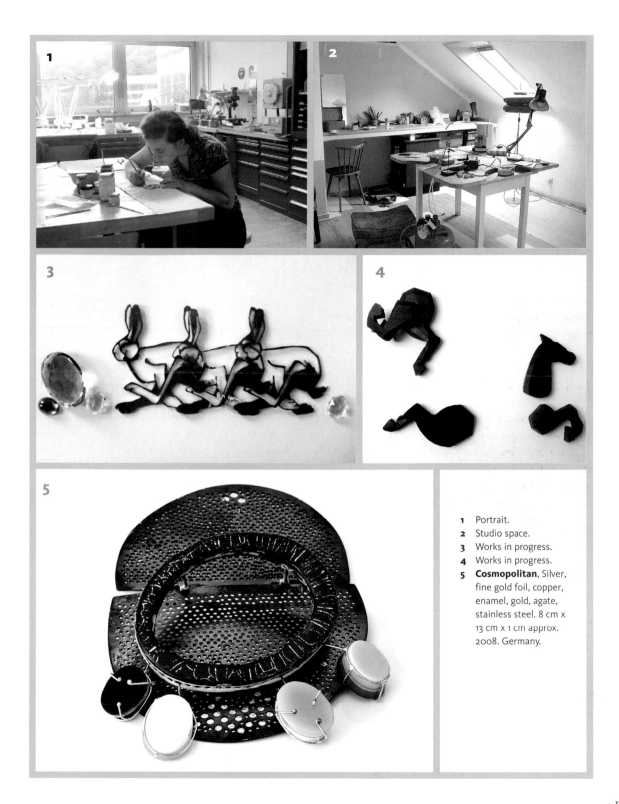

1 Portrait.
2 Studio space.
3 Works in progress.
4 Works in progress.
5 **Cosmopolitan**, Silver,
fine gold foil, copper,
enamel, gold, agate,
stainless steel. 8 cm x
13 cm x 1 cm approx.
2008. Germany.

the gallery

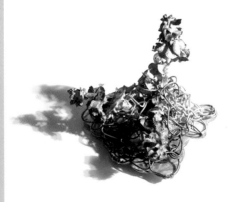

1 **Orange Fern brooch**, Marcia Macdonald. Carved wood, sterling silver, recycled tin. 12.5 cm x 6.5 cm x 1 cm. 2005.

2 **Brooch**, Alessia Semeraro. Iron, 24 ct gold. 5 cm x 5 cm. 2006.

3 **Flattened Brooch**, Lina Peterson. Gold-plated copper, steel, silver, silk thread, plastic. 10 cm x 7 cm x 1 cm. 2006.

4 **Brooch**, Mari Ishikawa. Silver and plant. 6 cm x 4.5 cm x 5 cm. 2006.

5 **Two Sides of Life – Brooch**, Tabea Reulecke. Coral, wood, enamel, copper, oil colour, garnets. 10 cm x 12.5 cm x 0.5 cm. 2006.

6 **Wishbone Brooch**, Jo Pudelko. Silver, resin, acrylic, recovered plastic netting, paper. 7 cm x 5.5 cm. 2007.

7 **Long Flower Ring**, Suzanne Smith. Oxidised white metal, hand made felt, vintage dyed lace, lace flower, tiger's eye. 3.5 cm x 3 cm x 1 cm. 2007.

8 **Necklace**, Jo Pond. Vellum, silver, thread, paper. 120 cm long. 2007.

9 **Brooch**, Ela Bauer. Copper-fabric, yarn, pink coral, silicone. 5 cm x 4 cm x 7 cm. 2008.

10 **Hair Necklace**, Francis Willemstijn. Human hair, silver, glass, iron. 40 cm. 2006.

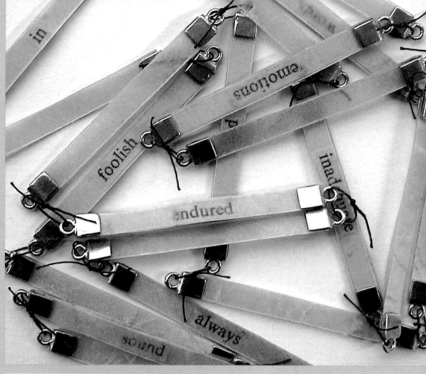

photo credits

Spanish Bride, p2 & p10 Photo: Mecky van den Brink; Sumerian court jewellery, p7 © The Trustees of the British Museum; Gold necklace set with the heads of hummingbirds, p8 © The Trustees of the British Museum; Dragonesque brooch, p9, © The Trustees of the British Museum; Winter Series Brooch, p11 Photo: Francis Willemstijn; Book cover brooch p11 Photo: Jo Pond; Green Mushrooms brooch, frontispiece, p11 Photo: Terhi Tolvanen; Resin and Thread Necklace, p11 Photo: Kathie Murphy; Grapes necklace, p21 Photo: Yael Krakowski; Propeller brooch, p21 Photo: Lindsey Mann; Necklace – growth series, p21 Photo: Natalya Pinchuk; Compass, p21 Photo: Ami Avellán; Staphorst brooch, p21 Photo: Francis Willemstijn; Maze brooch, p21 Photo: Roger Schreiber; Slate pebble brooch, p21 Photo: Maike Barteldres; Collage, Joanne Haywood, p34 Photo: Alan Parkinson; Painting, Joanne Haywood, p35 Photo: Alan Parkinson; Organic Forms, Paula Lindblom, p35 Photo: Paula Lindblom; Charcoal and Paint Design, p36 Photo: Alan Parkinson; Mixed Media Designing, p37 Photo: Jo Pudelko; Drawing and Paint Design, p37 Photo: Ramon Puig Cuyàs; Final Design, p37 Photo: Dionea Rocha Watt; Pencil on Paper Design, p37 Photo: Jo Pond; Ribbon and Metal Experiments, p38 Photo: Alan Parkinson; Metal Leaf and Silver Experiments, p38 Photo: Alan Parkinson; Drawing, p39 Photo: Alan Parkinson; Observational Drawing, p40 (two images) Photo: Alan Parkinson; Visual Research, Suzanne Smith p41 Photo: Suzanne Smith; Historical Research, p41 Photo: Dionea Rocha Watt; Visual Research, Alessia Semeraro p41 Photo: Alessia Semeraro; Visual Research, Mari Ishikawa p41 Photo: Mari Ishikawa; Test Pieces in Polystyrene, p43 Photo: Leonor Hipólito; Material Development, p43 Photo: Jo Pond; Test Pieces in Fabric and Threads p43 Photo: Alan Parkinson; Paper Burning Experiment, p43 Photo: Alan Parkinson; Fabric Test Pieces, p43 Photo: Suzanne Smith;

Works in Progress, Francis Willemstijn p44 Photo: Francis Willemstijn; Works in Progress, Ela Bauer, p44 Photo: Ela Bauer; Works in Progress, Jo Pond, p45 Photo: Jo Pond; Pectoral, p50 Photo: Marco Minelli; My Garden – Necklace, p50 Photo: Silvia Walz; Tulips – Necklace, p50 Photo: Ineke Otte; The Gloves Dream – Necklace, p50 Photo: Rama; Dualism – Ring, p51 Photo: mi-mi Moscow; Ruffle Bracelets, p51 Photo: Christine Dhein; Dipped Pin, p51 Photo: Lina Peterson; Necklace, p51 Photo: Ela Bauer; Crown Jewels, p56 Photo: Mats Häkanson; Duotone 2 – Brooch (Back), p56 Photo: Stefan Heuser; Halo for St. Ray Gaurino, p56 Photo: Hap Sakwa; Neckpiece, p56 Photo: Paula Lindblom; Necklace, p57 Photo: Ela Bauer; Torus – Neckpiece, p57 Photo: Joanne Haywood; Jade Banditos – Earrings, p57 Photo: Polly Wales; Necklace, p57 Photo: Karin Seufert; Bone Necklace with Ribbon, p64 Photo: Frank Thurston; Maui Birthdays – Bracelet, p64 Photo: Lynda Watson; Meercat Don Q, p64 Photo: Eddo Hartmann; Polka Dotted Chicken Brooch, p65 Photo: Hap Sakwa; Book Box – Pendant, p65 Photo: Roger Schreiber; Orange Alert, p65 Photo: R.R. Jones; Two Sides of Life – Brooch, p65 Photo: Tabea Reulecke; Commuter Train Bracelet, p65 Photo: Kristin Lora; Union 26 Years – Neckpiece, Nesting Case, p70 Photo: Evan J. Soldinger; Ring, p70 Photo: Federico Del Fabro; Book – Ring, p70 Photo: Fabrizio Tridenti; Untitled 6 Brooch, p71 Photo: Hu Jun; Guilded Rosewood Bowl Ring and Double Dish Earrings, p71 Photo: Kate Brightman; No 979 – Brooch, p71 Photo: Ramon Puig Cuyàs; Martha – Brooch, p71 Photo: Rachelle Varney; Sat Alone – Brooch, p71 Photo: Jo Pond; Dempire – Brooches, p76 Photo: Julian Kirschle - The Marzee Collection Silver and Elastic Bracelet, p76 Photo: Shannon Toffs; Bronzino – pearl Neclace, p76 Photo: Carla Nuis; Travelling Rings, p76 Photo: Pieter Huybrechts - The Marzee Collection; Smiley - Brooch, p77 Photo: Alexander Blank; Jeweler's Dozen: Andy Warhol –

Brooch, p77 Photo: Ingrid Psuty; Distress, p77 Photo: Robin Kranitzky and Kim Overstreet; Garden Brooch, p77 Photo: Richard Matzinger; Sphere Ring, p82 Photo: Ai Morita; Three Cake Rings, p82 Photo: Suzanne Smith; Spring Green Flowerpot Ring, p82 Photo: Suzanne Potter; Unicated – Ring Series, p82 Photo: Kirsten Bak; Music Box Rings, p82 Photo: Anastasia Young; Ring, p83 Photo: Kathleen Taplick and Peter Krause (Body Politics); Balance – Ring, p83 Photo: Kwangchoon Park Dark Blue Felted Ball Ring, p83 Phot: Chris McCaw; Large Pottery Pendant, p88 Photo: Rosie Bill; Jade City – Brooch, p88 Photo: Andrea Wagner; Binae Insula – Brooch, p88 Photo: Ramon Puig Cuyàs; In the Forest – Ring, p88 Photo: Dominic Tschudin; Stucco – Necklace, p89 Photo: Evert Nijland; Doll Head – Ring, p89 Photo: Steffi Kalina; Stethoscope, p89 Photo: Ami Avellán; Pipe Flower Neckpiece, p89 Photo: Alan Parkinson; Necklace, p94 Photo: Shannon Toffs; Spinning Propeller Pendants, p94 Photo: Helen Gell; Imprint – Suede Rosettes, p94 Photo: Jesse Seaward; Continium – Brooch, p94 Photo: Francis Willemstijn - Courtesy of Galerie Rob Koudijs; White Tea Bangle, p95 Photo: Claire Lowe; Entropus Atropos – Brooch, p95 Photo: Mark Rooker; Flora – Neckpiece, p95 Photo: Roger Schreiber; Vertical Ring Ball, p95 Photo: Marco Minelli; Kinetic Ring, p100 Photo: Mike Blissett; Ring, p100 Photo: Ermelinda Magro; Black and Red Coral Necklace, p100 Photo: Sarah Keay; Brooch: 334, p100 Photo: Fabrizio Tridenti; Growth Series – Brooch, p101 Photo: Natalya Pinchuk - Courtesy of Rob Koudijs Galerie; Bangle, p101 Photo: Gill Forsbrook; Polypropylene Bangles, p101 Photo: Rachel Mcknight; Lime Green Scatter Brooch, p101 Photo: Jo Pudelko; Collar, p106 Photo: Machteld Van Joolingen; Marine Fish Long Hook Rivet Earrings, p106 Photo: Sussie Ahlburg; Leaf Fairytale Earrings, p106 Photo: Shannon Tofts; Pendant, p106 Photo: Thierry Zufferey; Loin Du Train Train Quotidien, p107 Photo:

UK suppliers

Cooksons
Metal and General Jewellery Supplies
Cookson Precious Metals
59-83 Vittoria Street
Birmingham, B1 3NZ
Tel: +44 (0)845 100 1122 / +44 (0)121 200 2120
www.cooksongold.com

L. Cornelissen & Son
Gold Leaf, Gilding and Artist Equipment
105 Great Russell Street
London, WC1B 3RY
Tel: +44 (0)20 7636 1045
www.cornelissen.com

Fibre Crafts
Felt and Textiles Materials and Equipment
Old Portsmouth Road, Peasmarsh, Guildford, Surrey, GU3 1LZ
Tel: +44 (0)1483 565800
www.fibrecrafts.com

The Handweavers Studio
Felt and Textiles
29 Haroldstone Road
London, E17 7AN
Tel: +44 (0)20 8521 2281
www.geocities.com/Athens/Agora/9814/

HobbyCraft
Beads, Balloons, Embroidery Silks and Craft Items
The Arts and Crafts Superstore
Stores nationwide
Tel: +44 (0)800 027 2387
www.hobbycraft.co.uk

GF Smith
Polypropolene
Unit C4
Six Bridges Trading Estate
Marlborough Grove
London, SE1 5JT
Tel: +44 (0)1482 323 503
www.gfsmith.com

Rashbel
Metal and General Jewellery Supplies
24–28 Hatton Wall
London, EC1N 8JH
Tel: +44 (0)20 7831 5646
www.rashbel.com

Walsh & Sons
Metal and General Jewellery Supplies
Hatton Garden Showrooms
44 Hatton Garden
London, EC1N 8ER
Tel: +44 (0)20 7242 3711
www.hswalsh.com

where to study jewellery design

Below is a selection of courses and colleges in the UK. To find out more about the courses, visit the websites listed. To find even more institutions to study jewellery, the UCAS website (http://www.ucas.ac.uk/) lists all the UK, H.E. Jewellery, Design and Craft courses available. Equally, local adult education centres can offer very good training that should not be overlooked.

Buckinghamshire New University
Faculty of Creativity & Culture, High Wycombe Campus, Queen Alexandra Road, High Wycombe, Buckinghamshire, HP11 2JZ
Tel: +44 (0)800 0565 660
www.bucks.ac.uk
BA (Hons) Jewellery
BA (Hons) Silversmithing Metalwork and Jewellery

Central Saint Martins College of Art and Design
Southampton Row, London, WC1B 4AP
Tel: +44 (0)20 7514 7000
www.csm.arts.ac.uk
BA (Hons) Jewellery Design
MA Design, Ceramics, Furniture or Jewellery

Edinburgh College of Art
Lauriston Place, Edinburgh, EH3 9DF
Tel: +44 (0)131 221 6000
www.eca.ac.uk
BA (Hons) Design & Applied Arts

The Glasgow School of Art
167 Renfrew Street , Glasgow, G3 6RQ
Tel: +44 (0)141 353 4500
www.gsa.ac.uk
BA (Hons) Design, Silversmithing & Jewellery

London Metropolitan University
59-63 Whitechapel High Street, London E1 7PF
Tel: +44 (0) 20 7423 0000
www.londonmet.ac.uk
BA (Hons) Jewellery
Foundation and Silversmithing courses also available

Middlesex University
Cat Hill, Barnet, Herts, EN4 8HT
Tel: +44 (0)20 8411 5000 / 5010
www.mdx.ac.uk
BA (Hons) Jewellery
BNA (Hons) Fashion Jewellery and Accessories

Royal College of Art
Kensington Gore, London, SW7 2EU
Tel: +44 (0)20 7590 4444
www.rca.ac.uk
MA Goldsmithing, Silversmithing, Metalwork and Jewellery

Sheffield Hallam University
City Campus, Howard Street, Sheffield, S1 1WB
Tel : +44 (0)114 225 5555
www.shu.ac.uk
BA (Hons) Metalwork and Jewellery
MDes Metalwork and Jewellery

University College for the Creative Arts at Rochester
Fort Pitt, Rochester, Kent, ME1 1DZ
Tel: +44 (0)1634 888 702
www.ucreative.ac.uk/rochester
BA (Hons) Silversmithing, Goldsmithing & Jewellery
BA (Hons) Contemporary Jewellery

further reading

CONTEMPORARY & STUDIO JEWELLERY BOOKS

New Directions in Jewellery
Jivan Astfalck and Paul Derrez
Black Dog Publishing, 2005

New Directions in Jewellery Volume 2
Beccy Clarke and Indigo Clarke
Black Dog Publishing, 2006

The New Jewellery Trends and Traditions
Peter Dormer and Ralph Turner
Thames & Hudson, 1994

Jewelry of Our Time: Art, Ornament and Obsession
Helen W.Drutt English and Peter Dormer
Thames & Hudson, 1995

Unclasped: Contemporary British Jewellery
Derren Gilhooley, Simon Costin, and Gavin Fernandez
Black Dog Publishing, 2001

500 Brooches
Marthe Le Van
Lark, 2005
(There are several in this series including earrings, bracelets and rings.)

Jewellery in Europe and America, New Times New Thinking
Ralph Turner
Thames & Hudson, 1996

Jewellery Design Sourcebook
David Watkins
New Holland Publishers Ltd, New edition, 2002

DESIGN & TECHNIQUES JEWELLERY BOOKS

Textile Techniques in Metal for Jewellers, Textile Artists and Sculptors
Arlene M. Fisch
Hale, 1997

The Encyclopedia of Jewelry-making Techniques
Jinks McGrath
Running Press Book Publishers, 1995

The Jeweller's Directory of Decorative Finishes: From Enamelling and Engraving to Inlay and Granulation
Jinks McGrath
A & C Black Publishers, 2005

Resin Jewellery
Kathie Murphy
A&C Black Publishers, 2002

The Art of Jewellery Design from Idea to Reality
Elizabeth Olver
A&C Black Publishers, 2001

The Jeweller's Directory of Shape and Form
Elizabeth Olver
A&C Black Publishers, 2001

Wire Jewellery
Hans Stofer
A&C Black Publishers, 2005

Jewelry Concepts and Technology
Oppi Untracht
Robert Hale Ltd, 1985

HISTORICAL JEWELLERY BOOKS

Earrings: From Antiquity to the Present
Daniela Mascetti and Amanda Triossi
Thames & Hudson, 1999

An Illustrated Dictionary of Jewellery
Harold Newman
Thames & Hudson, New edition, 1987

Jewelry From Antiquity To The Present
Claire Phillips
Thames & Hudson, 1996

Seven Thousand Years Of Jewellery
Edited by Hugh Tait
British Museum, 1986

PERIODICALS

Crafts Magazine
Crafts Council

Findings
Association for Contemporary Jewellery (ACJ)

Metalsmith
Society of North American Goldsmiths (SNAG)

glossary

Annealing	Heating metal to make it easier to work with.
Base metal	A non-precious metal, e.g. copper, aluminium, brass, etc.
Binding wire	Wire that is used to hold metal together when soldering. It is made from iron.
Borax	Flux used for soldering. It comes in the form of a cone, used in conjunction with a ceramic dish and water.
Burnisher	A hand held tool for polishing metal surfaces.
Cabochon	A stone that is formed with a domed cut.
CAD	Computer Aided Design.
Calico	Cotton fabric.
Centre punch	A tool for marking a point to be used to help guide the drill. To be used in conjunction with a hammer.
Cover buttons	Buttons made from two components, so that you can cover them with your own fabric.
Creative buttons	A button with a series of piercings to stitch into. Usually with coloured cottons.
Crochet	A textile technique, similar to knitting, using a single hook.
Dressmaking chalk	Chalk for making marks on cloth that can be easily removed from the surface.
Emery paper	Used for cleaning surfaces. This is available in different grades of abrasiveness.
End cutters	Cutting pliers for use with various wires.
Epoxy resin	A thermosetting glue.
Fimo®	A brand type of polymer clay.
Findings	Elements such as earring posts, catches and brooch pins, and mass produced items in a variety of metals.
Fishing latex elastic	Used for fishing, this latex is very stretchy and strong.
Flux	Protective solution for silver surfaces, painted with when soldering to help the solder run and prevent oxides forming.
Hand drill	A drill that can be used by hand. An accessible low tech way of piercing materials.

Hand torch	A torch for heating metal. This is held in the hand, similar to cooking torches.
Joint tool	For cutting tube. Also known as a tube cutter.
Knitting	A textile technique involving linking loops together to form a surface.
Malleable	A material that can be shaped and formed with ease, e.g. clay.
Mandrel	A forming tool used for making rings, bangles and general shaping.
Merino felt	A fine wool used for felting.
Metal leaf	Very thin foil metal.
Milliput®	An epoxy putty.
Mud larking	Searching for objects from a river bed.
Needle files	Small files used for jewellery.
Pickle	A solution for cleaning metal after being heated and soldered. It is either made with sulphuric acid or safety pickle.
Piercing	Sawing the surface of metal, to take away areas either decorative or functional.
Pin wire	Wire that is made pre-hard, making it ideal for springy pins.
PMC	Precious Metal Clay.
Polypropylene	A thermoplastic, often used in a sheet format by jewellers.
Precious metal	E.g. silver, gold, platinum, etc.
Shearing elastic	An elastic thread, usually coated with a coloured thread.
Smocking	An embroidery technique, used to gather fabric.
Soldering	Joining metal with solder and heat.
Thermosetting	A chemical reaction that happens to set a plastic into a solid. It is irreversible and will stay as a solid once set.
Tiger tail	Flexible bead wire.
Tin snips	A tool used for cutting sheet metal.
Velum adhesive spray	A spray adhesive used for velum and other crafts.
Work hardening	Metal gets hard when it is shaped and worked on with tools. It can be reversed by annealing.

index